CIRCUS AMERICANUS

THE HAYMARKET SERIES
Editors: Mike Davis and Michael Sprinker

The Haymarket Series offers original studies in politics, history and culture, with a focus on North America. Representing views across the American left on a wide range of subjects, the series will be of interest to socialists both in the USA and throughout the world. A century after the first May Day, the American left remains in the shadow of those martyrs whom the Haymarket Series honors and commemorates. These studies testify to the living legacy of political activism and commitment for which they gave their lives.

CIRCUS AMERICANUS

◆

RALPH RUGOFF

**With original photographs by
Mark Lipson and Debra DiPaolo**

V

VERSO

London • New York

First published by Verso 1995

With the exception of "Gene Autry and the Marlboro Man," which appeared
originally in *Art Issues*, and "Gambling with Reality: The New Art of Las
Vegas," parts of which appeared originally in *Harper's Bazaar*, all pieces were
published originally in the *LA Weekly*.

Verso
UK: 6 Meard Street, London W1V 3HR
USA: 180 Varick Street, New York NY 10014–4606

Verso is the imprint of New Left Books

ISBN 978-1-8598-4003-5

British Library Cataloguing in Publication Data
A catalogue record for this book is available from the British Library

Library of Congress Cataloging-in-Publication Data
Rugoff, Ralph.
 Circus Americanus / Ralph Rugoff.
 p. cm.
 ISBN 1–85984–982–2 (hbk). — ISBN 1–85984–003–5 (pbk)
 1. Material culture—California—Los Angeles. 2. Arts,
Modern—20th century—California—Los Angeles. 3. Arts, American—
California—Los Angeles. 4. Museums—California—Los Angeles. 5. Arts,
Modern—20th century—California, Southern. 6. Arts, American—California,
Southern. 7. Los Angeles (Calif.)—Description and travel. I. Title.
 F869.L84R84 1995
 709'.794'90904—dc20
 95–34066
 CIP

Typeset by M Rules
Printed and bound in Great Britain by
Marston Book Services Limited, Oxfordshire

CONTENTS

ACKNOWLEDGEMENTS

I would like to thank my editors at the *LA Weekly*, where most of these pieces first appeared: in order of succession, Steve Erickson, Judith Lewis, and Steven Mikulan. Thanks also to that paper's two succeeding editors-in-chief, Kit Rachlis and Sue Horton, both of whom granted me *carte blanche* when it came to choosing subject matter for my biweekly column. I would also like to thank the patience of readers who repeatedly braved a mislabelled "arts" page only to find more circus fare.

For their conversation and knowledge of the terrain, my friends Fred Dewey, Jeffrey Vallance, and Daniel Marks were a great resource. Thanks also to my editors at Verso, Mike Davis (whose writings on LA created a new standard for all who work here) and Colin Robinson.

Above all, I wish to thank my wife and constant editor, Denise Bigio, who read most of these pieces while they were still being born. This collection goes out to her and to the memory of my father, a circus fan she never met.

Photograph credits are as follows: Excalibur Hotel, Las Vegas by David Sims, courtesy of *Harper's Bazaar* (p. 2); Sea World by Debra DiPaolo (p. 8); Alpine Village by Debra DiPaolo (p. 16); Universal CityWalk by Mark Lipson (p. 26); Miniature golf, Torrance (skull and pool) by Debra DiPaolo (p. 30); Magic Johnson, Hollywood Wax Museum by Mark Lipson (p. 54); *Security Guard* sculpture by J. Seward Johnson by Mark Lipson (p. 58); *Corporate Head* sculpture by Terry Allen by Mark Lipson (p. 61); Weapons destruction, Los Angeles by Flora Gruff (p. 64); Postriot architecture by Debra

DiPaolo (p. 68); Juan Soldado shrine, Tijuana by Debra DiPaolo (p. 72); Century Freeway Overpass by Debra DiPaolo (p. 82); Richard Nixon Library and Birthplace (painting) by Mark Lipson (p. 86); Scientology headquarters, Los Angeles by Mark Lipson (p. 92); Beit Hashoah Museum of Tolerance (hanging bodies) by Mark Lipson (p. 102); LA County Sheriff's Museum (female sheriff mannequins) by Mark Lipson (p. 108); Gene Autry Western Heritage Museum (Longhorn diorama) by Mark Lipson (p. 114); Liberace Museum (bronze hands) by Flora Gruff (p. 120); Butterfield's Auction House (*Star Trek* costumes) by Debra DiPaolo (p. 124); The Mutter Museum (wax head in belljar) by Debra DiPaolo (p. 130); Bodybuilder by Mark Lipson (p. 136); Max Factor Beauty Calibrator (mannequin head with apparatus) by Mark Lipson (p. 140); Plastic Surgery by Debra DiPaolo (p. 148); Wrestlers by Mark Lipson (pp. 154, 159, 163); Gas Mask by Mark Lipson (p. 172); Nudist in Tree by Mark Lipson (p. 178); James Njavro, chief of forensic photography, LA County coroner's office (photographer in morgue) by Mark Lipson (p. 182); Actor's head shots, Hollywood Boulevard by Mark Lipson (p. 188); Forensic animation by Alexander Jason ("Wound Path") by Mark Lipson (p. 192); Angelus Funeral Home, Los Angeles by Debra DiPaolo (p. 196); Racetrack TV watchers by Mark Lipson (p. 200).

INTRODUCTION

Most of the articles included in this collection were written in Los Angeles, and specifi-
cally address aspects of the visual culture and art of Southern California. Though I
didn't grow up in LA, when I moved there in 1983 I felt instantly, if somewhat oddly,
at home. Or perhaps more accurately, this strange city looked profoundly familiar, as
well it should – after all, I had grown up watching television programs filmed on its
streets. Settling here, I felt like I had entered a world seen only under glass.

In Walker Percy's novel, *The Movie Goer* (1961), the narrator bemoans the fact that
our everyday milieux have been drained of authenticity, and that only when one sees
a movie which shows one's very own neighborhood is it possible "to live, for a time at
least, as a person who is Somewhere and not Anywhere." In Los Angeles, however,
where every piece of scenery stirs memories, it wasn't a question of being Somewhere
but Everywhere, of inhabiting a matrix where all of television's worlds collided. Since
Angelenos don't walk but drive from place to place, the link between windshield and
TV screen only reinforced this impression.

Much of the writing in this book grew out of that initial, yet lingering, sensation. It
was additionally provoked by the exhibitionist nature of the megalopolis, its oft-noted
visual flair – a consequence of horizontal sprawl and vernacular displays designed to
catch the eyes of passing motorists. This is not a city where one can enjoy mingling
with crowds of people in a dense, vertical environment like New York; instead, one
speeds by panoramic vistas, Cinemascope-scaled billboards, outlandish signage, all of
it rendered with hallucinatory clarity by a desert light which endows everything it

touches with a lucid dreaminess – a quality noted by visitors even before Hollywood had been invented, and its images had infected every corner of the landscape.

As I gradually got to know this very private city, it occurred to me that beyond the influence of mass media and automobiles, an earlier technology seemed even more central to its evolving visual attitudes – namely, the museum vitrine. California, I soon discovered, was home to a growing epidemic of museums, from celebrity shrines to presidential mausoleums to places for which no category yet exists, such as the Museum of Jurassic Technology. By the early 1990s, this burgeoning museum culture was evident in most areas of the US, and it began to appear that an obsession with looking at artifacts preserved under glass had replaced spectator sports as our national pastime.

In writing about museums, I was interested not only in their collections, but in the psychology of display, in what it reveals about the work of constructing, and reconstructing, history, and also in a more general sense in what I came to think of as "the museumization of America." In Southern California, at least, we seemed to be heading towards a future in which we would become the curators of our own lives. From our trained or surgically altered bodies to our multi-media courtrooms, no aspect of daily life resisted the temptation to be turned into another occasion for display.

The museum – not as an institution but as an institutionalized way of looking – had even penetrated our wilderness areas, as was made clear to me during a trip to Joshua Tree National Park in the high desert south of Los Angeles. As you drive through the park's roads, a series of signs beckon with the promise "Exhibit Ahead," yet as you drive on, scanning both sides of the road for a set of display cases, it gradually becomes clear that the only exhibit is the expanse of desert surrounding you on all sides.

Shortly after that first trip to Joshua Tree, I encountered the then newly created Metro Park in LA – a place designed to exist only as a picture of a park, and from which all people were excluded. Just as a vitrine can effectively dematerialize its contents, turning them into mere images of themselves, so it seemed that many of our public spaces were likewise being transformed by display principles borrowed from the museum as well as from photography (and what is a photograph if not a kind of two-dimensional vitrine?). Relying on chance encounters and word of mouth, I tracked this trend wherever it seemed to be advancing, from race tracks to video funeral parlors to LA's Universal CityWalk, a themed shopping mall which simulates the very city in which it is set. Like the museum which seeks to reconstitute a lost universe, complete in every detail, these new developments appeal to us as

self-sufficient bubble worlds in which nothing is lost, and in which we can lose ourselves.

Somewhere in his writings, Walter Benjamin mentions a tribe which believed that photography blights the landscape – that every time someone photographs a given area, its integrity is depleted. In our era, photography and cinema may have blighted our ability to actually see the world around us; instead, we tend to merely recognize things seen in pictures. Passing beyond this truism, however, it seems we're already well into the stage of constructing new experiences that conform to photographic realities; strip shows and theme parks alike are now framed by these conventions. Though I never began writing with a preconceived agenda, these articles seem to circle around this idea, trying to describe it at ground zero.

If Southern California is arguably an extreme case, it is probably only leading the way in a general cultural shift, as the title of this collection aims to suggest. Besides conjuring the circus maximus, and a culture of alienated spectacle where all aspects of experience, from shopping to warfare, are routinely transformed into thematized entertainment, I hope the title also recalls Circus Circus, the first of the 1960s themed casinos of Las Vegas, and a forerunner of many of the places described in this book.

Whatever portents they might hold as cultural symptoms, circuses, even imperial ones, have their pleasures. Critics will no doubt continue to decry the museum as an ideological apparatus and paradigm of institutional power, but I think it's also possible, at the same time, to appreciate their peculiar, and often delirious, poetics. Why, for example, is a Chevy Nova squad car exhibited as a "mystical" vehicle at the LA County Sheriff's Museum? What are the results when a museum chronicling the Holocaust attempts to cater to the Nintendo generation? These are the kinds of questions which have spurred my interest in investigating our culture of distraction.

Los Angeles, 1995

PART I

CIRCUS AMERICANUS

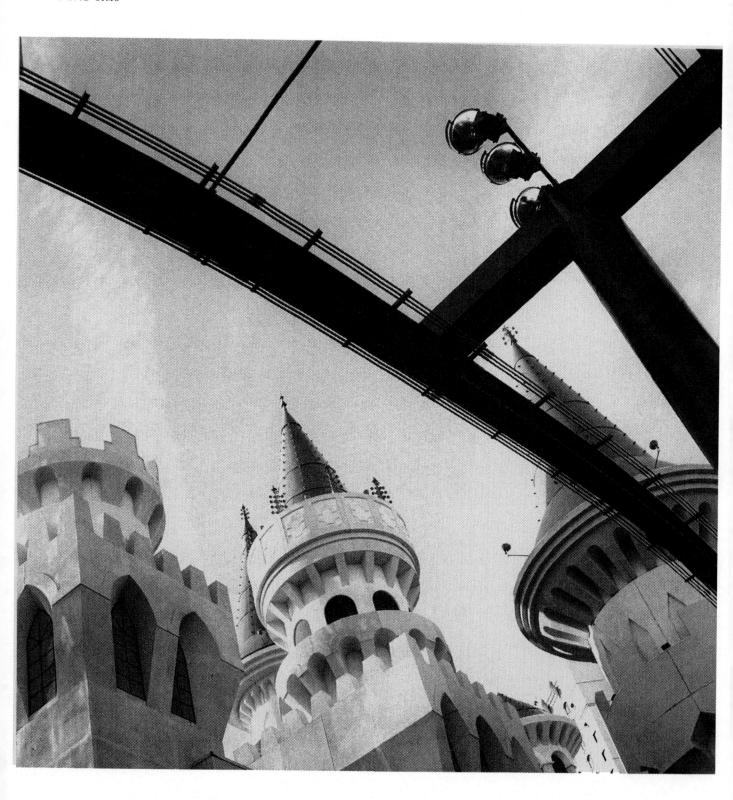

GAMBLING WITH REALITY: THE
NEW ART OF LAS VEGAS

If you want to glimpse the future of American aesthetics, you've got to go to a state where there are more cows than people, and to a city unburdened by Barcelona chairs and Philip Johnson towers. The mecca of your pilgrimage must be Las Vegas, Nevada, that museum without walls where a spectacular and telling contemporary art form has emerged (once again) to gamble not only with our taste but our sense of reality.

That Las Vegas can be considered a work of art is an idea first proposed (as far as I know) by the late, great British architecture critic Reyner Banham, who in 1970 called Vegas "one of the great works of collective art in the Western world." With tongue not necessarily in the vicinity of cheek, he compared the Strip to Michelangelo's *Last Judgement*: both gave you something fresh and profound each time you returned to them. "Great art communicates!" Banham yelped, and Las Vegas communicated something about "greed and elation and fear and daring and compulsion and escape and some of the higher forms of hypocrisy."

It still does, but the Strip Banham praised for its "ripe, sexy, harlot luminescence" is largely gone. Since the opening of the Mirage in 1989, a generation of themed mega-resorts has blossomed along this ribbon of Mojave Valley desert, replacing the Strip's legendary procession of glittering, epilepsy-inducing signs – "three-dimensional light sculptures," Banham called them – with a genre of overscaled installation art, an as yet unnamed mass medium in which you can live, and of course, gamble.

Taken as a whole, this new multi-themed Strip evokes something out of a bad *Star*

Trek episode: a time-warp where every era in history miraculously converges. Adjacent to the medieval Excalibur, the Luxor's glistening black pyramid rises like a vision from an anti-matter Egypt, while just down the road the Mirage's fire-belching Polynesian lagoon separates the ancient Rome of Caesars Palace from Treasure Island's shimmering eighteenth-century pirate village. Elsewhere, visitors have the option of checking into turn-of-the-century Paris, the Wild West of the 1890s, or contemporary Hawaii.

Inside these theme palaces, the aesthetic is one of total immersion. The Strip is no longer a work of art you can admire while driving by, but one which you must enter into and ride, whizzing through a maze of simulated environments. Essentially, it comprises a new communication medium, a hybrid joining special effects films and themed habitats. Venturing into these resorts, you're meant to feel like you've passed through to the other side of the movie screen: at the MGM Grand, visitors follow Dorothy's yellow brick road, while Treasure Island's Buccaneer's Bay was directly inspired by the set of Steven Spielberg's *Hook*. At Caesars, the staff dress not like Romans but like extras from Stanley Kubrick's *Spartacus*.

The new Vegas has already proven obscenely successful: the number of tourists here has doubled over the last decade, reaching an estimated 23.5 million people last year. This success, natives will tell you, is due to the Strip's remodeling as an adult theme park. Las Vegas's immense charm, you will hear, is essentially that of an R-rated Disneyland, a family resort area with twenty-four-hour drinking and gaming. In fact, its appeal is much more baroque. Indeed, if the Strip remains a key constellation in the American imagination, it's because it offers the complexity of great mannerist art; like that post-Renaissance idiom, it entices us into a labyrinth of paradox, ambiguity, glamor and nervy, off-key wit.

Yes, wit. I don't mean to suggest that casino owners are at heart purveyors of mirth, but they *are* in the business of seduction, and humor is one of the great tools of that trade – when we laugh, we drop our defenses. Underneath all the glitz, in other words, Las Vegas is a comic spectacle. The Mirage's ejaculating volcano, so punctual you can set your watch by its eruptions, provides a type of extravagant farce absent from the architecture of our major cities. Rather than beguile visitors with escapist promises, theme resorts like Treasure Island and Luxor appeal to our sense that in today's shrunken world, the exotic getaway is a notion that can only be spoofed. Las Vegas has become a place you visit in order to go somewhere else, but your destination is a joke.

The resorts' fantasy environments make no serious attempt to function as virtual realities; instead, they freely celebrate their fraudulence. Like the Roman cocktail waitresses at Caesars, Excalibur's medieval bellboys and Robin Hood waiters don't court credulity any more than the average female impersonator. But in Vegas, where make-believe isn't as dead serious as in Disneyland, what counts is not the specific fantasy motif being elaborated but the way it's perversely contaminated. The theme resort is primarily enjoyed as a burlesque of purity.

Institutions of "high" culture work on an opposite principle, erecting clear boundaries to distinguish their activity from "low" forms of entertainment. Las Vegas, however, thrives in a state of constant cultural tension, and this lends it the democratic appeal of a place where anything goes. Inside the Luxor's pyramid, a mock Times Square towers alongside King Tut's tomb and a Mayan archaeological site, while the Nile Deli serves lox and bagels by the hotel's indoor river. The Mirage raises multiculturalism to an equally dizzy pitch: tropical dolphin habitats and white tiger exhibits co-exist with environments inspired by Parisian modernists, including a bistro designed to make you feel you're dining in a three-dimensional Toulouse Lautrec. In the casino's poker room, meanwhile, a dozen different Gauguin paintings have been de-ethnicized – the Tahitians look like they've been given Beverly Hills nose jobs – and amalgamated in a wall-length mural.

Inevitably, Las Vegas returns us to a corrupted scene, rife with unstable transformations. In a limited form, metamorphosis is the underlying principle of capitalist society, where everything can be converted into money and then changed back into something else. As a culture, though, we're addicted not to real transformation but the illusion of continual novelty. In the new theme-oriented Las Vegas, visitors can laugh at the possibility of change without having to directly engage it. (As far as I know, there are no hotels where guests have to dress up in costume along with the employees.)

Yet like all good mannerist art, the Strip offers us an opportunity to get lost. The Forum Shops at Caesars, a mall advertised as "the shopping wonder of the world," simulate an ancient Roman street where classical statuary comes to life, and shoppers linger in "outdoor" cafés and piazzas engirdled by gold-tipped columns and ornate fountains. As in any truly romantic environment, time is suspended: the barrel-vaulted ceiling, painted to resemble a cloud-streaked sky, basks in a twilight glow every hour on the hour.

Returning to the "real" street outside, you can lose your bearings in a profound way.

The blue Nevada sky starts to bear an uncanny resemblance to a domed and painted ceiling, while the city itself seems like an oversized stage set. This experience, at once unsettling and stirring, springs in part from Vegas's hybrid nature. Unlike Disneyland's homogeneous paradise, Vegas retains a risqué quality. "There's only so far you can go from reality before it becomes either a nightmare or a cartoon," a casino owner told me. Vegas manages to be both at once. The 4,000-room Excalibur, which opened in 1990, epitomizes this schizophrenic identity with its central architectural statement: a group of red, blue and gold spires rising from gleaming turrets. Because detailing has been kept to an absolute minimum, the castle ends up resembling a generic scale model – from any angle or distance, it looks uncannily unreal. But with the addition of a pair of monolithic white towers, the resort suggests a cross between the Magic Kingdom and a metropolitan detention center.

In fairytales and horror films, we see how metamorphosis can cut both ways, provoking either awe or anxiety. Las Vegas rides this line with bravado. Its excess and hubris seem to court biblical catastrophe. Its leviathan hotels suggest sets of future disaster movies, and if you dig around, you hear tales of suicide leaps from casino roofs, personal bankruptcies ("whole countries have been lost here," a former pit boss assured me), and bouts of Strip-induced psychosis in which, understandably, one loses all sense of time and place.

But in the end, the city's nightmarish undercurrents only serve to lend a certain piquancy to the Strip's frivolity. Yes, Vegas may be a karmic cesspool where darkness and tragedy lurk in every corner, yet people come here of their own free will, and freedom American-style means we have the right to risk self-destruction.

For such a work of art, there can no be better frame than the hundreds of miles of Mojave desert that surround the city. This frame is the secret advantage Las Vegas holds over other places with legalized gambling, such as Atlantic City and New Orleans. It supplies a prophylactic barrier against reality: the instant you arrive here, you feel marooned from the world you left behind. Dry desert winds convey a delirious frontier freedom, and experience takes on a mirage-like quality. The sky is the limit in Vegas, and the sky here is limitless.

Plunked down in the middle of this Martian landscape, the city's vast mega-resorts ultimately seem less like hotels than massive biospheres, self-sufficient reality islands that demonstrate that we can survive in hell, even be entertained and distracted, without ever stepping outside. And that, according to historian Arnold Hauser, is the raison d'être of all mannerist art. "A mannerist work of art is no holy of holies you

enter in solemn awe and reverence," he wrote in his classic study on the subject. "Rather, it is a labyrinth you lose yourself in and do not seek to escape from."

Like it or not, Las Vegas is our aesthetic labyrinth of the moment, and for a populace which has learned to live in a state of permanent disbelief, it may be the most truthful art we have.

March 1992/March 1994

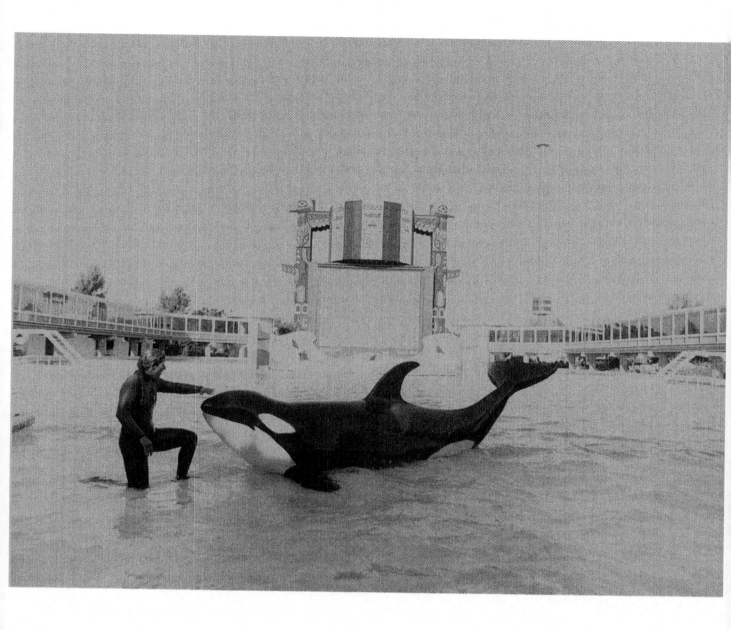

SEA WORLD TALES

I. THE COMMUNIST

In 1976, a French filmmaker, who was then teaching in San Diego, was visited by his father. At one time, they had shared an interest in politics: the father, a doctor by profession, had been an ardent communist for most of his life; the son, before moving to the USA, had co-founded a Maoist film collective. But when your family's in town, you end up taking them places you wouldn't normally go, and somehow the two ended up driving to Sea World.

In 1976, Sea World's "Shamu the Killer Whale" show had a bicentennial theme. The show's highlight, a re-enactment of Washington crossing the Delaware, featured a trainer in colonial costume surfing across the water atop a 5,000-pound killer whale. Near the end of the performance, the whale flipped its mighty tail, splashing cold sea water onto the crowd. For the father, it was no ordinary baptism. He walked out of Shamu Stadium with awe fixed on his face and his world view, that of a lifelong communist, unexpectedly altered. Grabbing his son's arm, he exclaimed: "Any culture that can do this to its own history, and survive, is invincible!"

II. THE CIRCUS ACT

"Make Contact with Another World:" Sea World's anthem, adorning billboards and brochures, beckons us with the promise of a close encounter. The sea is indeed another world, a liquid planet surrounding our solid earth. But how do you make contact with an alien world? How do you measure the intelligence of its creatures, or understand them, except in human terms?

At Sea World, the preferred terms are those of vaudeville and the circus. Unlike a simple aquarium or zoo, Sea World is an "entertainment park," a 150-acre complex where trained animals perform stand-up comedy and choreographed musical numbers you don't get to see in Jacques Cousteau TV specials. Some of the routines are truly astounding – on cue, killer whales soar out of the water to heights twice their body-length, defying gravity with the grace of submarine-launched missiles. Their bodies flash into the naked air in a moment of pure striptease. The crowd gasps and screams. You feel uplifted, as if the force of a whale's skyward thrust had made the air a little lighter for everyone.

In the most popular acts, animals mimic human behavior. A killer whale holds a pose like a professional bodybuilder; a lachrymose seal blows its nose into its trainer's handkerchief; a boorish Pacific walrus burbles into a microphone with the fervor of a true windbag. For a moment, these familiar gestures conjure a realm of fable, a cartoon utopia where animals take on human qualities and happily obey our commands. But there's low comedy here as well, since this transformation inevitably falls short of the mark. People laugh at a seal "clapping" its fins because, in human terms, it appears laughably inept, like a small child struggling to master an adult gesture.

"We will conserve what we love. We will love what we understand," affirms the eco-friendly message board at Shamu Theater. Yet at Sea World, we make contact not through understanding but by transforming this other world into a cute reflection of our own. The animals are presented less as exhibits than as entertainers, answering to stage names like Bubbles and Cathy. It's an act with a long tradition: the first public aquarium in the US was opened in 1856 by none other than P.T. Barnum.

III. THE ACTRESS

"I was doing a movie and they put me up in a motel across from Sea World," the Actress explains. *"So I go over on a day off when it's raining hard. Of course, the animals don't mind because they're water-resistant or whatever, but it's slightly depressing if you're one of the seven people who turn up for the Shamu show. This nice-looking lady in a wetsuit comes out, does a kind of Vanna White dance, and somebody tells us she's been working with this one whale for a long time. As she makes the animal go through its numbers, it becomes obvious it's very attached to her. All she has to do is snap her fingers and this giant creature will do anything she wants – it's every woman's dream relationship. And after each trick, the whale rushes over to her side of the pool and frantically tries to throw itself out of the water in order to be next to her. It's heartbreaking. I get this terrible feeling that it's really an unhappy animal, tragically in love with this trainer. It's so sad I suddenly start sobbing. I mean, this creature doesn't have hands, it can't read or write, it can't see a shrink – how is it going to survive this relationship?"*

IV. THE DEITY

The name "Shamu" is used to refer to whichever male killer whale is currently performing in the five-million-gallon Shamu Theater. (There are fourteen such whales in the Sea World organization.) Born to occupy the top rung of the marine food chain, these whales are the park's biggest draw. Gift shops specialize in Shamu merchandise, and Shamu strollers are available on a rental basis. An animated Shamu movie has been in the planning stages for years. Yet even before taking a place in our cartoon pantheon, Shamu has already achieved a practical immortality: the name is a registered trademark.

This year's theme show, "Shamu New Visions," exploits material lifted from Native American legends about divine whales. A carved totem towers alongside the stadium's giant video screen, where hokey images steeped in Spielbergian mysticism show us the mysteries of the deep as James Earl Jones's ageless voice-over explicates Shamu's mythological roots. Eventually an actual killer whale enters the pool and takes a warm-up lap before beginning more ambitious stunts. Inspirational music swells to a crescendo, and in your heart, you realize that your special privilege as a spectator is to watch a god jumping through hoops.

Like cartoon characters, gods are supposed to be able to defy death. At aquariums

and zoos, where all evidence of death is scrupulously concealed, the creatures on display seem to have similar powers. In this context, a violent public accident becomes almost unbearably traumatic. Such was the case on August 21, 1989, when the Shamu Stadium pool turned dark with blood after two whales collided in mid-air, leaving one with fatal injuries. A symbol of immortality had been destroyed before the eyes of children. It was scandalous, and media coverage was nationwide.

Yet should a whale die at Sea World – as six did in a two-and-a-half-year period in the late 1980s – there's always another 4,000-pound deity waiting in the wings.

V. THE SHARK ARTIST

In London last spring, the central gallery of the Saatchi Collection was dominated by a singular sight: floating in a formaldehyde-filled tank, a twelve-foot-long Great White shark stared out at the gallery's white walls. On first glance, it looked alive; its hard eyes and glazed smile still seemed to be stalking quarry, but the tables had turned, and predator had become prey, hunted by the gaze of art world voyeurs. This macabre aquarium was a sculpture by a young British artist named Damien Hirst. Titled *The Impossibility of Death in the Mind of Someone Living*, it aims to provoke viewers to think about the gulf between abstract knowledge and bodily experience. In another reading, several English critics saw the shark as an apt image of advertising mogul Charles Saatchi, who commissioned it.

By what process does a dead shark become a work of art? First of all, it must be shown in a context where it's viewed not as an actual shark, but as a representation. Eviscerated in this way, it serves as an icon which allows us to make connections with other symbols and ideas – in this case, ideas about the way we kill things to understand them, and then try to make sense of the world by isolating them in categories. Exhibited at Sea World, however, Hirst's sculpture would simply be a dead fish.

VI. THE REAL THING

Sea World's "Shark Encounter," billed as the largest zoological shark habitat in the world, sets out to convince viewers that sharks have been given an unfair rap. Like a public relations campaign organized by the shark chamber of commerce, it bombards

visitors with information detailing their benign habits and importance to marine life. But after a flashy multi-media build-up, including a triple-screen video presentation, the actual fish fail to step up to celebrity status. They don't do tricks, nor do they have adorable trademarked names. Admittedly, their teeth are impressive, but looks alone will get you only so far. For all their primitive charisma, sharks remain resistant to merchandising; like moray eels, they lack that certain user-friendly "personality" so essential to a career as a stuffed animal.

As if aware of the problem, Sea World has gone to great lengths to draw us into their world: visitors enter the big shark tank via a fifty-seven-foot acrylic tube that lies on the aquarium floor. But the slow-moving sharks passing directly overhead remain distant as ghosts, circling the outer edges of our morbid curiosity. The problem, of course, is that they're not behaving like the action movie stars we've learned to love and fear, and we stare at these creatures from another world and time, floundering to connect.

VII. THE GROUPIES

Playing to our fantasies of communion, many of the shows at Sea World involve intense physical play between trainers and animals, and a few exhibits allow visitors to have their own hands-on experience. At Forbidden Reef, a shallow pool packed with bat rays, children lean over and touch the creatures, squealing in delight and disgust as their hands imbibe information unavailable to their eyes. And during each performance at Shamu Theater, one lucky child is chosen as a surrogate for the audience and placed on the killer whale's back.

Of the various opportunities for caressing the collection at Sea World, the Dolphin Pool, where visitors can reach out and pet willing dolphins, seems to elicit the most intense devotion. A cult of die-hard groupies has formed over the years around the ritual of making regular physical contact with these mammals from another world; its members buy season-passes so they can perform this rite whenever the park's open. Occasionally, though, the pool is closed for renovations, and these devotees literally lose touch.

Can we touch something with sight alone? Certainly, we can be touched by images, in the sense of being moved, which is one reason aquariums have been recommended for people with high blood pressure. There's something uncannily soothing, almost hypnotic, about the spectacle of colored fish gliding through water, effortlessly rising

and descending as if freed from gravity, flying but without the effort made by birds. On some unconscious level, it must remind us of life in the womb.

Perhaps that's why we've been keeping fish since the Sumerians first built artificial ponds over 4,500 years ago. Yet aquariums also beguile us with one of the pleasures of fiction: they place us in a god-like position where we can look down on a neatly defined, and comprehensible, universe. Sea World, like *Wayne's World*, is aptly named.

November 1992

THEME PARK SLUMS

If J.G. Ballard were God, you could safely assume that Donald Duck gangsters and Snow White neo-Nazis would one day overrun Disneyland, turning the monorail into a drive-by shooting range. A boarded-up Main Street would be home to Skid Row dwarves getting high on half-pints of "Goofy" or some other potent Walt whiskey, while hookers in Mickey and Minnie outfits would service visiting fetishists, even taking off their white gloves for an additional fee.

While Ballard's divinity is unlikely, anyone less than thrilled with Disney's brand of bubble-wrapped perfection can find comfort in the modest scenarios of deterioration offered by the likes of Santa's Village, Pioneer Town, Tiki World, and Alpine Village. If Disneyland is the epicenter of American hygiene, these places stand as the equivalent of theme park slums. Lacking the enormous capital needed to maintain a sheen of perpetual newness, they keep a relaxed attitude about showing their age. Their thematic facades are usually riddled with leaks. And their employees, unbothered by enforced codes of "friendliness," usually look older than their Disney counterparts, and are free to look as depressed as they feel.

Founded by a Bavarian immigrant in 1968, Alpine Village lies nestled in a Torrance parking lot within easy shooting distance of the Harbor Freeway. Essentially, it's a shopping mall done up in edelweiss drag: buildings sport sloping shingled roofs, stained-glass windows, heavy wooden shutters, painted floral motifs and gothic lettering. You can get your teeth done at Alpine Dental, play Alpine bingo, browse through stores with endless cuckoo clocks and Hummel figurines, and then stroll over to

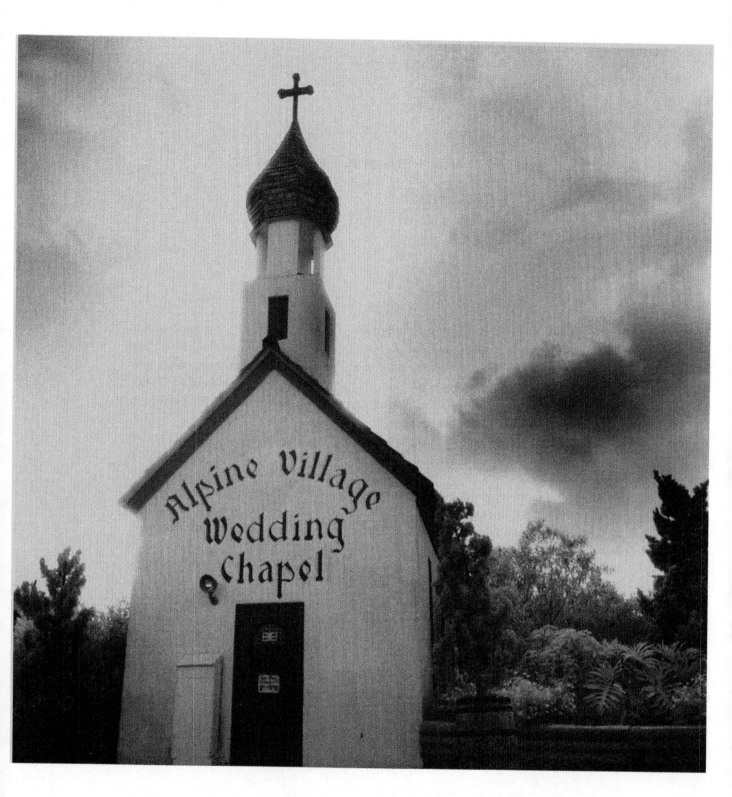

Alpine Chapel to get married. The Alpine Inn, where waitresses wear traditional German costumes, offers its own authentic Alpine Village Lager. An Alpine spokesperson assured me on the phone that many of the craftsmen who built the Village were European, and that basically it looks like a real village in Bavaria.

But Alpine Village boasts significant advantages over the real thing. Without ever asking visitors to suspend disbelief, it poses as a Bavarian community while being conveniently located alongside an eight-lane freeway. Since it shares LA's temperate climate, shoppers never need to wear winter clothing (bereft of irony, the Alpine Village sign towers over a tropical palm). A steady stream of piped-in polka muzak – a feature missing from most Bavarian towns – makes the quest for lederhosen and porcelain beer steins seem like one long Oktoberfest.

And unlike the Alps in Disneyland, Alpine Village has never been demystified by Jean Baudrillard or Umberto Eco, so you can eat your sauerbraten without wondering whether it's merely a simulation. Adding to the aura of authenticity is the fact that the place is frequented by actual Germans and German-Americans who speak real German, and purchase German-made goods.

But when I asked the Alpine spokesperson how reunification has impacted on the Village, she cryptically replied: "This is not a political place, though we do broadcast soccer games." Nevertheless, it's worth noting that the Hitler busts and copies of *Mein Kampf* once prominently displayed in a Village store are now gone, while a sign at the Alpine Inn forbids the wearing of any "political emblems," a veiled reference to swastikas. Instead, visitors can buy a t-shirt proclaiming "You can always tell a German, but you can't tell 'em much." Alpine Village is plainly ready for the New Europe.

Hints of decrepitude – unrepaired shingles, walls with flaking paint – lend the Village a pathos utterly absent from the pristine sentiments of, say, Colonial Williamsburg. These traces of history give it an address in the real world. And unlike many themed communities, Alpine Village has distinct "boundary problems:" designed without a formal entrance, it bleeds and blends into the vast surrounding parking lot, where a sprawling low-rent swap meet does a brisk trade in Dial soap bars and plastic shoes.

Ultimately, its imperfections and leaky Bavarian simulations exert a vaguely subversive effect, contaminating one's perceptions of the surrounding landscape. Getting back on the Harbor Freeway after a couple of hours in the Village, I unconsciously assume that I'm driving on an autobahn (this becomes clear to me only when a car cuts me off and I find myself muttering something about "goddamn German drivers").

Alpine Village had successfully infiltrated my image of the world in a way that the picture-perfect places never do; I've never left Disneyland thinking the other cars on the freeway were driven by copyrighted cartoon characters.

Conspicuously ignored by theorists of hyper-reality, theme park slums speak to the decay of our postwar suburbs, and the decline of the American middle class. But these decaying bubble worlds also raise a far dizzier question – namely, what happens when an ersatz place acquires a real past? If Alpine Village were to one day become a historical landmark, would it be fake history?

These questions may have been definitively answered in 1985, when a team of archaeologists unearthed the City of the Pharaoh in some sand dunes about 150 miles north of Los Angeles. This "ancient" Egyptian city, erected for Cecil B. de Mille's *The Ten Commandments* and buried when the filming was completed, had become, with the passing of years, an object of historical interest. Movies are part of history, of course, and the giant set, with its twenty-one enormous sphinxes and hundred-foot-high walls, is now considered an artifact from a venerable Hollywood era.

Situated in a rolling valley not far from this archaeological folly, Solvang lays claim to being California's original "recreated" reality. Created by a trio of homesick Danes in 1911, it's loosely modeled on a turn-of-the-century Danish village. Visitors ride into the town's cobblestoned Hamlet Square on a horse-drawn streetcar, passing houses with gleaming copper roofs, half-timbered walls, and gables crowned with stork weathervanes. Look in any direction and your eye is bound to fall on some quintessential sign of Danishness, whether a windmill, a clock tower, or shop windows filled with giant clogs and Viking helmets.

The commodification of ethnicity is probably as old as tourism itself, and in the US, immigrant communities occasionally drape themselves in theme park trappings to bolster business; the pagoda phone booths in Chinatowns across America are props that suggest a local neighborhood is actually an exotic destination. But flourishes such as these are generally grounded by the surrounding urban context. Solvang, on the other hand, sits in a rural area forty miles north of Santa Barbara; it's a landscape which makes a fairly credible backdrop for the Danish village it aspires to invoke.

Even more disconcerting, Solvang is a functioning town with more than 4,700 residents. It even has a sister city in Denmark. Yet while everything here refers you to some other location, it's not always a Danish one: Mexican restaurants and Belgian waffle stands compete with coffee shops offering aebleskiver pancakes and herring sandwiches, and in the market square Nordic kitsch is sold alongside the domestic

variety. Solvang's "historical" Danish identity comes to life mainly in postcards; from the right camera angle, it really does resemble a quaint Scandinavian village.

Photography has modified our sense of place in more ways than one, and the idea of recreating a Danish village in California may have been partly inspired by photography's principle of reproduction. Much of Solvang's Old World downtown, in fact, was developed following the publication of several photos of the town in a 1940s *Saturday Evening Post* story – the pictures, which presumably looked more like the genuine article than the existing village did, convinced town planners that Solvang's future lay as a photo opportunity for tourists. Around the same time, the local college where Danish folk traditions had been taught was torn down; today, local arts and crafts are typified by a "petography" shop, where people take their pets to be photographed in antique costumes.

A theme town like Solvang exists as a kind of three-dimensional photograph, a place where time is supposedly frozen. It shares as well the photograph's fetishistic quality, particularly in the way it dislocates a fragmentary scene from its surroundings and makes it available to the viewer's lingering look. And like travel photography, it allows you to access foreign worlds which are neatly, and seductively, composed in iconic bites, only here you get to insert yourself into the image.

The notion that life is simply a matter of appearances, thrown together for the purpose of being preserved in a reproduction, is one we see acted out every day by our most powerful institutions, from Washington, DC to Madison Avenue. For the picture-taking Solvang tourist, life may be lived to accumulate documentation of another, more exotic existence, which one never has to actually lead. And at Alpine Village, souvenirs of picturesque towns in Bavaria are sold alongside postcards of their Southern Californian imitation, and in reproduction, to tell the truth, they all look pretty much the same.

March 1992

THE LARGEST FREE EVENT IN
CALIFORNIA

Billed as the largest free event in California (the phrase "parking for 400,000" has a certain sublime appeal), the 42nd Annual Air Show at the El Toro Marine Corps Station offers a strange spectacle mixing vaudeville aerobatics, military power, and an advertising extravaganza on the scale of a Las Vegas trade convention. Though there's a theatrical dimension to the show (its "narrator" regularly instructs the audience to look "stage right"), viewers are reminded that the military flight teams are here to "demonstrate the power available to the American fighting man." In addition to the aerial stunt teams, some sponsored by beer and pizza companies, the show also includes ground exhibits where the whole family can become intimately familiar with grenade launchers, M-16s, and infra-red nightscopes.

The crowd, officially estimated at over a million during the two-day event, suggests El Toro may be the Woodstock of the Gulf War era. Where else will you find shirtless surfers hoisting bazookas, or toddlers getting their faces made up with camouflage greasepaint while Mom and Dad, sporting brand new *Top Gun* hats and day-glo jogging outfits, pose atop a 155mm. howitzer? These festive pilgrims, loaded down with coolers, fold-up chairs and other accoutrements of suburban beach excursions, are sufficiently enthused about their military circus to brave not only 94-degree heat, but the tail end of an earthquake advisory.

The cliché about air show crowds, of course, holds that latent in every spectator is the desire to witness a crash. At El Toro, the most crowd-pleasing routine isn't the looping and rolling aerial ballet, but an airborne game of "chicken," in which two

planes race towards each other at speeds up to 400 mph, avoiding a head-on collision by ten feet or less. The orgasmic "oohs and ahs" which inevitably rise from the audience hint at a blood lust that's been sublimated into an erotic experience. Perhaps it's no accident that El Toro is a heavy teen dating scene, with a large part of the crowd looking like it wandered over from an Orange County dance contest.

If spectators harbor an unspoken wish to behold destruction, however, it's clearly accompanied by a narcissistic desire to identify with these displays of celestial power. The near misses and kamikaze nose dives engineered by unseen pilots comprise a nervy brinkmanship, assuring us that with skill, timing, and the right technology we can keep death at arm's length. Human fallibility spikes the drama with suspense, but the thrill comes from controlled flirtation with disaster, not its realization.

Choreographed stunt flying may be less immediately titillating, but it boasts a compelling allure of its own. As with any synchronized group movement, be it water ballet or military goose-stepping, the sight of planes performing identical stunts while flying in tight formation provides us with an image of perfect conformity – a quality we don't usually associate with humans, but with machines and certain insects, such as ants or bees. When the routine is perfectly executed, each performer's individuality disappears, leaving viewers with the impression that some controlling group mind or higher power is creating a single entity out of disparate parts.

Calling to mind familiar stories of inanimate figures coming to life, the choreographed air show partakes of the uncanny. It provokes wonder, but also a certain anxious fascination; we carefully watch each plane, hoping to detect the telltale out-of-synch movement that would give the game away and reassure us that the performers are only human. And if you subscribe to Freud's idea of the death instinct as a drive to return to uterine existence by annihilating the self, the appeal of this spectacle – celebrating as it does the loss of individual ego – can be easily explained.

The most lyrical performance at air shows is always the aerial ballet, when planes swoop across the sky as if drawing bold and graceful lines over an endless blue canvas. Even the names of the maneuvers – Immelman half loops, Humpty Bump turn-arounds, hammerhead spins and reverse Cuban eights – have a poetic spin. Yet for all their elegant visual melodies, the various flight teams appear almost drably conventional compared to the ground exhibit of an F-117 fighter jet. The Stealth is such a radical departure from traditional aircraft design that it seems like a prop from a comic book fantasy – it could be the upper-class cousin to the Batmobile (which is exhibited elsewhere on the air base, courtesy of Warner Bros. and the show's giddy

curatorial logic). Matte black and ominously angled, the Stealth has rock 'n' roll charisma, and unlike the other ground exhibits, it's roped off and protected by a group of M-16-toting Marines, presumably to discourage over-eager fans.

Part of the Stealth's appeal as an exhibit – beyond its design and the lore of its magical "invisibility" – is the public opportunity to peer at an enigma long hidden behind the curtains of power. That you're allowed to see it only from a distance indicates its secrets are still potent. As philosopher Guy Debord has noted, this aura of secrecy haunts our society of spectacle: not only is military technology kept secret, but so is its failure (the Patriot missile's misreported "success" in the Gulf War being a recent example of this kind of concealment). In a shadowy world where true and false are officially confused, where no one knows for sure how much our secret weapons really cost, the Stealth's concreteness ("Hey, it's not *really* invisible!") is heartening, to say the least. Over and over again throughout the long hot afternoon, it serves as an irresistible backdrop for photo opportunities; indeed, for many the fighter jet appears to be a site of adoration, a sleek black altar commemorating the revelation of a holy mystery. Spectators linger along the ropes, gazing with looks of reverence and awe as if meditating on the unknown and the sublime. This is no longer the plane that dropped 2,000-pound bombs on Iraq – it's a vehicle of religious experience.

As taxpayers, however, many visitors also seem to take a proprietary interest in the Stealth and the other military jets on display. "How many of these do we have?" they ask each other, as if trying to decide whether they can afford another purchase. In practice, of course, we can only directly experience the pride of ownership by buying one of the countless Stealth patches, art prints and t-shirts sold by vendors. These give us a sense of participation, a feeling that we're part of the program. And this acts as a recuperative antidote to the pathetic attitude we display during much of the air show, when – with fingers and cameras pointing up at the sky and mouths agape – we emulate the humbled earthlings of a '50s sci-fi film, gawking at the spacecraft of superior aliens.

The real show at El Toro is the spectacle of our disenfranchisement. As Debord has observed, the pace of technological innovation since World War II has reinforced spectacular authority by surrendering everybody to the mercy of specialists. But it's not simply a question of having our insignificance driven home by the military's hi-tech ambassadors; in fact, the aviation activity at El Toro often seems like a mere backdrop for the advertising of the various beer companies, ice cream makers and bottled-water vendors sponsoring the event. For me, the sense of oppression devolves

from the seamless blending of military PR and Hollywood-style hype (the show features promotional booths for *Lethal Weapon III* and *Batman Returns*); it reflects, all too accurately, the blurred lines between government, the Pentagon, and private industry – a merger that leaves individual citizens out of the loop. One leaves such a show with a vision of Middle America as a slightly pampered underclass, loaded with toys but with no piece of the real action.

Perhaps it shouldn't be too surprising, then, that an hour-long performance of simulated combat, replete with fighter jets, infantry units, explosives and *Star Wars*-like theme music, provokes little in the way of appreciative war cries. The crowd's most demonstrative response is elicited not by any death-defying aerobatics, but by the AV-8B Harrier, a bulky-looking jet which can hover in place, travel in reverse like a car, and move sideways like a crab. The sight of a plane standing still in mid-air has an electrifying novelty value; it transforms the unreality of a doctored photograph into a 3-D, real-time event. The spectators scream with delight, not in the grip of war fever, but over something unimaginable, an astonishing sensory experience which leaves the viewer full of wonder.

It's an infantilizing pleasure, but appropriate to an air base whose insignia, a cartoon of a flying bull, was designed in 1943 by none other than Walt Disney.

May 1992

HONEY, I SHRUNK THE CITY

In the wake of Peter Ueberroth's departure, the "Rebuild LA" consortium should consult the MCA Development Company. After all, they've already rebuilt LA for a mere hundred million dollars. Universal CityWalk, a simulacrum which supposedly distills the essence of Los Angeles in two and a half blocks, presents itself as a new type of post-urban neighborhood: a crime-free, consumer utopia. Situated on a hilltop adjacent to Universal's Hollywood Tour, it offers pedestrian shoppers the added satisfaction of looking down on the perennially congested hell of the Hollywood Freeway.

On paper, the concept for CityWalk seemed to portend a startling new twist in the history of malls. Instead of replicating a faraway location in the manner of Torrance's Alpine Village or the old Roman street of Two Rodeo in Beverly Hills, it would offer shoppers an idealized version of their immediate surroundings. Supposedly condensing architectural highlights from Venice and Melrose to the Sunset Strip and Olvera Street, its giddy collage would be stamped with an aura of "instant history," as candywrappers were to be embedded in the sidewalks and storefronts streaked with ready-made graffiti.

As it turned out, CityWalk isn't quite so radical. At some point in the design process, the virtual history touches were abandoned, and as built, the development doesn't really resemble a city street. Strolling along its hyperactive pastiche of signage and oversize facades, you feel you've walked into an airbrushed cartoon, which is at once relentlessly sanitized and unrelievedly manic.

MARK LIPSON

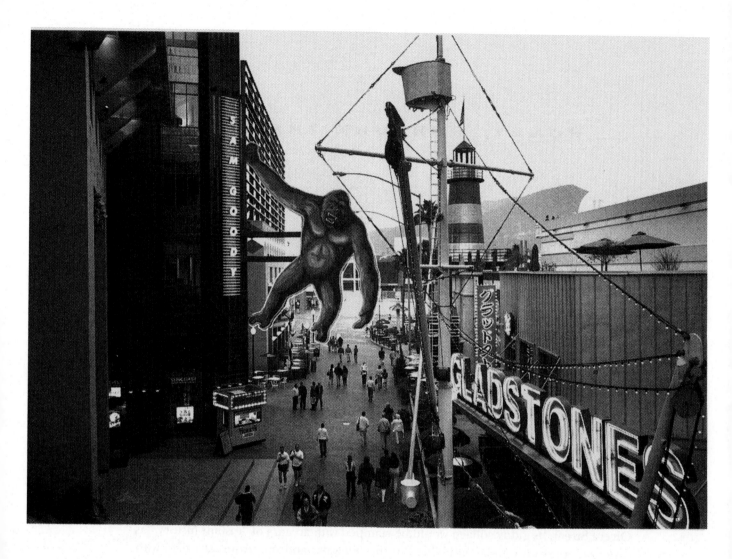

Like the architectural equivalent of *Twin Peaks*, CityWalk's forced "quirkiness" exudes a hollow desperation. Its ideas of LA-style eccentricity are mostly third-hand: the obligatory '50s Chevy is wedged into one facade, while a flying saucer juts out of another. Vernacular motifs, ranging from a giant copper kettle to a towering light-house, compete with twenty-one vintage neon signs, and there are even regular street performers who, unlike those on the Venice boardwalk, don't ever pass a hat. But the most interesting touch is the addition of two not-for-profit cultural spaces: a suite of UCLA extension classrooms and the new home of the Museum of Neon Art. These institutions endow the project with an air of legitimacy, insisting that it's not simply a mall but a well-rounded urban environment.

The development's "Honey, I shrunk the city" concept is the handiwork of megamall architect Jon Jerde. Jerde, who also helped design EuroDisney and Minnesota's Mall of America (the world's largest shopping complex), is a leading proponent of what could be called "consumerist architecture." In his vision of postmodern life, giant regional shopping centers, dubbed "urbanopolises," form the core of an area's community and cultural activity. Jerde maintains that the mall – like the Athenian agora – not only brings us together, but defines our dreams.

In a CityWalk press release, Jerde notes that the "big deal here is to create a communal place for Los Angeles where people can come together, be safe, be on the street and do multiple things." At first, it sounds like a well-meaning response to the perennial complaint that LA lacks collective spaces, but as Jerde goes on to explain, CityWalk is safer than the neighborhoods whose motifs it borrows solely because it's *private property*. And with a sheriff's substation on the premises, it guarantees a risk-free "communal" experience.

Of course, Jerde's idea of collectivity has little in common with the traditional public spaces of cities – the plazas, parks and streets where people are able to gather as citizens, not just consumers. Its implicit equation "private = safe, public = dangerous," leads directly to the "fortress LA" environment which urban historian Mike Davis has so eloquently described – a fragmented polis of gated communities, cordoned-off streets and bubble-world office complexes.

In a recent pamphlet on the politics of fear, Davis wonders if CityWalk "isn't the moral equivalent of the neutron bomb: the city emptied of all lived human experience." Even more alarming than this one mall, however, is the way consumerist architecture is increasingly slipping over to all kinds of urban structures, from municipal buildings to public housing developments.

Much like advertising, which it resembles in its attention-grabbing ploys, consumerist architecture aims for something close to mind control. As Jerde himself remarks: "We think of it as designing the experiences rather than the buildings; designing all the things that happen to you." Towards that end, consumerist architecture seeks to distract and stupefy; every square foot of CityWalk's visual overload noisily asks if we're having fun yet, without ever leaving space for a reply. Anticipating the dizzying future in which we'll surf the waves of five hundred cable channels, it's first and foremost an architecture for couch potatoes; instead of addressing the physical space shared by real bodies, its seamless and circumscribed hysteria only fills the void of the consumer self.

The real theme here is benign disorder, and a simulation of upheaval. As described by MCA Development vice-president Tom Gilmore, CityWalk aims to "create high energy in a controlled environment. I call it 'safely chaotic.'" The aesthetics of "safe chaos" – evident everywhere from MTV to new currents in magazine design – speak to our era much in the way that the sublime was the visual foil to the industrial era. The figure of the lone individual facing a landscape of endless potential – the classic motif of industrial capitalism – is now paralleled by the idea of immersion in a swirling sea of media.

It's not surprising, then, that a growing cottage industry of cultural critics have embraced the theme park as the salient metaphor of contemporary life. Yet all too often in this literature, an implicit bias bleeds through: fantasy is bad because it's "false." But fantasy is pernicious only when it obscures our view of real conditions.

To a significant extent, that's the goal of the folks at MCA, as well as architects like Jerde. At a moment when European governments have begun issuing advisory warnings to tourists traveling here, the assumption behind Universal's enclave is clearly that shoppers want to be protected from our "dangerous" streets. (In an *LA Times* article last year, one MCA executive compared shopping on Melrose to dodging bullets in a Third World country.) Places like CityWalk lure visitors with the promise that our fun won't be tainted by run-ins with homeless people or any other form of urban blight; having this option available implicitly suggests that we need no longer bother with trying to remedy the underlying social conditions that make our cities unsafe.

What CityWalk offers us, then, isn't a virtual Los Angeles, or even an advertisement for one, but a funeral monument to the idea of public space. Essentially, it's a mausoleum, an embalmed street that's been prettied up for an open-casket viewing. And as long as we're drawn to these urban waxworks, the city's real streets will continue to deteriorate.

Our sense of what holds us together as a society is likewise endangered. Consumerist architects like Jerde chillingly argue that all that really unites us is our lust for things, which drives us to the mall. If the center still coheres, we have only advertising to thank. But outside Jerde's urbanopolis, the desire to consume and possess doesn't bring people together, it splits them apart – a message driven home by that mass violation of consumer protocol, the 1992 Los Angeles riots.

Universal CityWalk, of course, is neither the cause of urban decay, nor does it mark the end of reality. (Not even CityWalk can successfully suppress the awareness that LA exists in an undeclared state of emergency – especially when homeless people are now stationed at almost every freeway off-ramp, and their signs are an integral part of our visual landscape.) Yet as middle-class life increasingly finds asylum only in themed resorts and shopping centers, "reality" is becoming the imagined province of the disenfranchised.

Indeed, it's the very poorest in this society, those excluded from Jerde's urbanopolis, who are asked to assume the burden of being "real." If street culture is fashionable right now, it's because its hard edge promises to cut through the illusions that anesthetize mainstream America. And for all the indignation it provoked, the looting and burning during LA's riots brought a momentary relief, and even engendered a perverse civic pride, because it showed the entire nation that we are in fact a *real* city, with *real* urban problems.

Back in the late '60s, historian William Irwin Thompson remarked that in Los Angeles, "it is much harder to distinguish between personal fantasy and social reality because the realization of fantasy is one of our dominant cultural traits." Our "dominant cultural trait" isn't a regional characteristic, however, but proliferates wherever collectivity is replaced by privatized space, and a corollary regime of fantasy.

The logical next step in reality management could well be hybrid developments which merge urban-themed shopping complexes with gated communities. These privatized, satellite cities would mean the end of public life as we know it. Yet by the time the first residential theme park opens its gates, it may already be obsolete, because with the coming of cyburbia – the sprawling network of interactive TV realities and computerized environments – geographical space itself may seem an antiquated concept.

June 1993

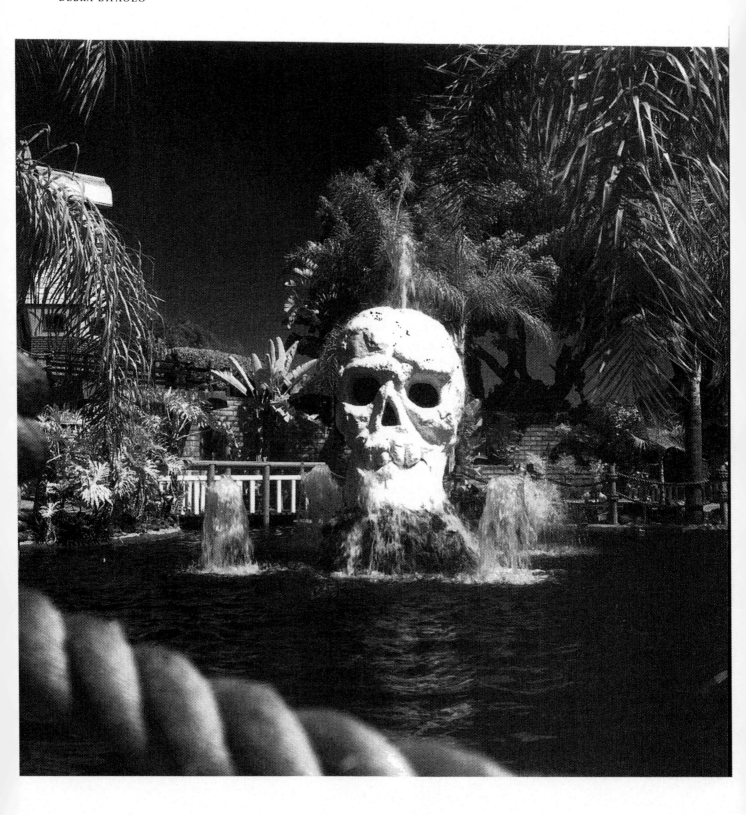

COURSES IN SEDUCTION

"Have you ever wanted to have a broad that could give you everything you've ever wanted? . . . Her body is exactly like the one you've always dreamed of. And she's even nice to be around after you've fucked her? That's how I feel about golf courses," explains a character in James Ellroy's *Brown's Requiem*, bluntly summing up the appeal of the picturesque. Though not everyone feels so passionately about the eighteenth hole, the traditional links landscape is undeniably a seductive proposition: gently sculpted contours are customized to player desires, and their green expanse seems "to promise peace and friendship," as Ellroy's narrator declares.

In greater Los Angeles that promise is made with abandon. Study a road map and you can instantly grasp the extent of our seduction. On maps of other cities, the green patches typically represent public parks, but on LA maps they usually indicate one of the area's 130 "peace and friendship" courses, many of which are privately owned. Their ubiquity testifies to a pervasive cultural need that clearly goes beyond the pleasures of stroking a small dimpled ball with a steel club.

For residents of Southern California, or any environment that specializes in natural disasters, golf's lush pastoral scene no doubt provides a comforting escape. Here, nature's unpredictable forces are orchestrated into a melodious mix, an Eden where shaved fairways co-exist with unmanicured roughs and numbered flags mark out each player's orderly pilgrimage. And despite the inevitable vistas of smog-kissed suburban sprawl and stripped hillsides, many of our links are floral wonderlands.

There's also an alluring mystery to golf courses, as if they were vaguely sacred sites,

cleverly disguised and misplaced. Something about all those tumescent hillocks and ceremonial holes suggests consecrated ground, burial mounds for suburban ancestors. To the uninitiated, public and private courses alike convey an enigmatic aura: removed from the view of passersby, they are serenely private worlds. As Ellroy's narrator exclaims: "Golf courses: a whole solar system of alternate realities in the middle of a smogbound city."

Essentially, it's the alternate reality of eighteenth-century England. According to John Dixon Hunt, whose *Gardens and the Picturesque* recently came out in paperback, the typical English estate provided the model for golf courses as well as other nineteenth-century developments like public parks and cemeteries. Gardens are telling relics, Hunt insists, because they reveal how we process the natural world for our consumption. The eighteenth-century English garden, "one of the most revolutionary ideas in the history of mankind," is a stealth landscape: a form of order which looks unordered, a deceptive harmony where art and nature are artfully confused.

In LA some of the most renowned courses dutifully obey this paradoxical aesthetic. Many of them, including the Riviera, Bel-Air and LA Country Clubs, were designed in the 1920s and '30s by a former gardener named George Thomas, Jr, who proclaimed, in a 1927 treatise, that golf architects should copy "nature's universal diversity." In the ideal course, Thomas maintained, manmade features should melt into the surrounding landscape as if they'd "always been present."

Thomas's treatise, part of the Ralph W. Miller Golf Library's collection, cagily allows for a few "minor" exceptions to this principle, such as including sand traps in a landscape otherwise devoid of sand, neatly barbered fairways amid uncut roughs, and planting non-indigenous trees, shrubs and grasses. These elements are manipulated by the golf architect for varied effects: tree shadows can throw out a green from sunlit surroundings, white sand can add dramatically contrasting accents to a clipped fairway. Abstract painters, apparently, have nothing on golf course designers.

Unlike the isolated rock formations in a Zen garden, sand traps and other golf hazards don't usually serve as objects of meditation, but in both landscapes nature is presented as a kind of outdoor museum. This is what the picturesque tradition is all about: looking at the natural world as if it were an exhibit, a painting, or a theatrical backdrop (we talk of "nice *scenery*" and "bucolic *settings*"). And a golf course, if it is to be taken seriously by connoisseurs, must provide dramatic spectacle. "One must get the thrill of nature," Thomas advised, "to secure the complete exhilaration and joy of golf."

Getting the thrill of nature, in this case, seems to roughly translate into worshipping

the environmental equivalent of a cheesecake pin-up; indeed, there's something faintly pornographic about the ideal of golf course beauty, built as it is around a fantasy of power and mastery. Push this point too far, however, and we might end up agreeing with Jose Knight, a writer for *Wild Earth* magazine, who argues that exposure to too much "eco-porn" causes our perceptions to be "blunted and perverted, just like those of the readers of *Playboy*. We devalue homely, flat-chested, overweight landscapes . . . [while] we are collectively seduced by the bosom of the Grand Tetons."

Beyond its ideological fallout, golf's picturesque hang-up has prevented the medium from developing its full range of possibilities. It also denies the game's roots as an urban and plebeian sport. Though its origins lie shrouded in controversy, the earliest mention of golf is a 1360 Dutch ordinance banning "colf" from within city walls. Evidently, it was originally a street sport, something akin to freestyle urban skateboarding, with buildings and pedestrians serving as freelance course hazards.

The closest thing we have today is the miniature game. Having shed the burden of the picturesque, midget golf celebrates the medium's latent surrealism, revealing the unlimited potential of the collaged landscape. In a topography of grafted realities, the miniature golfer treks past medieval castles, jungle lagoons, onion dome churches, Tiki heads and giant skulls, steamboats, tepees and windmills. With a nod to Lewis Carroll's croquet vivant, a pixy links in Florida even features live rabbits sprinting across the course as moving obstacles.

The surreal dimension of miniature golf was directly acknowledged early on: when actress Mary Pickford opened a Lilliputian course in Hollywood in 1930, its design was inspired by Max Ernst's paintings. At the time, movie theaters were losing business to the carpet golf craze, and a number of studios responded by converting motion picture palaces into indoor courses; the picturesque mission of theatricalizing nature had somehow come full circle, with golfers cast in the role of actors. Throughout Southern California, miniature golf courses developed into elaborate fantasy sets where every Lilliputter is a star.

Architect Charles Moore once called miniature golf "one of Southern California's true art forms." But all golf links, regardless of size, traffic in the same kind of incongruous juxtapositions; it's just that the collage of nature and culture which makes up the traditional links is a picture we're still too confused about to see straight. We forget that nature and culture are relative terms, not opposing forces, and that their strange and fertile partnership defines every landscape we know.

August 1994

FAREWELL, MY FERRIS WHEEL

According to the program of psycho-geography Niuenhuis Constant worked out in the 1960s, the utopian city of the future would be divided into color-coded sectors, each "tuned" to conjure up specific emotions. Constant, an artist and urban planner who associated with the Situationists in France, envisioned his "New Babylon" as a city on stilts where environmental and multi-media cues would trigger various subjective climates, and where therapeutic public spaces would help cleanse the mind. Constant saw his proposal not as an actual town model, but as an attempt to give material shape to his theory of unitary urbanism.

Forgetting for the moment its more eccentric details, the gist of his plan seems to have been realized in most of our cities. In Los Angeles, for instance, South-Central could be considered a sector conjuring rage and depression, while the Bel-Air hills elicit euphoric serenity; Venice Beach, on the other hand, provokes a libidinal eruption in stark contrast to the stringent self-control imposed by Downtown's corporate biospheres.

If our urban spaces already constitute a type of psycho-geography, amusement parks fit snugly into the scheme. From its nineteenth-century origins, the amusement park has been conceived as a utopian space, where the visitor could choose from a selection of systematized follies, enjoyments and sensations. But in practice, even the most organized parks retain something of the carnival's warren-like spaces, its labyrinth of secret possibilities; located on the edges of town, they are places which invite you to get lost.

Judging from the exhibits at the 75th Annual Convention of the International Association of Amusement Parks and Attractions (IAAPA), that disruptive landscape seems destined to be replaced by rows of numbered theater seats. The inaugural event at the new LA Convention Center, it drew more than eight hundred companies marketing everything from motion-simulator movie rides to interactive animatronics and virtual reality games. Though traditional carny staples such as Ferris wheels and cotton candy machines were amply represented, a tour of the IAAPA convention left no doubt that the entertainment future involves a full-scale retreat from physical reality.

Using 3-D and high-definition imagery, interactive virtual reality technologies, dimensional sound systems and motion replication systems, a new wave of entertainment firms – including a number of Hollywood special effects studios – are creating "rides" that contain the spectator within a simulated world. Within the industry, this trend is genteely conceptualized as a move towards heightening audience involvement. Omnimax's new "motion simulation" theaters, like the "Back to the Future" ride at Universal Studios, boast moving seats which are synched up to the on-screen action. You don't just watch a movie, you ride it.

Even virtual reality games may eventually be developing in this direction. At the convention, one booth featured a hybrid ride that incorporated an "Orbotron," a gyroscope-like contraption in which you get whirled about to experience weightlessness, with a "Cyberchair" for sensory effects, and a virtual reality headset programmed with flight-simulator software. The preferred industry term for this kind of multi-leveled experience is "immersion." Companies routinely advertise rides that take you "over the edge," while proclaiming "there is no envelope" to push any longer, as if the very parameters of our sensory world had been liquidated with the flick of a switch.

On one level, the immersion aesthetic requires a shift in role from spectator to partner. In "Virtual Goalie," the barrier between sports fan and TV spectacle dissolves: players stand on a simulated ice surface facing a large video monitor where they can see their image superimposed in front of a hockey net; by moving a real goalie's stick, they can block shots aimed at their video alter ego by televised hockey players. If some of your closest companions are known only through television, it's a great relief to finally be able to reach across the media divide and interact with them. Iwerks's Vactor technology, which utilizes a hidden operator/performer, even allows you to have custom-tailored conversations with your favorite animated characters.

Part of the thrill of immersion is that it obscures all sense of borders. Q-ZAR, a cult

sensation in England, requires players to shoot it out with laser guns and chest-pack targets in dark, fog-filled rooms that suggest absolute limbo. The model for Q-ZAR seems to be the movie *Tron* (1978), in which the hero, played by Jeff Bridges, accidentally enters a video game and has to battle his way out. This kind of experience may be the most obvious expression of the immersion aesthetic, but there are other ways to confuse our perception of boundaries, including the use of highly sophisticated animatronics.

With advances in robotic control and skin fabrication technologies, animatronic figures are approaching the point where it's easy, at least for a moment, to mistake them for living beings. A number of exhibits at the IAAPA show underscored the growing intimacy of this relationship: "Hello, I'm a robot, made of skin and skeleton, just like you," declaimed a bookish-looking male mannequin with a beard and tortoise-shell glasses, his eyes twinkling. "Do not look upon me as a machine, but as your friend," insisted a punk robot with spiked wire hair and chain-link skin. Elsewhere, "spokesmannequins," which feature video images of "live" human features mapped onto head-shaped "screens," offered a picture of the next century's sales force.

Probably the most haunting image of our immersion into machine-generated realities is that of the goggle-wearing virtual reality player; it may well be the icon of the age. Like the gas mask, the VR head-deck conjures visions of an uncanny hybrid, a post-industrial being with half-forgotten human roots. There's something terribly vulnerable about the wearer's appearance, as if he were blind and defenseless, and at the Convention Center, where you could see groups of players with heads and necks twitching arhythmically in response to environments only they could perceive, the VR player also embodied an ostrich-like ridiculousness. Yet alongside the camp trappings of sales booths where female personnel swarmed in silver Flash Gordon bodysuits, the sight of businessmen with head-decks straddling their faces like mechanical parasites suggested something slightly more sinister as well.

As a cultural phenomenon, the aesthetics of immersion seems like a timely response to pervasive alienation, and our consequent hunger for a heightened sense of involvement. Most of us have a deep need to feel connected, and in a social landscape increasingly filled with generic public environments and non-places, the theme park's virtual realities are a sanctuary of certainty. Traditional rollercoasters and other "gravity rides" provide thrills by literally shaking you up, but the new regime, to ensure that we're having fun, must offer a replacement for our terminally estranged mode of existence, surrounding us with environments in which we can feel an illusion of absolute

belonging. The meaning of "carnival," as a result, may be returning to its Latin roots, which literally mean a "putting away or removal of flesh," a farewell to the carnal. The amusement park of the future, where visceral experience is triggered only by simulated cues, will say goodbye to all that with a new force.

Given this backdrop, it was hard not to feel a tinge of nostalgia at the convention when confronted by "The Moneygrabber," an old carny favorite in which the customer stands inside a narrow glass box where dollar bills are blown about by gusts of air. It's a simple kind of titillation, yet that image of being surrounded by swirling possibilities in a confined space perfectly captures the defining principle of seduction. Of course, at an industry convention, the assembly-line quality of that "fun" is ludicrously transparent, leaving us with only the possibility of disappointment, and its subsequent denial.

December 1993

CHRISTO'S UMBRELLA LIABILITY

From the start, there seemed something ominously ironic, even doomed, about umbrellas that couldn't be opened in the rain. When a storm in Japan delayed the official commencement of Christo's bi-national parasol superspectacle, you had to wonder about the well-orchestrated promotional campaign's repeated emphasis on the project's technological sophistication. A great deal of hype had circulated about structural engineering specs, wind-tunnel tests and environmental impact reports, creating the impression that Christo's CVJ Corporation was a free-enterprise rival to NASA. But when one of Christo's 448-pound, 20-foot-high umbrellas toppled over in a gust of wind, killing a 33-year-old mother in Kern County, California, the tragedy couldn't be chalked up as a sacrifice to scientific progress. It couldn't even be said that Lori Keevil-Mathews had died in the name of art, because Christo isn't really in that line any more. Her grisly death was caused by a publicity stunt gone awry.

That Christo is a master of spectacle is certainly no moral crime; what *is* troubling, though, is the shamelessness with which he and his cohorts publicly dismissed the accident as a freak occurrence. Christo even went so far as to claim the tragedy as part of his art, which supposedly expresses the unpredictability of nature. Yet problems with the umbrellas' construction and placement had become evident early on: three umbrellas in Japan were uprooted by gusts twenty-four hours after the project there got underway, and the rest had to be closed for several days. In California's Tejon Pass, where a sign on the highway warns drivers they're entering a "Gusty Wind Area,"

volatile breezes led to the cautionary closing of the umbrellas on the night of October 19. After they were reopened, close to a hundred were eventually shredded or smashed by winds; on one particularly exposed ridge, their smashed remains littered the hillside like a fleet of crashed gliders.

A week before Keevil-Mathews was killed, an angry column in the *Village Voice* denounced Christo as the art world's Donald Trump for conspicuously squandering $26 million on his ephemeral "installation." The vast majority of Californians, however, were enthralled: the number of weekend visitors to the umbrellas – which ran alongside Interstate 5, spiking the craggy landscape like glistening lemon darts – easily surpassed the attendance figures for Raiders' home football games. But the most astonishing evidence of Christo's grip on what is usually called the "public imagination" came in the wake of Keevil-Mathews's death. As reported by the media, the public's chief sentiment was bloated compassion – not for the victim's family, but for Christo. The death of a young woman was unfortunate, but the real tragedy was that the umbrella show had to be closed prematurely. In the remarks of some of the more fervid Christo fans, you could detect an underlying petulance, as if Lori Keevil-Mathews had merely been a party-pooper out to ruin everyone's free picnic.

Admittedly, there is an appealing poetic largesse to Christo's Umbrella Project, but one suspects that he could have erected giant beach balls or multi-colored pup tents and elicited similar reactions. At the core of the project's allure lies not a work of art, but the carefully marketed myth of Christo himself. It's a familiar story Americans never tire of hearing: an immigrant refugee achieves an improbable dream in the land of the brave. (That Christo fled an Eastern Bloc country only enhances its appeal.) As his single trademarked name plainly declares, Christo stands for Individualism, but he is also something more than that; like Madonna, Christo is an individual with the glamor of a multinational corporation. As portrayed in the media, the CVJ Corporation, run by Christo and his wife, Jeanne-Claude Christo-Javacheff, is a ma-and-pa operation which audaciously negotiates with government agencies and industrial giants.

Though he flaunts his role as venture capitalist-cum-artiste, a crucial aspect of the Christo myth is that he and his wife are left with absolutely no money at the end of a project. There is thus no mistaking him for a vulgar profiteer; instead, he appears as a virtual martyr, a pillar of moral purity willing to sacrifice personal gain for his singular obsession. But while money supposedly means nothing to Christo, it was essential that the public be informed exactly how many millions he spent on the

umbrellas. As in the pre-release hype for a Hollywood blockbuster, we were told it was a multi-million-dollar extravaganza, an event "years in the making," with an international cast of thousands. Yet despite the communal activity required by a Christo event – the collective labor required to construct, install, document and, finally, remove thousands of giant umbrellas – it is inevitably presented as the work of a single visionary.

Keevil-Mathews was killed on a Saturday. When I drove to Tejon Pass on the following Monday, almost all the umbrellas were already closed – a gesture of mourning ordered by the CVJ Corporation. The souvenir shops, however, were doing a thriving business. Enterprising merchants were selling umbrella mugs, t-shirts, lighters, miniature umbrellas, and "the original umbrella painted rock." Like most visitors, I felt compelled to get out of the car for a personal encounter with one of the homicidal parasols; the other mandatory ritual was taking a picture. People disembarked from cars with camera in hand, eager to document not the actual object, but their attendance at an historical event.

One of Christo's most cunning strategies is that his visual stunts are installed for only a couple of weeks. Official Christo literature relates this decision to personal modesty: it is evidence that despite the grandiose scale of his projects, Christo has no wish to erect self-important monuments. But the excruciatingly thorough documentation that accompanies every project, ranging from films and photography books to transcripts of public hearings, belies any such claims; on the contrary, Christo makes sure his endeavors are recorded with the scrutiny due a World Historical Event. Their artificially limited life-span is a marketing device useful in creating an aura of rarity; Christo's celebrity, on the other hand, is a monument which endures.

In the aftermath of Keevil-Mathews's death, the quixotic Christo persona temporarily retreated behind an icy corporate facade. While the victim's family was making funeral arrangements, Christo's attorney brazenly announced his skepticism that Lori Keevil-Mathews was actually killed by the falling umbrella, adding that in any event it was "an act of God" and so the CVJ Corporation could not be held liable. Of course, had Christo placed his umbrellas in a less exposed area, one not subject to gusty mountain winds, there would have been little chance of such an accident occurring. The blame for Keevil-Mathews's death lies partly in faulty testing procedures and the incompetence of state and county officials who allowed the project to proceed, but mainly it lies in one man's uncontrollable hubris and our willingness to countenance

and support it, seduced by the pleasure of identifying with an ego so relentlessly larger than life that it promised to verify our own importance. That pleasure becomes irresistible whenever democracy and the notion of equality have begun to seem like insufferable burdens. For this reason, and this reason alone, Christo may well be one of the defining artists of our time.

November 1991

HEAVENLY VEHICLES

In an inspired, turbo-charged hyperbole, French critic Roland Barthes once declared that the automobile was the cultural equivalent of the great Gothic cathedrals. Writing in the mid 1950s, Barthes maintained that cars were "the supreme creation of an era, conceived with passion by unknown artists, and consumed in image if not usage by a whole population which appropriates them as a purely magical object."

While freeway commuters might be surprised to learn that they drive to work each morning in a purely magical object, the fetishistic heart of the American car cult is manifest to anyone who visits an auto show. At the Greater Los Angeles Show, the countless sedans, trucks and vans seem less like functioning vehicles than prototypes beamed down from car heaven. Their scratchless and dustless surfaces insinuate something unborn, outside of history. It's a phenomenon familiar from advertising, where cars appear as transcendent symbols of everything from family values to sex and power. But it's a little unnerving to encounter in person objects with such a blinding metaphysical sheen.

The idea that new automobiles come unsullied by human hands is supposed to make them that much more desirable. The brochure on Nissan's Altima boasts: "51 precision robots conspire with 30 laser-eyed optical sensors to craft its unibody . . ." These are immaculately conceived vehicles, in other words. Perfection, essentially a religious concept implying a greater-than-human agency, has at last been given earthly form thanks to assembly line robotics.

Yet the thrill of a car show doesn't come from adoring contemplation, but from

touching – and for many of us, it's touching something we can't afford. At the Convention Center, visitors lined up to climb into the $50,000 and $60,000 cars. In the relative privacy of the interior, you could stroke the leather seats, embrace the wheel and test its play, adjust the rearview mirror, and generally engage in the tactile forays of a grooming chimp. Meanwhile, the special scent of a new car washes over you, a peculiar perfume that's inhumanly expensive, like an aerosol version of money.

Hygiene is a major issue at car shows. Hired detail crews race around with dust cloths, wiping off fingerprints and other traces of mortality. Stainless engines gleam under hermetic plexiglass cases, their pistons thrusting in dreamy slow motion like giant metallic hearts. You're supposed to marvel at their power and efficiency, but the most impressive thing is their absolute sterility. And parked on parquet floors and carpets, the automobiles look oddly domesticated; you get the impression you could invite them into your living room without worrying about whether they'd drip oil on your new rug. With its promise of unrestricted access and variety, an auto show is a kind of safe-sex orgy.

Since the beginning of such exhibitions, concept cars have added a heady infusion of make-believe, subverting one's sense of the practical realities at hand, and suggesting that the car you buy today is an investment in the utopia the manufacturer will bring you tomorrow. Until recently, these vehicles were essentially non-functional sculptures, but many of the models exhibited at the Convention Center have evolved into practical machines. Only the styling is still designed with an eye to the future.

It's a future which hasn't changed much in the last forty years. It comes in two essential shapes: aerodynamic and globular. Mazda's hydrogen-powered HR-X, which might make it to showrooms by the early 2000s, is the latest avatar of the bubble car. In contrast to its streamlined competitors, the HR-X doesn't evoke velocity; instead, it suggests a comfy personal biosphere. The bubble's allure used to be its panoramic windows and *Jetsons* space-pod style, but these days it appeals to us more as a symbol of self-containment in a contaminated world. It's a domed vitrine on wheels, protecting its driver exhibit.

Representing the aerodynamic school, the Oldsmobile Aurora V8 Aerotech embodies a lesson in modernist aesthetics; a Batmobile-type, single-passenger vehicle, its seamless, sinuous contours look like they were sculpted by Brancusi. There's nothing in this design that smacks of any future currently on the horizon, but at one time – at least when I was growing up in the '60s – it seemed that by now we'd all be driving models just like the Aurora. As it turned out, those concept designs weren't harbingers

of a coming epoch, but metaphors for the way we envision the future. Fusing science fiction tropes and modernism's machine aesthetic, futurism proved to be merely another convention in the language of shape, a static motif for a Tomorrowland that never changes because it never arrives.

Traditionally, auto shows make use of some kind of theme-park-style presentation. At a Paris exhibition several years back, Renault displayed its cars in a tranquil woodland scene, replete with computer-controlled perfume sprayers which "freshened" the air with natural scents. A recent show in Frankfurt touted eco-friendly vehicles with a revue starring dancers dressed as trash cans and trees, boogieing down in tribute to Mother Earth.

At the LA Convention Center, however, the cardinal theme seemed to be reality itself. Only a few displays, such as Range Rover's chintzy recreation of an English drawing room, were even remotely theatrical. Far more typical was the approach of Mercedes, which set up an "invitation only" VIP lounge, replacing fantasy with an all-too-real exclusiveness. Many of the more expensive European models, of course, have always made a pretense of emphasizing the factual. Instead of trying to create a personality for a car with a catchy name, the makers market these high-end vehicles with numbers and letters: 850 GLT, 525i, SE500. This bluntly technocratic approach quietly hints that anyone able to cough up the sticker price is beyond the need for illusion, and is interested only in an "ultimate driving machine," not a conceptual enhancement of his or her identity.

With fewer and fewer people in this country able to own a home, the car has become our true castle, a place of sovereign, protected solitude. Yet the price of a new car is increasingly out of reach for many Americans: the average price of Chrysler's three new 1993 models, including options, is $21,000. Seated in a $69,000 Mercedes, a car worth roughly three times the average American's annual income, I try communing with its aura of luxury. The hubbub outside, muted by airtight windows, fades away completely, and I'm reminded that the interior of an expensive car is a space licensed for unhampered fantasy. After a while, though, an itchy frustration blooms. When another visitor climbs into the passenger seat beside me and starts running a hand over the dashboard as if conducting some kind of psychic dousing procedure, I grab my bag of free brochures and surrender my place to the next in line.

In the end, it's hard to tell whether exhibitions like the Greater Los Angeles Auto Show are designed to arouse desire or smother it. Initially you're stimulated by the

vision of abundance and diversity, but on closer inspection many of the American and Japanese cars seem virtually identical. And faced with 650 new models from more than 40 manufacturers, whose eyes don't start to glaze over? Unwittingly, car shows end up revealing one of capitalism's little ironies: the unrestrained "free" market culminates in producing consumer paralysis. Evidently, there's a limit to the "choices" we wish to make: according to a recent *USA Today* poll, prospective buyers are staying at home because they're overwhelmed and confused by the array of options offered by car dealers.

Beneath the auto show's appearance of endless variety and unlimited options, however, the hard fact remains that we don't really have much of a choice at all – at least those of us living in an automotive culture like Southern California's. Unless we construct a new city, choice in this matter is another luxury we can't afford. Like it or not, most Angelenos need a car the way a Mongol needed his horse – simply to survive.

January 1993

PART II

INVESTIGATING A
PUBLIC DISAPPEARANCE

EXCREMENTAL JOURNEY

You shall cover your dung.
DEUTERONOMY, 23:13

The Hyperion Waste Treatment Plant isn't a typical subject for dinner party conversation, but a friend brought it up because he'd recently heard a rumor from a plant employee that every month 300 fetuses turn up in the facility's grit-removing gate. Conversation stopped for a long moment, then it started again. Did this reflect the number of abortions performed at home in LA? Was it the grisliest statistic of urban life anyone present had ever heard? Or was it simply a contemporary folk tale?

In nineteenth-century London, after all, garbage-eating wild hogs were reputed to live in the sewers; a century later in New York, it was albino alligators, the reputed offspring of souvenir pets brought home from Florida vacations and then flushed away. The notion that Los Angeles' sewers are a funeral tunnel for the unborn dead could simply be this myth's latest edition. Or then again, it might be true.

Situated across the street from the El Segundo beach, Hyperion (a name borrowed from a Greek god of beauty and light) is a vast industrial compound that serves four million Angelenos. Six thousand, five hundred miles of sewer pipes – a transportation network that dwarfs the freeway system – converge here; on an average day, the plant takes in 320 million gallons of wastewater. It attracts visitors from around the world, and like the Pantry restaurant downtown, it operates around the clock.

Most of these facts are relayed by the friendly tour guide, a retired sewage engineer who seems immune to the stench. The smell is strongest by the plant's primary open-air facility, an aeration tank that resembles a series of dirty lap pools whipped up by giant Jacuzzis. Air is pumped into the wastewater to promote the growth of various

micro-organisms which decompose organic materials. So much air, in fact, that the water has no buoyancy: if you tried to float in it, you'd sink straight down.

Walking around Hyperion, you soon realize you've entered a world where such disconcerting phenomena are commonplace. Set against a treeless dunescape, the plant – which has doubled as a set for a James Bond movie – suggests a mining operation on Mars, and though it's only a stone's throw away from the beach, you can neither see the ocean nor even smell it. The only clue to your bearings are the low-flying jets which regularly dump exhaust vapors while passing on their way to and from LAX. Hyperion, it turns out, is a center for all kinds of pollution.

Equally disorienting is the facility's monumental scale. The various centrifuges, air scrubbers, turbines and pumps look like they were designed by a gargantuan race: in an age of microchip miniaturization, heavy industry has yet to shrink much. Among the largest items are the Anerobic Digesters, eighteen cylindrical tanks which Aldous Huxley once compared to "very large Etruscan mausoleums," adding that here "something hideous and pestilential was transformed into sweetness and light," thanks to a lot of hardworking bacteria. Writing in 1956, five years after the plant's postwar modernization, Huxley concluded that Hyperion was a marvel of the modern technological world.

Huxley's essay belongs to an intellectual tradition of sewer boosterism. John Ruskin, the nineteenth-century English art critic, maintained that a properly functioning sewage system was a "far nobler and far holier thing . . . than the most admired Madonna ever printed." For Victor Hugo, sewers were a symbol of the city's conscience, a democratic forum where "all things converge and clash. There is darkness here, but no secrets." Perhaps it's their inherently egalitarian nature that endears sewers to liberal thinkers – like death, a sewage treatment plant is a great equalizer. In Hyperion's primary sedimentation tank, your shit meets the Reagans', and nobody's waste gets special treatment.

When the tour stops for a look at the plant's bar screens – grilled scoops which remove solids from incoming wastewater – Joan Didion springs to mind. Didion always had a weak spot for public works, particularly water transport systems; in *The White Album*, one essay begins: "The water I will draw tomorrow from my tap in Malibu is today crossing the Mojave . . . The water I will drink tonight in a restaurant in Hollywood is by now well down the Los Angeles Aqueduct . . ." Yet had she written about Hyperion, I somehow doubt she would have speculated on the whereabouts of her last evacuation.

Didion's interest in more heroic public works, like Hoover Dam and the Operations Control Center for the California State Water Project, grew from a poetics of the sublime. She repeatedly invokes memories fated to stick in her mind for all time ("Since that afternoon in 1967 when I first saw Hoover Dam, its image has never been entirely absent from my inner eye;" or "There is no day that I do not think of [lifeguards] Leonard McKinley and Dick Haddock and what they are doing.") Her consummate vision of the giant turbine at Hoover Dam is of "a dynamo finally free of man, splendid in its isolation, transmitting power and releasing water to a world where no one is." It's the kind of noble apocalypse only a dedicated solipsist could conjure.

Hyperion doesn't encourage this line of thinking; in a world without people, no wastewater would be surging through its network of brightly colored and neatly labeled pipes. Ninety-nine-and-a-half percent of the incoming torrent is water, yet in a year, the plant removes eight million gallons of "sludge" (a generic term covering all solids separated from wastewater). Cleaned-up sludge is known as "wetcake" and stinks like hell; high in nitrogen, it's trucked off and used as fertilizer for non-edible crops. Probably the only truly excremental image at Hyperion is the sight of wetcake plopping out of a funnel-shaped storage silo onto flatbed trucks.

Sociologists say that one can judge a society by its waste products. Or perhaps you could look at how it disposes of them. In the late nineteenth century, the practice of ocean dumping, which seems to be based on the assumption that the ocean is a bottomless cesspool, was almost rejected by Angelenos. Convinced that sewage water shouldn't be squandered in a land where water was scarce, a private coalition in the early 1880s put forward a plan whereby treated wastewater would be sold for irrigation. The "sewage farm" concept was adopted by Pasadena, where city-run orchards grew crops like walnuts, but Los Angeles voters were eventually swayed by the City Engineer and his cronies, and opted to dump their sewage in Santa Monica Bay. The Hyperion outfall, an undersea pipe carrying what may be the largest freshwater stream in Southern California, is the legacy of that decision.

Another legacy is Hyperion's status as an environmental delinquent. The Federal Clean Water Act requires that all major cities process raw sewage through two treatment stages, but at present, not much more than half the wastewater discharged from Hyperion undergoes secondary treatment.

Pointing the way to a future that may never arrive, the Donald C. Tilman Water Reclamation Plant in Van Nuys offers an alternative vision. Though it processes far less

sewage than Hyperion, all incoming wastewater undergoes not only secondary treatment, but a tertiary process as well. The resulting "reclaimed water" isn't exactly potable, but it's eminently suitable for a variety of recycling purposes, including watering the plant's $4 million Japanese garden.

The aptly named "Garden of Fragrance," which abuts the plant's futuristic administration building, was designed as a grandiose testament to the virtues of water reclamation, but ends up seeming more like an expensive folly. The Tilman tour is led not by guides but by "docents" (some wearing Japanese judo outfits) who interpret the symbolic elements of the landscaping while attempting to convince visitors that their garden is an ideal place for meditating and contemplating the glories of nature. It's a hard sell because the place is redolent of chlorinated sewage – it smells like a heavily used public pool where the water hasn't been changed in fifty years – and the din of the adjacent treatment plant drowns out any birds chirping in the manicured pines.

Though it boasts a rustic tea house and a recreation of a fourteenth-century *shoin* (a type of country home favored by aristocrats and upper-class monks), the Garden of Fragrance has no outhouse, which, under the circumstances, is a serious omission. The traditional Japanese toilet, according to novelist Jun'ichiro Tanizaki, was a place of spiritual repose. In his book on Japanese aesthetics, *In Praise of Shadows*, Tanizaki recounts how a fellow writer considered his morning trips to the toilet as a "physiological delight." "And surely there could be no better place to savor this pleasure," he notes, "than a Japanese toilet where, surrounded by tranquil walls and finely grained wood, one looks out upon blue skies and green leaves . . . No words can describe that sensation as one sits in the dim light, lost in meditation or gazing out at the garden."

After hinting that this is the spot where *haiku* poets over the ages have come up with their best verse, Tanizaki concludes that in contrast to Westerners, "who regard the toilet as utterly unclean and avoid even the mention of it in polite conversation," the Japanese sensibly realize that, "in such places, the distinction between clean and the unclean is best left obscure, shrouded in a dusky haze." Of course, the aseptic ambience of Western bathrooms, all bright lights and white tiles, belongs to a very different concept of hygiene where the "unclean" is sharply delineated from an ideal purity.

Our loathing of excrement can't be explained away simply by its odor or rapid putrefaction. In "A Load of Shit," an essay in his recent collection *Keeping A Rendezvous*, John Berger describes the raw feelings roused by his annual outhouse clean-up. "However calmly I start the operation of removing the shit from the outhouse, transporting it in

the barrow, and emptying it into the hole, there always comes a moment when I feel a kind of anger rising in me. Against whom or what? This anger, I think, is atavistic. In all languages 'Shit!' is a swear word of exasperation. It is something one wants to be rid of."

Not unlike an incriminating corpse, Elias Canetti might have added. Canetti claimed that shit conceals a guilty secret: something has been killed, eaten, and then destroyed through digestion. To avoid being publicly associated with the evidence, we build separate rooms so we can be alone when we dispose of the body.

Whatever the sources of our uneasiness, our attitudes towards shit generate concrete consequences. Because of our obsessive desire to separate the pure and impure, we waste billions of gallons of reusable water, including most of the water treated at the Tilman plant. Preying on our collective denial, real estate developers push for faster urban growth without considering necessary increases in sewage capacity. The recent pipeline disaster in San Diego, as well as Hyperion's outfall cave-in back in November, suggest that infrastructural decay has been routinely ignored. Apparently, no one wants to deal with the amount of shit we've got on our hands.

But there are still a couple of Koi fish floating in ponds of reclaimed water at Tilman and Hyperion, and administrators in both plants are proud of their history serving as sets for the motion picture industry, where it's said shit often turns into gold.

February 1992

MARK LIPSON

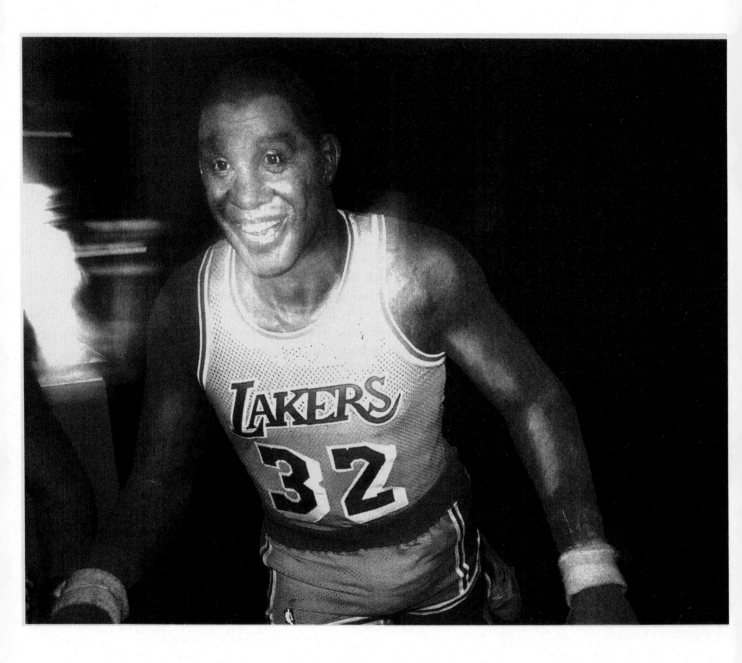

WORLD UNDER GLASS

On the well-trafficked corner of Western Avenue and Hollywood Boulevard, a formidable steel security gate encloses a city-owned lot known as Metro Park. The gate remains closed at all hours. No one is allowed to enter the park, stroll around its landscaped flowerbeds or attempt to enjoy a moment's respite beneath an anemic tree. The park has been quarantined in this manner out of a concern that were it open to the public, homeless people, drug addicts and vagrants would obscure the area's park-like qualities with a clutter of human refuse. By erecting a prophylactic barrier, city planners have chosen to preserve the picture of a park at the cost of its practical use. Metro Park is thus a new kind of public space: a Platonic environment that really isn't a space at all, so much as a display representing the idea of one.

Even in a city where the unreal is a longstanding civic tradition, Metro Park represents a new departure. As an abstract image, it seems to offer visual evidence of a city that cares, that offers its citizens a garden vista among the labyrinth of mini-malls it has zoned. In fact, the park stands for the opposite: a city that refuses to address the problems of homelessness and drug addiction. Images, of course, are a lot easier to manipulate than concrete realities, and in an environment where social participation consists largely of consuming and producing pictures, Metro Park may be the prototype for a future where "look, but don't touch" is the code of the road.

The museum, perhaps more than any institution, has pioneered the model for this mode of experience. While display cases are ostensibly useful in preserving artifacts from decay, they also effectively isolate an object's materiality, so that for the

viewer it becomes a metaphysical entity, or at best a theatrical prop. Unable to touch the object under glass, we become the consumer of a distanced, contemplative gaze. That look has come to define the way we regard the world, as if it existed only under glass – be it a vitrine, a television screen, a windshield, or a security monitor.

This museumization of experience nourishes illusions of total control, but every once in a while, a public vitrine is unexpectedly shattered, and our faith in images is shaken. When basketball superstar Magic Johnson announced that he had tested positive for the HIV virus and was retiring from the game, he momentarily ruptured a widely held picture of HIV as the exclusive property of gays and junkies – a misunderstanding that had long served as a strategic container, relegating our image of the disease to a world where sufferers were infected not only with a virus, but with values frowned upon by conservative doctrine.

Johnson's immediate retirement intensified the shock. It struck fans as a symbolic death anticipating his physical demise. (Why else did so many sportswriters invoke hearing the news of JFK's assassination?) Though Magic assured fans he was still planning a long and happy life, his retirement abruptly altered his iconographic status: rather than an on-court wizard, he would now appear only as a spokesman "for the virus," as he repeatedly phrased it.

The drama of an athlete afflicted with illness is always disturbing; an emblem of health and vitality is transformed before our eyes into a reminder of imminent mortality. But for many, Johnson's appeal reaches beyond his extraordinary success as a player. Celebrated for his generosity in feeding the ball to his teammates and raising money for charities, Magic appeared to his public as a nurturing figure. In an era when sports have become big business, his incandescent smile suggested a homespun alternative to '80s-style greed. Every aspect of his public demeanor conveyed an alluring image of openheartedness and warmth, and judging by the televised pictures of crying African-American schoolchildren and lachrymose fans, a great many Americans evidently regard Magic as a close personal friend.

Yet people were profoundly upset for another reason as well: with Magic's announcement, two salient cultural images had proven treacherously unreliable. A picture of wholesomeness turned out to represent infection and death, while a deadly virus had assumed the image of perfect health. For a society which relies heavily on iconic sources of information, this reversal carried the traumatic message that images can't be trusted. The global media spasms provoked by Johnson's news involved far

more than a show of compassion; the credibility of the media's language was on the line, and its frenzied coverage suggested a kind of hysterical reaction.

On a more practical level, Johnson's retirement may unfortunately help reinforce the notion that containing the spread of AIDS means isolating all those who carry the virus. Of course, Magic's image is itself a product of quarantine: though his disease is spread by activities that involve touching or penetrating, his fans never have to worry about having intimate contact with their hero. Not unlike Metro Park, Johnson exists for most of us only as an exhibit. Those who knew him personally weren't necessarily dumbfounded by the bad news. Pamela McGee, a former USC basketball star and friend of Johnson's, publicly declared that she wasn't terribly surprised because she knew the star as someone who claimed he'd had sex with thousands of women he called "freaks."

Regardless of what Johnson comes to represent in the future, the recent orgy of media coverage has momentarily made him a bigger star than ever. Two days after his announcement, the Topps basketball card of his rookie year reportedly doubled in value from $250 to $500. Unlike more manageable abstractions such as Metro Park, however, Magic Johnson cannot be preserved forever under glass. As his health starts to decay and his image breaks down, we'll all face the same choice: either reexamine our vitrine-based viewpoint, or change the channel.

Those who are bitter about the fact that, before Johnson's announcement, thousands died of AIDS without receiving any comparable public support are forgetting what kind of world we live in. Never mind our homophobia and anti-drug panic – most Americans have ignored people afflicted with HIV and AIDS simply because they don't have charismatic media profiles. As former porn-queen Traci Lords recently editorialized in the *LA Times*, all our collective values are now defined by media heat. Without a winning presence on the electronic vitrine, you're condemned to being invisible in a museumized world.

November 1991

MARK LIPSON

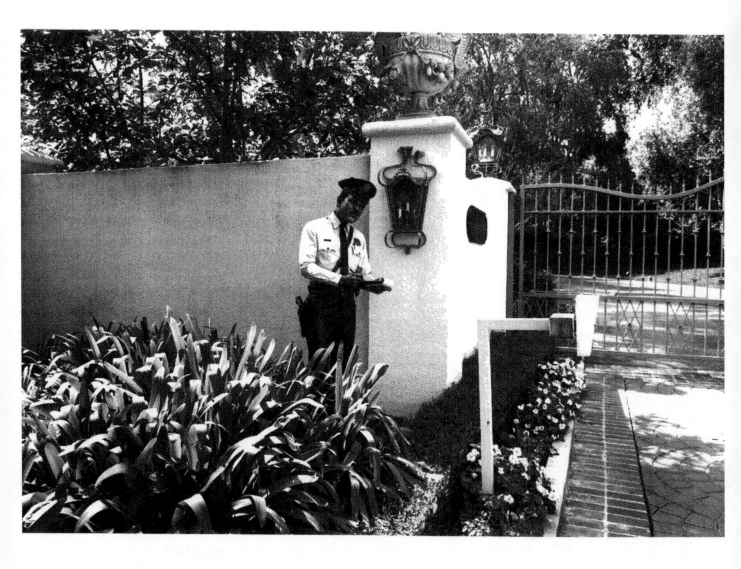

STATUES OF LIMITATION: THE PRIVATIZATION OF PUBLIC ART

A little over a year ago, the citizens of the former USSR were tearing down works of public art. Surging crowds gathered around monuments to Lenin and other state icons and toppled them off their pedestals. Gorky Park was transformed overnight into the sculptural equivalent of a battlefield: giant statues lay strewn on the ground, some roped and gagged like Gullivers in a land of angry Lilliputians.

As the US media exultantly paraded these images, hailing them as emblems of the birth of democracy, an Estonian woman I know watched with sour humor. She had lived in the shadow of these government monuments, had suffered their insult on a daily basis, and she was appalled that the crowds weren't destroying them on the spot with picks and hammers, but instead were allowing trucks to carry them off intact to state storage facilities. It was a terrible failure of nerve, she said, a sign that people weren't ready to do away with the old oppressive structures. Until they could destroy the former regime's art, there was no hope for building a new society.

It's difficult to imagine anyone taking our public art so seriously. (During the civil disturbances last April, no one attacked the John Wayne statue in Mid-Wilshire, though as a law-and-order figure, Wayne wouldn't have been an inappropriate target.) Because Los Angeles lacks the open squares and pedestrian life characteristic of Moscow and Leningrad – as well as Chicago and New York – public art occupies only a marginal place in our daily consciousness. In most cases, it's not something we live with, it's something we drive by.

As a city of modular and private spaces, where the automobile and TV set are salient

features of the local architecture, Los Angeles poses a formidable challenge to the very idea of public art. Monuments by our better-known artists typically fail to even address this dilemma, but a stimulating solution has been provided by J. Seward Johnson, Jr, an heir to the Johnson & Johnson fortune who, according to his press release, is "the most popular contemporary sculptor in the United States." Displayed in corporate head-quarters, resort hotels and urban plazas around the country, Johnson's life-sized painted statues depict "ordinary" people in "everyday" poses. Despite a debt to the hyper-realistic tableaux of pop artists such as Duane Hansen and John de Andrea, they avoid any hint of satiric wit or social commentary; instead, they offer us a nostalgic pic-ture of "the warmth of human spirit," drained of any contemporary trace.

What makes Johnson's art interesting is the way each statue is placed in a context related to its narrative content. Rendered with *trompe l'oeil* realism, a taxi-cab-hailing businessman is situated in front of a hotel; a sculpture of a man sleeping on a bench is installed in a public park; painted bronzes of a jogger and a tourist couple gawk out-side the driveway of a famous rock star's estate at 10,000 Sunset Boulevard. Driving by and glimpsing these statues out of the corner of your eye, it's easy to mistake them for real people. Unlike heroically scaled plaza art or monuments on pedestals, Johnson's sculpture isn't set off from the surrounding milieu, but duplicitously merges with it.

There's more at stake here than the frisson offered by games of illusion. In fooling the eye, Johnson's banal sculptures unexpectedly place the familiar on an uncertain footing. They also call into question the way we separate art and life, reality and the-ater; placed in highly visible sites, they invite us to see the "real" world as home to both artifice and actuality. And as a privately financed form of public art, they offer an ex-perience which is accessible, intimate and treacherous – which is what space in Los Angeles is all about.

Johnson's statues deftly skirt the stultifying fate entrapping a great deal of our more ambitious public sculpture. When attached to government buildings and cor-porate plazas, most art inevitably appears as a territorial marker, testifying to the sponsoring agency's fiscal might and its power to make things happen. The art becomes the medium of a forbidding institutional message: "We are a sovereign entity, able to erect monuments of our choosing, and we can change your visual land-scape at will. We can create your culture."

This lurking subtext is compounded in LA by the murky boundary between civic and corporate space. Some of the most visible "public" sculptures in the city, such as Jonathan Borofsky's towering *Ballerina Clown* in Venice, are in fact owned and maintained by pri-

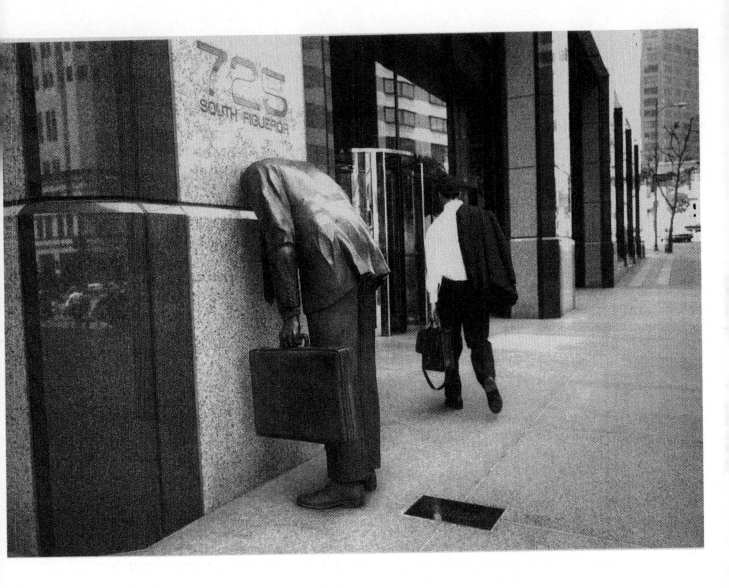

vate companies. Adding to the confusion, government agencies and commercial corporations often commission work by the same artists. When should their work be considered public art? Can sculptures commissioned by business interests speak to community needs?

In a post-urban megalopolis like Los Angeles, the most natural setting for public art is probably a backyard, which is precisely where our greatest monument, the Watts Tower, was erected by an immigrant laborer in the 1950s. Planners and artists alike could learn a similar lesson from J. Seward Johnson, and disperse art in the intimate spaces of this private city. If Los Angeles' centerless sprawl has a lesson to teach, it's that no pocket of existence is insignificant, that each comprises a center of its own.

One of the few "fine" artists to employ an approach similiar to Johnson's is Texan Terry Allen. His *Corporate Head*, a slightly larger-than-life-size bronze statue of a headless businessman, fronts the Citicorp headquarters downtown. Allen's briefcase-carrying figure stoops forward so that his neck plows into the ground floor's marble facade, creating the impression that his missing head has burrowed into the building. The disorienting virtue of this site specific art is that the 43-story skyscraper, and the suited executives rushing in and out with their own briefcases in tow, seemingly become part of the sculpture.

Is Allen's work a witty allegory on the dangers of losing one's self in one's work? Certainly, there's a poignant slapstick humor in evidence; the statue's absurd and vulnerable posture invites laughter, if not a kick in the pants. Yet on another level, Allen's corporate foot soldier conveys the pathos of an anonymous casualty, someone who's been violently stripped of mind and will by the faceless bureaucracy of big business.

But Allen's sculpture is actually more ambiguous than this: despite its victim-like pose, the statue's impressive size militates against its seeming too pathetic, while the use of bronze lends it the dignified air of a traditional monument. But a monument to what? To the team player who makes the ultimate sacrifice? Or to the ostrich-like blindness of the business community? This may be why the bike messengers going in and out of the Citicorp Building appear to get the biggest kick out of *Corporate Head*, chuckling as though it caricatured the executive drones to whom they must answer.

Allen's figure is no Atlas supporting the world with his manly frame; instead, he appears unnaturally stooped, bending not from the legs (which remain rigid), but from the shoulders and neck, as though someone had grabbed his head and pulled it down into a compromising position – as though, in other words, he were being forced

to give corporate head. This black humor invokes some disheartening realities: dwarfed by the high-rise shrine to banking power which towers above it, the statue suggests that in our corporate society, the individual is insignificant, expendable and impotent. How many of us, after all, can claim to influence the corporate power structures downtown? Yet the decisions made there by banks and oil and insurance companies will affect our lives, as well as our art. *Corporate Head*, for instance, was funded by the Prudential Insurance Company as part of an ongoing "public" art project.

The art world increasingly reflects the interests of big business, from the sponsorship of major exhibitions to the merchandising tactics of galleries and artists themselves. Allen's sculpture reminds us what happens when we're unable to make the crucial distinction between private and corporate structures. It alludes to an identity crisis of monumental proportions, addressing not just the business community, but an entire society whose collective head is buried in corporate-sponsored culture, from our ad-driven TV programming to our so-called public art.

September 1992

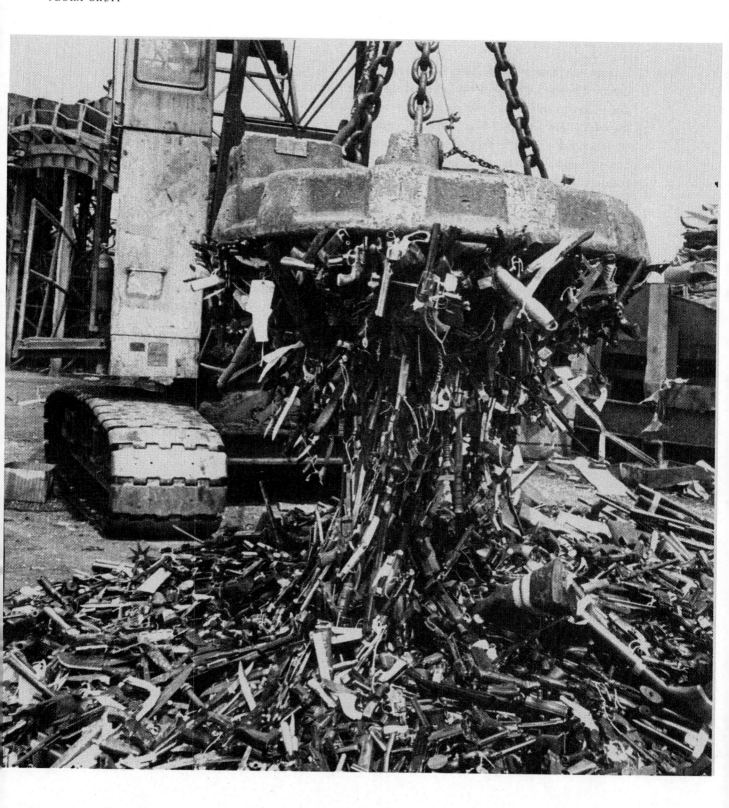

GUN RITES

Out for a walk the other night, I found myself to be the only person on the street. When I heard a car slowing down alongside me, I glanced over out of habitual paranoia. The passenger window unrolled and a crew-cut guy leaned out, smiling malevolently as he aimed a gun barrel of a finger at me. "Bam bam," he shouted, and then the car raced off resounding with laughter, leaving me angry, and relieved he'd only been pointing a finger.

Los Angeles is a city where guns force their way into your consciousness on a daily basis. This is a place, after all, where citizens randomly shoot into the air to celebrate major holidays. Even if you don't own a gun yourself, you almost certainly know people who do. And regardless of whether you've ever witnessed a drive-by or freeway shooting, you live in the shadow of these acts. Public crimes with often arbitrary victims, they possess a psychic weight which plunges below our specific fears of hold-ups and murders, and ends up coloring our outlook on the routines of daily life, such as taking a walk after dinner.

People who believe in karma might point out that Los Angeles – or rather, Hollywood – spreads the image of guns worldwide, and so their ubiquity here is a case of pigeons coming home to roost. But the area's intimate relationship with firearms has a firm industrial base: of the approximately three million guns made legally in this country in 1990, one out of eight was manufactured in Southern California. And since the 1992 Los Angeles riots, during which 3,000 firearms were stolen, business has been booming for the county's 3,240 licensed dealers. On local radio stations, meanwhile, gun experts offer free advice to consumers, including what type of bullet

can stop an intruder, but won't damage your home's plaster walls, should you miss.

One of the city's more compelling firearm traditions is staged every July when the Sheriff's Department destroys its cache of confiscated weapons. This year, 14,500 instruments of violence, collectively weighing in at 10 tons, were ferried to a Carson salvage dump under the supervision of a SWAT team. In addition to 9,000 guns, including stacks of rifles bound together like firewood, the stockpile contained swords, machetes, studded numchucks, knives, blackjacks, crossbows, and baseball bats. Poured out of a dump truck, they formed an ominous-looking mound.

The Department has been bringing its weapons to this particular site since 1980 (before that, weapons were dumped in the ocean), and the event has become an annual photo opportunity. In the presence of TV news teams and press photographers, the Chief Sheriff – who wore a Mickey Mouse tie to underline the occasion's festive atmosphere – left his fingerprints on a choice selection of confiscated weapons, including a Sten sub-machine-gun taken from an over-zealous collector, before tossing them one by one onto the potlatch pile.

However seemingly straightforward, this simple drama yearns to reach beyond mere PR fluffery to become a full-blown ritual, partly obsessive and partly carnivalesque, and dedicated to restoring safety to our public spaces. If Spielberg were producing it, a hole in the ground would open with a roar, spitting flame and sulphur, and the forces of good would then dispatch the evil weapons to the underworld. As it is, a derrick hoists a giant magnet over the assembled heap and, with guns dangling like metallic dreadlocks, swings over to a conveyor belt, where the weapons are carried off to be shredded down to coin-sized fragments. Though it's not especially spectacular, by the time the ground has been cleared of the last firearms you're left with a feeling of catharsis, as if this cleansing ceremony had the power, through some kind of sympathetic magic, to purge the city of all violence.

Of course, guns remain with us for a host of reasons. They make up part of the sacrament of the West, an area forged by an armed populace, and where even today "the great equalizer" is still a symbol of democracy and individualism. In a city as segregated as Los Angeles, it's no coincidence that the drive-by shooting has become an institution. As a form of killing, it mirrors the city's character – it's about anonymity, keeping in constant motion, maintaining a profound distance. As the ultimate extension of Southern California's drive-in culture of convenience, it's just one of the prices we pay for our alienated comforts.

July 1992

BUILDING A LOST FUTURE

From presidential campaigns to shopping malls to resort complexes, contemporary life is increasingly rendered for us in crisply thematic terms. Even our wars are now merchandised with appealing motifs, and at home, a similar approach characterizes the popular media's depiction of the inner city as a kind of deadly theme park, or urban Scaryland. Ironically, in Los Angeles it's the neighborhoods with the fewest examples of fantasy architecture, such as South-Central, that are symbolically quarantined with the Scaryland designation.

Judging by its title, you might reasonably expect to find these matters elucidated in Charles Jencks's latest book, *Heteropolis: Los Angeles, the Riots and the Strange Beauty of Hetero-Architecture* (1993, Academy Editions). After spotting a chapter called "What Caused the Justice Riots?", you might even expect an attempt at linking social and architectural theory, ethics and aesthetics. But like the buildings he ends up championing, Jencks engages in a game of dissimulation, adapting liberal themes and rhetoric to an agenda of alienation.

He begins promisingly enough with the idea that LA is the model of the future world city where there are *only* minorities – where no single group, economy or style of living dominates. To reflect this pluralist reality, our city planners need to embrace "hetero-architecture," which strives "to accept the different voices that create a city, suppress none of them, and make from their interaction some kind of greater dialogue . . ." So far so good. But this preamble merely introduces a rambling apology for the Frank Gehry school of architecture, whose industrial funhouse-cum-fortress

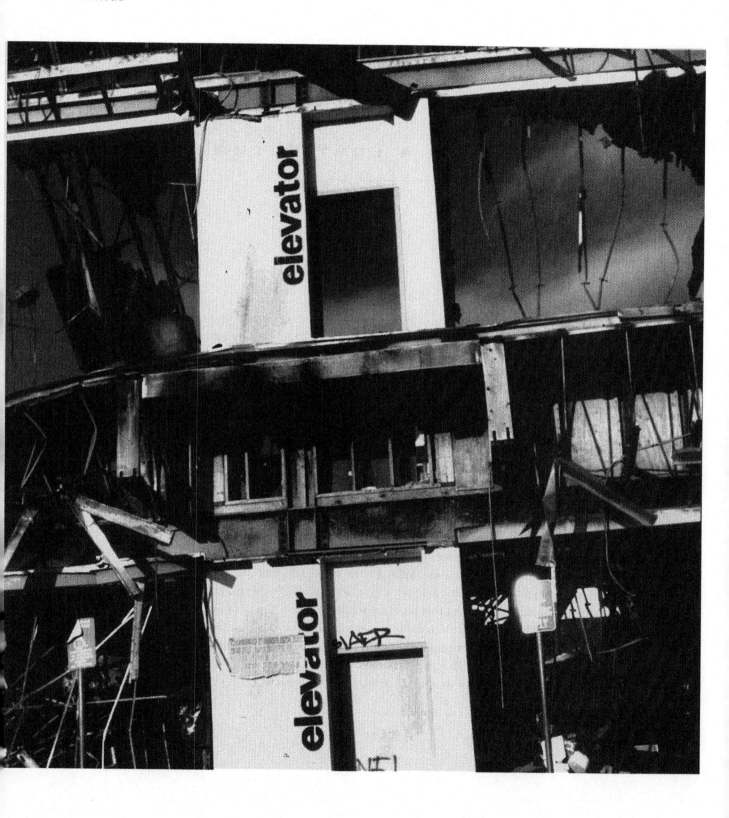

thematics Jencks cynically recasts as a salute to cultural diversity. The busy pastiche in the work of architects like Morphosis, Eric Owen Moss and Frank Israel, we're told, actually "suggests ethnic pluralism without naming it;" it's a way of building that manages to be "inclusive without being condescending."

Jencks's absurdities climax in a section eulogizing the aggressive "cheapskate" architecture pioneered in the late '70s by Gehry and Charles Moore, whose buildings used materials like corrugated metal and chain-link fencing to create tough-looking facades that camouflage sumptuous interiors. In a key passage, Jencks extolls this "riot-realism" – a theme architecture if ever there was one – as our only hope for the future: "Architecturally, [Los Angeles] will have to learn the lessons of Gehry's aesthetic . . . how to turn unpleasant necessities such as chain-link fence into amusing and ambiguous signs of welcome/keep out, beauty/defensible space." He goes on to remark that "defensible architecture," however unfortunate as a social trend, actually "protects the rights of individuals and threatened groups." By "threatened groups," presumably, he's referring to yuppie home-owners.

Obviously, Jencks's chosen architects aren't to blame for our social ills – they're merely responding to their clients' needs. But to laud this kind of expedient aesthetic in the name of safeguarding civil rights is rank cynicism. For all the lip service Jencks pays to the virtues of pluralism and a decentered city, his real project is validating an architecture that turns social alienation into a positive virtue, cloaking its paranoia in an aesthetic of safe chaos.

With a wit and intelligence missing from Jencks's book, an earlier model of "hetero-architecture" is outlined by artist Robert Smithson in a 1972 audio-and-slide show, part of an exhibit of his photographs organized by Robert A. Sobieszek at the County Museum of Art. Smithson, who died in a plane crash in 1973, maintained an abiding interest in destitute landscapes and entropic systems, and his slide lecture drolly celebrates the "decentered" architecture of the ramshackle Hotel Palenque, an idiosyncratic establishment near the famous Mayan ruins in Mexico's Yucatan.

Smithson's deadpan slides of the hotel detail an odd collection of architectural spaces seemingly unconnected by any overriding plan. In an older section of the hotel, a series of rooms have been left roofless, as if to accommodate guests with a love for the open air, and throughout the facility unexpected transformations abound: an empty pool traversed by a drawbridge has metamorphosed into a giant "iguana pen," providing constant entertainment to the guests. Elsewhere, the remnants of destroyed floors are left protruding from the sides of existing buildings; balconies are supported by

crooked poles braced on stacks of cinder blocks; and a garden alternates strips of lawn with piles of rubble.

The artist's voice-over commentary, though marred by occasional clichés about Mexico, convincingly argues that these ad hoc features comprise a pluralist architecture where every solution is individually improvised using whatever's at hand, and where detritus and decay are incorporated into an ever-evolving design. In praising this example of contemporary Mayan architecture, Smithson admires both its spontaneity and the casual way it embraces signs of human frailty and contingency. Its jerry-rigged aspect is never reduced to an upbeat theme; instead, Smithson discusses the Hotel Palenque as a model of architecture with a tragi-comic dimension, an idea which might make a lot of sense in Los Angeles at this particular moment.

Of course, theme presentations are so much easier to consume. They distract us from paying attention to anything outside their neatly framed purview, and feed our illusions of control. But just as propaganda relies on the complicity of those it deceives, our addiction to designer realities depends on a denial of more complex truths. As our field of vision diminishes, so does our ethical code; lost in the theme park, we end up clinging to our virtual morality as if it were the real thing.

October 1993

TIJUANA'S SOLDIER OF FORTUNE

Tijuana's Panteón No. 1 is a charmless, ramshackle cemetery that lies at the bottom of a hill, just a few dusty blocks from the border. At first sight, it's distinguished mainly by an odd assortment of randomly placed trees and graves made mysterious by overgrown foliage. But though it lacks the elegance of nearby graveyards, Panteón No. 1 attracts a steady stream of pilgrims, many decked out in their Sunday best, who come to visit the shrine of Juan Soldado, the city's unofficial saint of border crossers. They come to pray for his assistance, and to give thanks for successful journeys.

The local story holds that Soldado (the name means "soldier") was an infantryman framed for the rape and murder of a young girl some fifty-six years ago. The innocent soldier was facing a firing squad when his commander, rumored to be the true culprit, told him to run for the border; as he turned to flee, he was immediately shot down. A group of outraged witnesses buried Soldado in an adjacent cemetery, but when they tried to clean up the murder site, they found that his bloodstains could not be washed away. That day a martyr was born: Juan Soldado, deliverer of border miracles.

Located amid derelict and neglected grave sites, Soldado's shrine is an eye-catching piece of folk architecture. A painted bust of the soldier and a Mexican flag command the roof of a light green stucco shack, the entrance to which is garlanded with garish satin wreaths and floral bouquets set in concrete urns. Next door, the actual grave, a bright turquoise tomb framed by astro-turf matting, appears at once festive and melancholy, like the wake left by a passing parade float.

Several pairs of tiny crutches suggest that more traditional miracles aren't beyond

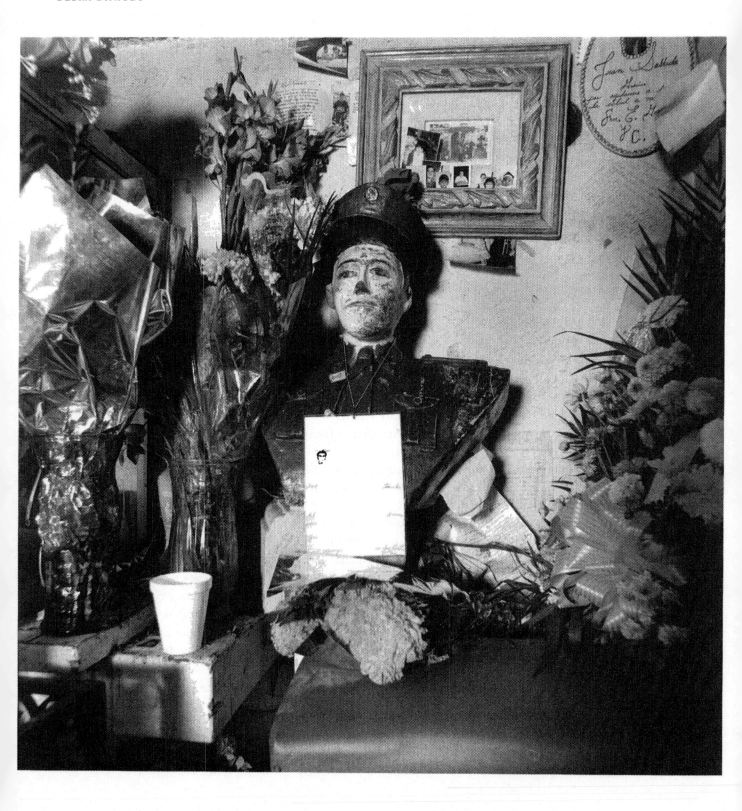

Juan Soldado's ken, but most come here seeking help in immigration matters. The patio and walls of the shack are plastered with testimonials, written on everything from pieces of wood and enamel to stone and paper; most express thanks for safe passage to the US. "Juan Soldado. Gracias por el milagro concedio," is a line that recurs like a liturgical phrase. Many handwritten letters also include more personal items, like an 8×10 photo of the author, or a photocopy showing a family's newly acquired resident alien cards, or a daughter's diploma from a California high school. Tacked onto a side wall, an ancient leather boot and a set of rusted shock absorbers tell stories of adventure, and give anonymous witness to Soldado's merciful intervention.

When I visited the shrine a few weeks ago, two abundant braids of brown hair hung from the doorway, each marked by a piece of masking tape bearing the date "22.7.94." No other information was included. The chopped-off locks dangled like a pair of amputated limbs, hung out to dry in the warm sun. Possibly they were a sacrifice made in gratitude for a successful passage on that date. But how did the hair arrive here? Was it sent back by the North-bound traveller, or was it given in thanks by a local resident for another's crossing? As though a promise had been made: if they make it safely, I will cut off all my beautiful hair.

Within the shrine's dark inner sanctum, a table of burning prayer candles emits a strong scent of wax and cheap perfume. Visitors enter one or two at a time, kneeling to pray before a trio of brightly painted handmade busts of Soldado, as well as ceramic sculptures of Jesus and the Virgin of Guadalupe. A small tableau of toy soldiers recalls Soldado's martyrdom, while a clutter of letters and photos testifies to his current powers. Each testimonial conveys both a private expression of gratitude, and public encouragement to others: with Juanito's help, you, too, can make it to the North.

A number of items in the shrine, such as prayer candles emblazoned with Soldado's portrait, can be purchased from a couple of vendors selling various articles of faith, including Soldado key chains, mugs and pendants, from pushcarts at the cemetery gates. Now that California's voters have passed Prop. 187, which denies state services to undocumented immigrants, business could turn brisk as pilgrims find themselves praying for new forms of assistance such as help in obtaining schooling for their children and access to public healthcare. Perhaps Soldado's cult will continue to grow: as a martyr of military injustice, his appeal to those suffering from social inequity and official prosecution is bound to be strong.

Nor does he have much competition. The Catholic Church has designated a patron saint of television (Clare of Assisi) and of bankers (Matthew), but it leaves border

crossers without a saint of their own. In Tijuana, that symbol of cultural contamination and the world's most visited city, people have taken the matter into their own hands. But can their secular saint protect them in a California that has outlawed the basic miracles of generosity and compassion? Whatever the answer, there seems little chance that Soldado's grave, which is maintained by volunteers, will suffer the fate of its neighbors, all of which have vanished under the bubbling ivy of Panteón No. 1.

November 1994

THE ILLUMINATING DISAPPEARANCE OF ROBYN WHITLAW

In 1967, Robyn Whitlaw, a black conceptual artist, put herself up for sale in a New York gallery. At the time, that gesture alone would have raised a host of issues related to the history of slavery and the exploitation of black women, not to mention the artist's status in a consumer society. But Whitlaw offered herself for sale not as a slave, but as a master. When no buyers came forward, one could only conclude that people in the art world, for all their liberal posturing, were unwilling to let a black woman run their lives.

As April Fool's Day arrives, my thoughts keep turning to Whitlaw, who spent much of her "career," to use a word she abhorred, here in Los Angeles. Though she isn't mentioned in any of the standard texts – Whitlaw emerged in the 1960s and resolutely disappeared shortly thereafter – she produced some of the most cogent art I know of. And some of the funniest. Born in Chicago on April 1, 1940, she seemed to treat her work as an extended joke, or more precisely, a series of caustic pranks in which she married humor to a pugnacious critical sensibility.

During the height of the Vietnam War, Whitlaw's *Monument to the Unknown Artist* (1968) cleverly recontextualized culture itself as a battleground strewn with casualties. Instead of creating a physical monument, she deconstructed one: the Museum of Modern Art. In its entirety, *Unknown Artist* consisted of a recorded tour that radically reinterpreted MoMA's galleries; over the course of a week, Whitlaw managed to

substitute several copies of her version for the official tapes the museum rented out to visitors.

Drawing attention to the absence of work by "unknowns" such as black artists and women, Whitlaw's narrator went on to discuss the museum's "masterpieces" as reflections of the elite's ideological needs. It was a straightforward leftist critique, but the tape also featured moments of lighthearted mischief: visitors were encouraged to fully appreciate the tactile quality of Jackson Pollock's *Number One* by running their hands across the painting's surface. After several groping patrons had been tackled by security guards, MoMA's staff discovered the tapes and destroyed them.

Critic Flora Gruff, who had learned of Whitlaw's connection to *Unknown Artist* through word of mouth, mentioned her in *Artnews* as one of the year's more promising young artists, concluding that "she appears to be one of the brave few who realize that to develop an interesting sensibility, you must first invent your own medium." It was the only review Whitlaw would ever receive in a mainstream publication.

In the years that followed, Whitlaw appeared to be forsaking, rather than inventing, artistic media. On the verge of a promising career, she dropped out of the art scene and in 1970 enrolled in a philosophy program at the University of Saigon. On one level, her action was a political performance, designed to humanize our image of that war-torn country. Whitlaw took her student role seriously, however, and her studies eventually pushed her art in a new direction, or perhaps more accurately, a non-direction. Influenced by a mix of Buddhism and Roland Barthes's writings on "the death of the author," she embraced a zero-degree aesthetic; her new goal was to create work devoid of taste or opinions of any kind.

Back in the States, her first performances consisted of showing up at various demonstrations and holding up blank signs and banners. (She scored a coup when one of her empty placards turned up in a 1972 *Life* magazine picture of an SDS rally.) Intrigued by "non-places and non-sites," she settled in Los Angeles, where she met Charles White, a black figurative artist who had been toiling in relative obscurity since his days with the WPA. Though she wasn't directly influenced by White's work, it was around this time that Whitlaw developed her concept of the "secret artist," an idea which crystalized in the *In-Visibility Project* (1973–78), a series of clandestine exhibitions for which she sent out invitations only after each show had closed.

Besides calling attention to the way artists of color are systematically ignored, the *In-Visibility Project* resonated in the aftermath of Watergate. The notion of the "secret

artist" seemed like a spoof on secret agents and the whole climate of subterfuge which surrounds the manipulation of power in a national security state.

Back in the early '60s, Marcel Duchamp proclaimed that "the only solution for the great man [sic] of tomorrow in art is to go underground." With the *In-Visibility Project*, Whitlaw had clearly staked out the limits of this new frontier – if her work became any less conspicuous, it would be utterly indiscernible. As it was, she was already straddling the edge.

By the beginning of the '80s, Whitlaw's disappearing act had become perilously successful. But in lying low, she had just been setting the stage for a dramatic reappearance. In 1984, against the backdrop of appropriation art's tremendous success, she was arrested for breaking and entering the house of a New York dealer who represented many of the leading appropriationists. During a pre-trial hearing, Whitlaw maintained that if theft could be art – at least in the hands of appropriation artists – then her action, and those of thousands of other thieves, should likewise be judged by aesthetic, rather than penal, codes. Worried about negative publicity, the dealer dropped charges.

Whitlaw had broken the law in pursuit of her art; unlike so many art world radicals, she had proved once again that she was willing to walk her talk, to erase the line between her work and life. With her final series, she took this process one step further, calling the bluff of postmodern theory and identity politics: immediately following her legal confrontation, she enacted her own version of a witness protection program, constantly relocating under changing names.

Signs of these new incarnations have occasionally surfaced over the years. One hears of pieces that seem to bear the Whitlaw imprimatur – a gravestone at Forest Lawn bearing only a bar code, or a 45 record titled "$1.29 Happy Birthday," released on April 1, 1986, by an unknown named Byron Lawwit (an anagram for Robyn W(h)itlaw).

As time passes, I find myself wondering if her disappearance isn't a kind of cop-out, like Duchamp's decision to give up art for chess. Yet from another angle, Whitlaw's evasive behavior, which suggests a fugitive on the run, could be her most subversive statement to date. "In a way, the Negro tells us where the bottom is," James Baldwin observes in *Nobody Knows My Name*. "Because he is there, beneath us, we know where the limits are and how far we must not fall." Make that limit invisible and you may arouse the deepest fears of white America.

So it is with Robyn Whitlaw's vanishing. In the end, Whitlaw disappeared to call

attention to the absence of others. If she left little behind, it's because she didn't want to tie down her thinking to a finite, and definable, body of work; she hoped, instead, that her thought might continue to develop in the minds of those who followed her, whoever and wherever they might be. Art doesn't begin and end in a frame, but lives on in the uses we make of it, a process by which we can change our relations with the world.

It's no joke. But on April Fool's Day, Robyn Whitlaw might want you to imagine that she's a prank you can take to heart.

April 1994

STREET MEDALLIONS

Among industrial structures, the manhole bears one of the more suggestive names on record, conjuring up visions of a gender-specific anatomical portal. The idea of falling into one, a classic motif in comics and motion-picture comedies, is rife with ribald associations – not only on account of the sexual innuendo, but because manholes are wedded in the popular imagination to sewers. Adding an extra frisson to this yeasty semiotic cocktail is a hint of death and decay: as a pathway to an urban netherworld, the manhole evokes a kind of public-service catacomb.

Fortunately for us all, some unsung sanitation genius from the first Industrial Revolution devised the manhole cover, a humble and hardworking piece of streetware that performs its essential duties with an often surprising stylishness. *Manhole Covers*, a book of photographs and text by Robert and Mimi Melnick, offers testimony to that inconspicuous grace, along with an affectionate and obsessive look at an artful world under our feet.

In 1974, the Melnicks published a small tome with the slightly more descriptive title *Manhole Covers of Los Angeles*. As Allan Sekula notes in his foreword to the new work, the Melnicks' original project flew in the face of popular conceptions of LA as a city without depth, a horizontal sprawl lacking subterranean spaces. That regional irony is exchanged in *Manhole Covers* for the authority of a national survey, as the Melnicks cover their subject from Tallahassee to El Paso, from New Orleans to Boston.

In her sprightly introductory essay, Mimi Melnick demystifies the 150-year evolution of this lowly yet ubiquitous lid, while illuminating its underground social history. The

bulk of the book, though, is devoted to her husband's pictures of more than two hundred intricate and exquisite covers. Their elegance is something of a revelation: while the manhole cover may be the symbolic buttplug of the metropolitan body, in the nineteenth and early twentieth centuries it was designed as though it were a piece of refined street jewelry, a 300-pound brooch set into the city's tarred skin. Ranging from whimsical to just plain handsome, their surfaces are emblazoned with stars, crosses, basket-weaves and waffle patterns, as well as Gothic tracery; many bear the stamp of the period's more prominent design tribes, including Victorian, Art Nouveau, and Art Deco.

Practical concerns dictated this visual extravagance: the covers' embossed surfaces were originally designed to provide traction for horses and carriages as well as pedestrians. Other distinctive features, such as glass insets which allowed sunlight below, were also functional. The great diversity of styles, meanwhile, developed as a way of identifying which particular vein a given manhole tapped in the great subterranean network of gas, telephone, water, power, and sewer lines.

Their diversity also reflects the fact that manhole covers were initially produced by thousands of local foundries. "Downtown streets at the turn of the century jumped with a veritable jam session of lids, few of them replicated in nearby towns," notes Melnick. Nowadays, predictably enough, standardization reigns as large companies dominate the market with homely yet cost-effective products. In fact, many of the dazzling lids documented in *Manhole Covers* have already been removed by modernization and rebuilding programs, and in turning the pages of the Melnicks' book, it's hard not to feel regret that this singular adventure in public design – when civic hardware was glamorous – will probably never be repeated. As a result, there's a distinct memorial undertone here, nicely complemented by the quasi-forsenic aura of Robert Melnick's black-and-white photos.

Just as any obsessive enterprise, if pushed far enough, takes on a peculiar weight and torque of its own, the Melnicks' book quietly teeters between absurdity and elegy. The most lyrical images depict covers that have been transformed by the passing years: a vault door, brushed with clumps of tar, resembles a landscape with scattered clouds; a lid bearing the words *Water Gate* looks like it's dissolving in fluid; a cover from Glendale, with biomorphic stains breaking up its embossed grid, has become a delicate abstract composition. These photos remind us of the potential beauty in decay, and suggest that aging isn't simply degeneration, but metamorphosis.

Because most urban planners don't see it that way, early manhole covers will soon

be an endangered species. Mimi Melnick notes that several cities have recently taken to installing customized covers in their historic districts, but these self-conscious efforts (one Seattle lid is bordered by Picassoesque faces) inevitably evoke the simulated past of fake '50s diners and restored shopping arcades. Even the name itself may be in jeopardy, as sundry city bureaus seek to avoid the taint of sexism by using terms like personhole covers, access covers, and sewer viewers.

In the meantime, there's been little attempt to preserve examples of historic lids in any kind of institutional collection – even the American Sanitary Plumbing Museum in Massachusetts has overlooked this compelling artifact. If you wish to eyeball the beauties that still remain, you've got to prowl the museum of our streets and alleyways. Or take a stroll through the pages of this sparely beautiful book.

December 1994

DEBRA DIPAOLO

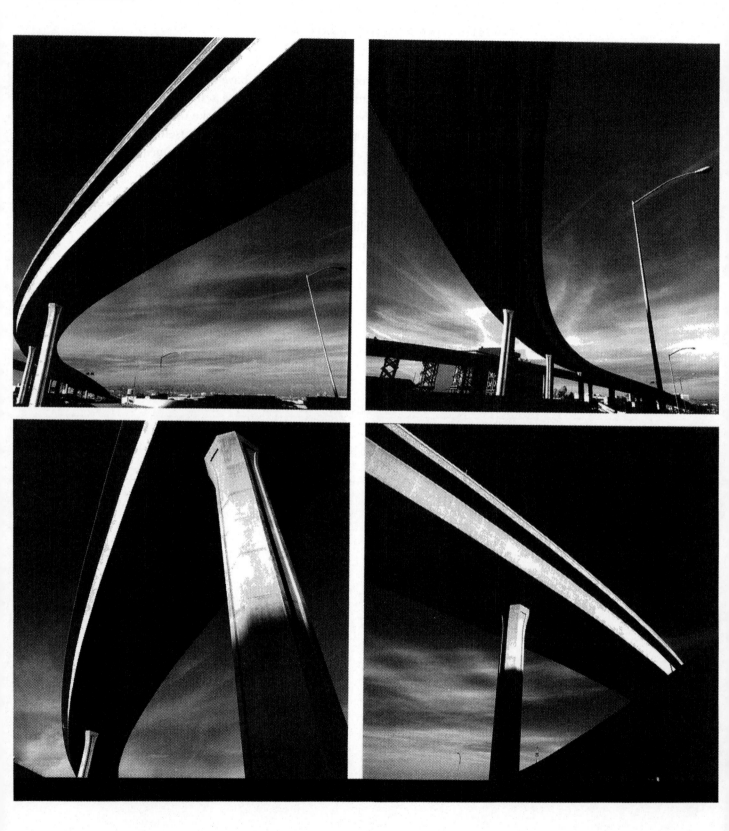

THE LAST PUBLIC SCULPTURE

In California, the birth of a freeway is a semi-mythic event, and its initial appearance is always slightly shocking – as though a bodily growth had appeared overnight to link previously unattached organs. More than thirty years in the planning, the $2.22 billion Interstate 105, also known as the Glenn Anderson Freeway, lays open a new vein for our daily public communion, binding the city's far-flung body with yet one more groove. Stirring a dormant postwar dream of mobility and mass wealth, it may be the last freeway that will ever be built in Los Angeles (private toll roads seem to be the wave of the future). It's also the most awe-inspiring public sculpture we have.

The 105 snakes a mere 17.3 miles from Sepulveda Boulevard in El Segundo to the San Gabriel River Freeway in Norwalk, and en route includes 650 acres of landscaping and 25 miles of well-crafted soundwalls. But it's the freeway's ebulliently sweeping interchanges, which link it to the San Diego, the Harbor, the Long Beach and the 605 freeways, that ultimately demand status as *objets d'art*. The 105–San Diego concourse alone boasts seven miles of smoothly swerving connector ramps reaching higher than a seven-story building. Sailing and singing their way into sinuous loops and twists, the ramps carve through space with alluring, musical lines; like a note held until it thins and curves into another register, they seem to rise towards a lofty future.

Uncannily, these interchanges retain the looseness and audacity of an inspired doodle. Indeed, they seem dislocated from their true medium: their refined trajectories and formal complexities would seem credible on paper, but in their actual imposing scale, they almost defy belief. You feel you're encountering a profoundly

private fantasy that's somehow trespassed into the real world, bursting into three-dimensional existence with a visceral kick that blueprints and computer modeling programs can never deliver.

If you approach the 105 from either the Harbor or the San Diego, bands of elevated freeway appear on the horizon as a vision of serpentine elegance, festooned over your route like a tangle of weightless party streamers. The sight of twisting concrete soaring atop tall, tapering columns is enough to lift you out of your traffic-bound rut; for a brief moment, it evokes the kind of dynamic movement that freeways are supposed to make possible for drivers, but in practice rarely do.

Arcing above the endless flatness of Los Angeles, the 105 insinuates a flight away from the horrors of the surface – the twelve-vehicle pileups, chemical truck spills, drive-by shootings, and the continual rush hour caused by the city's ever-expanding population. It promises to raise you up to a smog-free stratosphere where kinesthetic thrills await on unclogged arterials. Speaking of bravado, grace, and daring, its fluid masses seem to embody a concentrated surge of the city's supressed life force. This is a freeway that lives up to the name, in other words; it's a creative eruption that majestically deviates from the prosaic option of the straight lane ahead. And though it carries an expensive price tag for a piece of sculpture, it gives its audience a priceless feeling, a liberating poetry, which public art rarely tries for, and even more rarely achieves.

December 1994

PART III

A Conspiracy of Vitrines

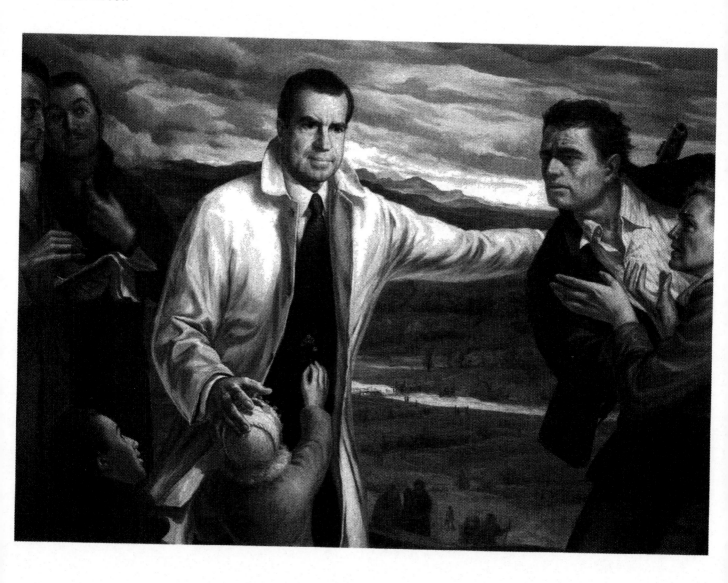

A CONSPIRACY OF VITRINES: THE RICHARD NIXON LIBRARY AND BIRTHPLACE

The Richard Nixon Library and Birthplace promises to make Yorba Linda a mecca for the Republican faithful. For the rest of us, the NLB is a scary and decadent funhouse where the tactics of surrealist exhibitions are seamlessly blended with those of Big Brother. In addition to providing fodder for liberal indignation (the library's exhibits present Nixon as a plucky saint of world peace), the NLB offers a few inadvertently subversive surprises. It's not always clear, for instance, whether the multi-media exhibits in this presidential Graceland were designed to restore Nixon to grace or to entrap him within a kitsch hallucination. More pointedly, the NLB is also a model for the ongoing museumization of America, a conspiracy of vitrines and touch-screen video monitors that one day, if we're lucky, will allow us all to become the curators of our own lives.

While it will eventually house an archive of Nixon documents – minus, of course, Nixon's presidential papers and tapes, which were impounded by Congress – the NLB is foremost a hi-tech pyramid filled with remembrances of Nixon's earthly life. As if inspired by the Borges story about a library containing every book ever written, the NLB includes seemingly every object ever to cross the ex-president's path. A ledger from his father's grocery store, a coat button, a Converse All-Star sneaker on loan from the National Archives – all have been numbered, cataloged, enshrined, and exalted to the status of historical artifact. Numbingly exhaustive, the museum's

labyrinth of video exhibits, memorabilia installations, and life-size dioramas hopelessly entangles the ridiculous and the sublime in a voluptuous, carpet-hushed delirium.

In the library's grand lobby, where tiles of patterned terrazzo glisten under a vaulted ceiling, a window-rail display shows off a collection of mementos from Nixon's youth: a "Dear Dick" note from the back of his high school yearbook; an ancient-looking poker hand Nixon held while in the navy; stained and yellowed letters to young Pat. The eye-opening inconsequentiality of these items, all of which are expensively mounted under glare-proof glass and dignified with explanatory texts, makes it clear that nothing is so lowly that it cannot be redeemed by the Nixon aura.

The date and origin of every trifle is scrupulously recorded, yet some of these seemingly legitimate artifacts are actually facsimiles, meticulously torn, tattered and aged to convey an impression of authenticity. In effect, this kind of chicanery is not much different from the practice of trial lawyers presenting in court visual aids manufactured by specialized "evidence stores." The faked Nixon artifacts are likewise displayed as a kind of proof, in this case asserting the factuality and realness of the library's role as a repository of historical record. But nowhere is the viewer told that he or she is looking at forgeries; instead, the genuine and the fake are glibly interchanged.

It's a policy that may reflect Nixon's own affinity for simulacra – after all, his reported willingness to forge cleaned-up versions of the Watergate tapes may have expressed more than mere disdain for the law. It may also have implied a cynical understanding of modern media. In any event, the NLB's curators seem well aware that tangible bits of evidence, whether genuine or not, have a power to convince and to instill belief that we deny to less concrete forms of testimony. It is precisely this insistence upon the materiality of the real that makes it so easy for us to believe in forgeries.

Many of the NLB's fraudulent artifacts are supposedly duplicates of original articles stored either in the library's vaults or at the National Archives. In the Hiss-Chambers exhibit, however, the relationship between copy and original goes slightly haywire. This display includes a model of the Woodstock typewriter on which Hiss supposedly typed State Department secrets bound for Soviet hands, yet there is little reason to believe that the "original" Woodstock, which is stored in the museum's basement, ever belonged to Hiss; indeed, there has been speculation ever since Hiss went to jail that the typewriter was a manufactured piece of evidence, set in place by the FBI as part of a frame-up. Which would make the exhibited machine a surrogate for a fake artifact, with an unreality quotient worthy of nearby Disneyland.

In the NLB, history is often presented as drama and the world a stage. The most obviously theatrical exhibit is the "World Leaders" hall, in which life-size statues of ten heads of state, who clearly never occupied the same room before, are posed as if engaged in casual conversations. You're free to slide up alongside Churchill and Sadat, Mao and de Gaulle, Meir and Khrushchev, to compare their heights with your own and perhaps to notice that what appeared at first to be bronze statues are in fact *faux* bronzes (a deception accomplished with epoxy paint). By calling up a computerized menu on the handy touch-screen video monitor, you can eavesdrop on these historic figures' private thoughts – all of which, not surprisingly, obsessively revolve around Nixon.

Curiously, there's no statue of the disgraced ex-president himself, although evidence of tribute paid to Nixon abounds. Glass cases that rise twenty-five feet to the ceiling are filled with jeweled baubles, *real* bronze statues from the sixth century BC, rare tapestries and elaborate chess sets – priceless gifts from heads of state. Also included is a work of modern art, an abstract painting by Sonia Delaunay, given to Nixon by Pompidou. Presented in this context, the art is stripped of any aesthetic or historic meaning, and appears as just another trophy in a glass case. (Jeff Koons and Haim Staimback, take note.)

A debased corollary to the "World Leaders" hall is "Gifts of the People," a nook featuring the humble offerings of the powerless, yet faithful. Three display cases are crammed with Nixon fetishes, including homemade Nixon clocks, clothes hangers, crocheted elephants, and several pathetically detailed sculptures of the first family's dogs. Exhibited as signs of the common folk's love for their leader, these items are bizarre enough to create a picture of "the people" as provincial Okies, lovably cute nincompoops who are obviously in need of a strong ruler. As far as the NLB is concerned, there is clearly something embarrassing about the people, their gifts, and perhaps even their role in history – like a discarded afterthought, this small exhibit is shunted off to the side of a large and largely empty recreation of the Capitol rotunda.

The heights of both embarrassment and shamelessness, however, are reserved for the Watergate hall. Narrow, dimly lit and claustrophobic, it's dominated by a glistening black rail-display that suggests a space-age memorial. Three horizontal tiers of text relate a blatantly biased version of the events leading to Nixon's resignation. The use of imagery, though, is much more subtle: partially concealed within the black monolith and unobservable until you're almost on top of them are photographic

portraits of the whole Watergate crew: convicted criminals like Haldeman, Erlichman, John Mitchell, and even Martha Mitchell – characters shown in no other exhibit. What you see, in fact, are not actual photographs, but mirrored reflections of light-boxed transparencies that remain hidden from view.

It's an idiosyncratic installation strategy, one that also crops up in the work of Chilean-born artist Alfredo Jaar. But whereas Jaar employs mirrors to emphasize our distance from the oppressed peoples shown in his photographs, the curators at the NLB are up to something else. They're more interested in dampening the impact of these shameful figures; by showing us only the reflections of images, the exhibit slyly echoes Nixon's contention that Watergate was a fabrication hatched in the mass media's hall of mirrors.

Following the same line, the texts in the Watergate hall portray Tricky Dick not as a tax cheat and lawbreaker, but as an innocent victimized in a tragic witch hunt. While this whitewashing is predictable, it makes unnervingly clear how easy it is, given enough money, to rewrite history. Walking through the NLB's many halls, you may wonder why there isn't a Bebe Rebozo Gallery, or a Teamsters display, or why they've excluded from the many vitrines of campaign memorabilia the notorious "They Can't Lick Our Dick" button. Of course, it's a free country, and since the NLB is privately funded – in contrast to every other presidential library – it can serve up any version of history it pleases. It's all part of the beauty of having your own museum.

Spookier than the distortions of history, though, is the way Nixon himself somehow ends up vanishing from sight. Represented in countless photographic images and historical contexts, the former president has been multiplied into oblivion, leaving an empty core at the heart of his own monument. You certainly won't find any trace of him in his restored birthplace, an idealized white farmhouse so immaculately quaint it seems impossible it was ever anything other than an exhibit in a political theme park.

Overwhelmed and exhausted by the NLB's multi-media assault, you leave wondering what they did with the politician you loved to hate, the man whose gnarled personality had an adhesive contour so unlike Reagan's Teflon surface, a grimy solidity that made him an easier target than the TV mirages of today's political scene. It's worth noting that there are no three-dimensional statues of Nixon at the NLB – no heroic bronzes, not even a bust, nothing you can put your hands around. It's as if he could find grace only as a disembodied icon.

The key to this curious insubstantiality can be found in the NLB's gift shop. Jogging shorts, tennis shirts, ties, coasters and assorted glassware are emblazoned with the signature "RN," written in a stylish script. In the ultimate cultural apotheosis, the former president has become a designer label. In the US, that's as close as you can get to being canonized.

November 1990

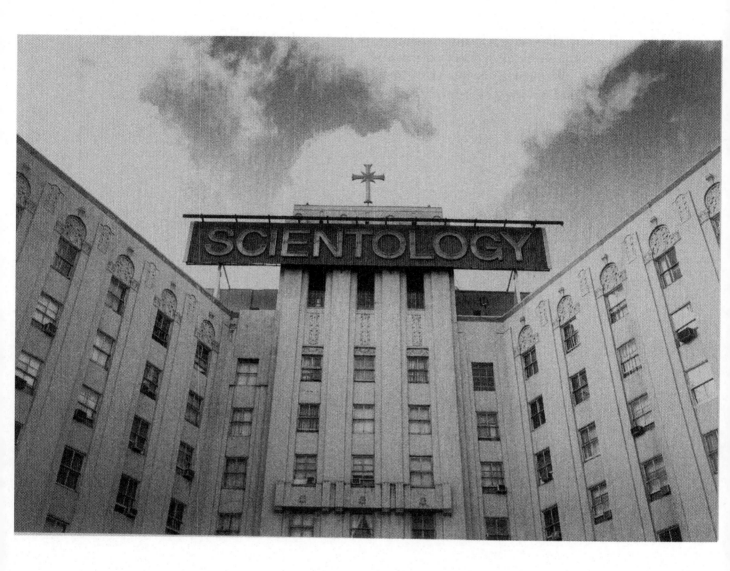

MOTHERSHIP HUBBARD: THE
SCIENTOLOGY COLLECTION

I arrived for my appointment at the L. Ron Hubbard Life Exhibition Hall a few minutes early. Unlike other commemorative mausoleums, such as the Nixon Library and Birthplace, the Hubbard doesn't allow visitors to walk around by themselves; instead, you must sign up for an hour-and-a-half guided tour. Possibly the curators don't trust the unassisted viewer to fully reap the museum's rewards, though the presence of a young guard dressed in the Church of Scientology's special uniform – a khaki outfit appropriate for a paramilitary force – indicates security is also an issue here. Wordlessly presiding over the defense of the lobby is a bust of Hubbard himself, his open, toothless mouth suggesting the appearance of a hooked bass.

It doesn't seem like a very respectful way to represent a cult icon, but then, even a quick walk around the lobby tells you that this isn't your run-of-the-mill shrine. While places like Las Vegas's Liberace Museum seem content to promote the glory of a dead celebrity, the Hubbard's mission of veneration is complicated by an agenda of salesmanship. Where you might expect to find a bronze plaque listing museum founders, there is a wall of testimonial statements from Tom Cruise, John Travolta and Sonny Bono. Books with fiery covers, filling several racks, extol Hubbard's achievements as sci-fi author and Scientology founder. While waiting for my tour guide, I'm also forced to watch a continual video display advertising the museum I'm already in.

On entering the Life Exhibition Hall, my fears of being run through a thinly disguised brain laundry are momentarily put to rest by the first display, an innocent-looking collection of artifacts from Hubbard's youth. A Boy Scout sash

decorated with merit badges, a bugle, and photos of Blackfoot Indians, who allegedly made the six-year-old Hubbard an honorary tribal member, forge a vision of an ideal Western childhood.

This relatively uncommercial interlude is abruptly shattered as my guide, who throughout the hour-and-a-half tour steadfastly maintains the rictus grin of a hardened stewardess, waves her remote control unit and triggers a multi-screen, audio-visual onslaught which has all the bombast of a Desert Storm promo. Juggling pictures of the various cultures visited by the young seafaring "Ron" (as the guide refers to him, because that's the kind of casual cult icon he was), it includes a memorable sequence in which a stone Buddha is repeatedly juxtaposed with a photo of a white-haired Hubbard appearing as sage-like as possible for someone who looks like he could be the retired president of a repo man association.

In like fashion, most of the exhibits at the Hubbard strain to create a picture of the Scientology founder as a larger-than-life action/adventure hero, a daredevil pilot and courageous sea captain, and above all, an author whose diarrheic output suggests either an inspired demiurge or a one-man literary sweatshop. The '40s manual typewriter on which Hubbard gushed out the sacred text of Dianetics is presented as a holy relic, and throughout the museum, we encounter copies of a photograph showing Hubbard clutching a quill pen at his desk, looking as if he were about to sign the Declaration of Independence.

Elsewhere, a full-scale Depression-era newsstand, replete with a cigar-chomping vendor, features endless rows of the period magazines which published Hubbard's pulp fiction. Their lurid covers, featuring buxom, space-suited blondes and robots ejaculating lethal beams from their eyeballs, provide one of the museum's artistic highlights. Disappointingly, the exhibition doesn't include a lovingly detailed recreation of Ron's writing office – probably because three such recreations already exist at the nearby Scientology headquarters where tours are also offered.

Hubbard's most innovative creation wasn't a literary one, however, but an invention called the E-meter, a low-grade lie detector used in Scientology counseling sessions. A large vitrine contains about two dozen models, ranging from the earliest '50s black box model to the latest hi-tech design, which resembles a bathroom floor scale. Nearby, the "See A Thought" exhibit affords the visitor a hands-on trial. After suggesting I relive a painful memory to prompt the E-meter's needle, the guide decided to help things along by pinching me. A few seconds later, the needle swung sharply to the right. "Now try to remember what the pinch felt like," she instructed. I didn't have

to try to remember, I could still feel it. About twenty seconds went by and the needle abruptly jerked again – sure proof that the machine could measure my thoughts.

Though the device plays an important role in Scientology, ultimately it seems more like an offshoot of Hubbard's science fiction, especially when the exhibit's text describes it as "a thousand times more sensitive than existing Earth technology." As an artifact, the E-meter plays to a cultural fear of the unconscious as something uncontrollable, hence evil, which this technology tames and measures through a "rational" system. It's an appealing fantasy because the E-meter obviates the hard work required for any kind of insight. This is part of the lure of kitsch: a scrupulous avoidance of any sign of conflict or difficulty. By promising to synthesize the once-irreconcilable truths of science, religion, and psychoanalysis, Hubbard's device qualifies as kitsch of a particularly ambitious order.

Hubbard's more straightforward sci-fi achievements are celebrated in several space-epic dioramas which bring the Life Exhibition Hall to its camp climax. In one, a giant, gas-masked alien towers over what could easily be mistaken for a Hollywood Boulevard street person – a bearded longhair dressed in leopardskin and a fur cape. When my guide flicks her remote control, they exchange some clunky dialogue and the longhair's chest starts heaving as if he's been sexually aroused. Unfortunately, no one rushes over with an E-meter to measure his excitement.

In an adjacent art gallery, which has been strangely done up as a plastic flower garden, key moments of Hubbard's life are depicted in old-fashioned oil paintings. Each hangs beneath its own miniature awning, and their antiquated aura, enhanced by the timeless quality endemic to bad painting, lends itself to the task of mythicizing. Hubbard is shown hobnobbing with Mongolian bandits and Tibetan monks, and curing fellow patients at a naval hospital, but rather than the subject, what is compelling about these pictures is the gulf between the idealized imagery and its awkward rendering.

As the guide ushers me out under a garlanded archway announcing "The Way To Happiness," unanswered questions seem to multiply in my mind. With its fantasy park ethos, the Hubbard effectively subsumes all earthly traces of its symbolic occupant. Ron himself is curiously absent from the various film and video clips, and in most of the audio presentations his speeches are read by actors. More remarkably, there is no mention of his family life, or even the fact that he was married. (Nor, of course, is there any mention that his wife was imprisoned in the early '80s for obstructing private and government agencies investigating the church he founded.) The

absence of any memorial exhibit – L. Ron departed from his body in 1986 – also seems odd, as if the Hall's curators still wished to shield us from any knowledge of the Founder's human frailty.

Though it's tempting to dismiss the Hubbard as the shrine of a crackpot pseudo-religion, we shouldn't. At a formal level, after all, its vocabulary derives from the heart of American media – the TV commercial, the educational museum, and the sales expo. And in its comingling of faith and art, the Hubbard reminds us that "cult" and "culture" come from the same root, a word meaning "worship." Like the wall of celebrity faces which lines every newsstand, the Hubbard Life Exhibition Hall testifies to the fact that we have yet to build a popular culture which is distinguishable from a cult.

May 1991

THE MUSEUM OF JURASSIC
TECHNOLOGY

Few museums in the world actually flirt with their visitors, and when you encounter such a place, it's very easy to fall in love – not with a given collection, but with the romance of its display. Situated on Venice Boulevard between a realty office and an In-N-Out Burger, the Museum of Jurassic Technology projects an understated dignity at odds with its surroundings, as well as with the monumental architecture favored by most cultural institutions. Inside, the space is as dimly lit as a religious shrine, and on entering its labyrinth of exhibits, the viewer plunges into an enveloping, womb-like obscurity, completely dislocated from the outside world.

For all its kinship to a mausoleum, the MJT is equipped with the kind of state-of-the-art display technology proper to a contemporary natural history museum. Visitor-activated exhibits, multi-media dioramas and other audio-visual presentations chart out an eclectic terrain ranging from a model of Noah's Ark to exhibits on esoteric South American bats and questionable geological phenomena. Traditional glass-and-wood vitrines shelter an array of preserved insects, animal bones, and technological artifacts like the antiquated Boules of Conundrum, a brass mechanism for producing manmade gems.

As you make your way through its shadowy halls, a vaguely disturbing thought arises like a faint scratching at a back window of the mind: while this *is* supposedly a Museum of Jurassic Technology, there are few displays which actually make reference to either the geographic Jurassic (the area of the lower Nile) or the prehistoric time period. Yet the museum's varied subjects are approached with reassuringly meticulous

scholarship. Boorishly academic panels of text legitimize even the quirkiest exhibits, and the voice narrating the audio components is a familiar one: pedantic, slightly pompous, logical and devoid of ambiguity. It's a Voice of Authority, and the moment you hear it you feel you can believe everything you're being told, even when – as in a jungle diorama depicting the self-destructive compulsion of the Cameroonian stink ant – "nature" is presented as a metaphor or parable rather than an object of scientific study. With this flawless delivery, the museum enacts its stated mission of leading viewers "from familiar objects toward the unfamiliar . . . guided along, as it were, a chain of flowers into the mysteries of life."

The MJT's current exhibition, the "Delani and Sonnabend Hall," takes the viewer step by step into the heart of those mysteries. Through a series of theatrical installations, museum director David Wilson chronicles the lives and work of two remarkable individuals from the early twentieth century: Madalena Delani, a classical singer afflicted with Korsakoff syndrome (a disease which destroys short-term memory), and Geoffrey Sonnabend, a memory researcher and physiologist.

Like a Borges fable, the exhibit tells a story of two parallel universes that inexplicably collide. Though Sonnabend never met Delani, he attended one of the singer's concerts in the spa town of Mesopotamia, Argentina, home to the gargantuan Iguazú Falls (depicted in an alluring diorama replete with running water, the sound of which fills the museum with a constant murmur). At one of several "listening stations," we learn that Sonnabend spent a sleepless night after the concert, and that by dawn, he'd devised his eccentric model of memory, which is elaborately detailed in the nearby "Hall of Obliscence."

Did Delani's singing, which contemporary critics described as filled with a haunting sense of loss, inspire Sonnabend's theory of forgetting? Was the melancholy of her vocal expression a result of her own traumatic loss of memory? In a dark chamber of reliquaries that is the exhibit's most poetical installation, Delani's story is recounted by a voiceover narration that hints along these lines. Accompanying the deadpan rise-and-fall biography, illuminated, wall-mounted photographs show the singer at progressive stages of her career, but like the visuals on most PBS documentaries, the information they provide is negligible. Similarly, wood-and-glass cases display a range of artifacts, including sheet music, opera gloves and a velvety concert outfit, which add little to our understanding of Delani's fate. The viewer is left to mull over a grim coda: after giving the concert in Mesopotamia, the singer returned to Buenos Aires and was killed in a car crash.

Is this a true story? One can never be too sure at the MJT, where a number of exhibits – such as a display devoted to a South American bat that uses radar to fly through solid walls – strain credibility. But even when the suspicion arises that fact and invention have been deftly intertwined, it remains impossible to delineate their respective borders. The adage that "truth is stranger than fiction" provides small comfort. Making use of information that lies at the edges of our cultural literacy, the museum functions in a penumbral zone, conflating science and art with a fluidity that makes both categories seem suspect.

Nowhere is this more apparent than in the elegant diagrams used to illustrate Sonnabend's theories. Briefly, Sonnabend held that memory is an illusion and that forgetting, rather than recollection, is the unavoidable outcome of all experience. In other words, we are essentially amnesiacs, and what we call "memory" is nothing more than an imaginative act scaffolded around fragments of lived experience. It is merely a buffer, Sonnabend maintained, against "the intolerable knowledge of the irreversible passage of time and the irretrievability of its moments and events."

Rather than clarify this radical premise, the diagrams suggest models for Constructivist architecture projects. "Planes of experience" penetrate "cones of obliscence," while directional arrows indicate "obverse" and "perverse" experience boundaries, as well as "attitudes" and "altitudes" of experience. Here, as elsewhere in the museum, the language of science and humanist inquiry appears absurdly poetic; its peculiar madness is embraced as a distinctive voice, though not a definitive one.

On one level, the "Delani & Sonnabend Hall" is a rumination on twists of fate. It provokes you to reflect on the unforeseen ways one person's life can influence another's without either person being aware of it. In charting a strange confluence of parallel destinies (among other coincidences, Sonnabend's father had at one time worked on a failed project to build a bridge across the Iguazú Falls), it shakes your confidence in the ability of linear narrative to tell the whole story. It also drolly implies that museums, as repositories of cultural memory built up around "fragments of experience" (to use Sonnabend's phrase), may be no more reliable than Delani's short-term recall. They provide a fictive picture of a history that no amount of evidence will ever retrieve or render accountable.

Of course, the past is only as fugitive as our own transient lives. To quote New York jazzman Jemel Moondoc, "Time doesn't pass, we do." This viewpoint is banished from the fictional universe of museums, where nothing decays and history is served up on a never-ending loop. At the MJT, Madalena Delani continues to sing and crash, and

Geoffrey Sonnabend repeatedly endures a sleepless night before fabulating his fantastic theory. Only in this particular museum, you're not required to suspend disbelief; instead, you're asked to surrender the comfort of certainty, as well as the idea that history and fiction can be neatly separated.

In this respect, it's a deeply romantic place – it turns your world upside down. This kind of romanticism may be the one thing our culture can't tolerate. We want everything to be spelled out, safely packaged for easy consumption. What makes a place like the MJT so magical is that here meaning is mercurial, promiscuous, virile. Nothing is nailed down, not even its own history, which is recorded in an introductory slide show that mentions a "controlled program of expansion," while discussing the haphazard process of acquisition that belies the coherent identity of any museum collection.

On leaving the MJT, the visitor's mind reels with unanswered questions. Is this a real museum or a simulation of one? A science museum or an art installation? And how do you categorize an exhibit like the "Delani and Sonnabend Hall"? As a tribute to cognitive dissonance? By breaking down the categories that structure our "normal" perception, the MJT assumes a power the art world has largely abdicated. Indeed, as demystification continues to be the order of the day, nothing is so unfashionable in art as the idea of mystery. Nowadays, many artists seek to replace that missing weight by attaching their work to weighty subjects: political critiques, issues of race and gender, ecological apocalpyse. But in a world dominated by disinformation – spread by everyone from the CIA to the TV networks – the MJT's labyrinth of confusion offers a far more accurate, and more entertaining, reflection of contemporary experience.

Malcolm X said art functions as a type of anesthetic – Duchamp suggested valium – which may be one reason more Americans now attend museum exhibitions than sports events. As places where logic and order reign as they never will in the streets outside, museums play to our desire for rational explanations, numbing us to the unfamiliar and the mysterious. You're told when and where to look, and what to learn, until all curiosity is immobilized.

One of the remarkable accomplishments of the MJT is how it opens our eyes to the bizarreness of our cultural institutions, which function much like human beings, creating history and meaning from scraps of experience. In the process, the MJT reminds us that we are all far greater artists than we may suspect.

June 1991

JUMP-CUT TO AUSCHWITZ: THE BEIT HASHOAH MUSEUM OF TOLERANCE

"The truth of the Holocaust will never be known." In *The Murderers Are Among Us*, Simon Wiesenthal recalls how this notion was used by SS militiamen to taunt concentration camp prisoners. "Even if some proof should remain and some of you survive," they mocked, "people will say that the events you describe are too monstrous to be believed." This same theme, according to Primo Levi, surfaced in the prisoners' nightmares: in the typical dream, a survivor returned home and told of their sufferings with passion and relief, only to watch their disbelieving listeners turn and walk away in silence.

The enormity of the Holocaust is in part what defies credibility. Its scale was sublime. I don't use this word glibly, but to conjure the idea of a horror so vast as to seem beyond our comprehension. And like any phenomenon that exceeds our standards of proportion, the Holocaust exerts a kind of hypnotic fascination; it remains a subject which can abruptly and totally obsess someone, entering their life as if destined to consume it.

In pop culture, the Holocaust lives on as the object of renewed attention, from the Pulitzer Prize-winning comic book *Maus* to feature films such as *Au revoir les enfants*, and documentaries like *Shoah* and *Hotel Terminus*. Clearly there's more at stake in this continual uncovering and re-working of history than exploiting the dramatic potential of genocide. Besides the struggle to digest an event that most people still consider an

MARK LIPSON

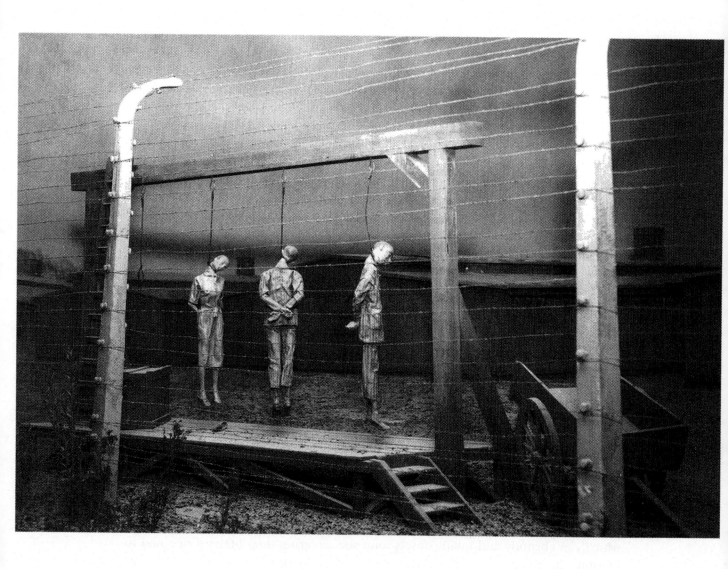

aberration, these pop accounts seem to embody a determination, even a compulsion, not to let the Holocaust fade from memory.

It may be no coincidence that this recent surge of interest occurs at a time when the last survivors of the camps are themselves fading away. But I think another underlying reason is a deep foreboding that in our society of the spectacle, our very ability to remember is on the line. The Holocaust has become a litmus test: to fail it means losing history itself.

The Simon Wiesenthal Center's new fifty-million-dollar Beit Hashoah Museum of Tolerance brings a new angle to the task of remembering. Its stated intention is to renew the relevance of the Nazi atrocities by linking them to current events. Towards this end, the museum is divided into two parts – one dealing with ongoing forms of racism, particularly in the United States, the second focusing on the genocide of World War II (Beit Hashoah means "House of the Holocaust" in Hebrew).

Visitors are welcomed to the museum's 28,000 square feet of exhibition space by a ten-foot stack of TV monitors featuring a manic video host, who abrasively challenges our tacit biases while revealing his own. To move on, you must choose between two doors marked "Prejudiced" and "Unprejudiced." Those with clear consciences who choose the latter find that it's permanently locked.

The main gallery of the Tolerance Center, where contemporary issues are explored, resembles a tony video arcade, replete with design elements like neon tubing, flashing colored signs, and matte black ceilings. Described in its literature as a "conceptual museum," it offers no collection of rare artifacts, but instead appeals to the computer generation with a mesmerizing arsenal of multi-media and interactive exhibits.

The gallery's centerpiece is a group of six video "work stations" which chronicle the 1992 LA riots. A basic control panel enables visitors to access a "video timeline," and to key in specific categories such as "Acts of Heroism" or "Police Response." If the images and truncated sound-bites seem familiar, it's because they've been compiled from TV news footage – now the preferred medium of historical record.

To pursue subjects in greater depth, you can call up a range of first-person testimonies from South-Central residents, Korean grocers, police officers, reporters, and politicians. This *Rashomon*-like approach goes a step further as viewers can enter the data matrix by responding to brief polls; your answers are then compared with the overall responses, which are usually broken down by ethnic group.

Only a few exhibits challenge conventional readings of history. A three-tiered time-line of the United States diverges from the standard classroom model by including a

chart of racial discrimination, while a wall-sized map of "The Other America" lists 250 active hate groups, which can be researched through a touch-screen monitor. But more subtle and pervasive forms of racism, such as the de facto segregation in our school system, are generally overlooked by the museum's emphasis on quick hits and dramatic visuals. And in many exhibits, historical narrative is reduced to a formal exercise: a sixteen-screen display on the civil rights movement transforms documentary footage into a dazzling collage where images are composed and recomposed in elegant geometric patterns. The message conveyed, ultimately, is that the tube shall overcome.

Despite its declared aims, the Tolerance Center shies away from delving too deeply into contemporary bigotry. Few exhibits examine its internal architecture, or the psychological soil in which it's nourished. Nor does the museum included any detailed exploration of racism's long-term consequences, how it perverts the spirit of those oppressed. In *The Drowned and the Saved*, Primo Levi writes that prisoners in Auschwitz were forced to abase themselves – to steal, lie and betray – merely to survive; today, we've re-created this situation for residents of our inner cities, but the museum never pursues this kind of parallel.

In the end, you can't help but suspect that the Tolerance Center, which supposedly reveals the greater share of man's inhumanity to man, exists largely to lure into the museum folks who might not be especially interested in the fate of Jews. In any event, the institution's heart and soul clearly belong to its second, and larger, section, where visitors are taken on a carefully programmed, multi-media journey into the heart of the Nazi darkness.

Entering a dimly lit hallway, we are asked to return to 1920s Germany as witnesses brought back to the scene of the crime. In an initial series of dioramas that owe a debt to the sculptor George Segal, spotlit plaster figures stand in for a historian, a researcher, and a museum designer; through their voiceover discussions, which are accompanied by archival films and slides, we follow the Nazis' rise to power. The use of these figures isn't as self-reflexive as it sounds, however; instead of elucidating the exhibition's layout or historical approach, they simply serve as our bridge into the past, raising and answering typical concerns, such as how average Germans could have countenanced their government's policies, or why more Jews didn't flee the country.

Continuing further into the labyrinth, visitors enter a realm of simulated environments that call to mind the work of Disney Imagineering. A 1932 Berlin café is recreated in a muted palette of black, white and grey, as if it were an old photograph

given three-dimensional form. As a spotlight moves from table to table, we eavesdrop on various conversations that span the political spectrum. A young American woman asks her Jewish friend Ilse if she's worried about the Nazis. "My family has always lived in Berlin. Let's not talk about it," she replies. One of our plaster hosts then informs us that Ilse was later refused entry to the USA, and in 1941 was deported to Latvia and murdered.

Other scenes simulate a devastated street in the Warsaw Ghetto and the barbwire gates to the Auschwitz-Birkenau death camp. A pair of passageways, labeled "Able-Bodied" and "Children and Others," lead on to the Hall of Testimony, a bare concrete room which, though it avoids any exact replication, suggests nothing so much as a gas chamber. The allusion is driven home by a video detailing the camp's brutalizing admittance procedures, as well as the command given to those about to be gassed: "Breathe deep and strengthen your lungs."

These stagey installations strive to add an experiential dimension to history, and to make an emotional statement. Yet given a subject as charged as the Holocaust, the problem would seem to lie in the opposite direction: how not to overwhelm viewers or blind them with horror. Images of extraordinary violence and affliction inevitably shock because they depict a reality far removed from our everyday experience; the challenge is to present these images in a way that doesn't alienate viewers with awe or arouse indignation but connects them to the history they recount.

Granted, this is a daunting task, one that has stumped a large number of the contemporary artists whose work documents social and political crimes, but in the Beit Hashoah, historical material is consistently undercut by the museum's rush to jolt and stun viewers. A film in the Tolerance Center races through three different twentieth-century genocides in ten numbing minutes; despite the triple-screen presentation and ominous synthesized score, the images of depredation, mass graves, and refugee children blur together in a generic picture of suffering, as stripped of context as a Benetton ad.

Elsewhere, though, the museum goes out of its way to personalize the statistical abstractions of genocide. Each visitor receives a magnetic-striped "passport" bearing the name of a child who was directly affected by the Nazi pogrom; at a sequence of computer stations, you can insert your passport and receive a printed biography and picture. The child's final fate is revealed only near the end of the exhibition: not surprisingly, most were among the one and a half million children murdered by the Germans and their collaborators.

Eyewitness accounts are also used to add harrowing intimacy. In the Hall of Testimony, we hear from a woman who watches as her newborn niece is thrown from a high hospital window into a waiting truck; a mother whose child is shot to death while cradled in her arms; a twelve-year-old who writes a letter to God begging for the return of her imprisoned parents. There are also salutary stories of resistance by partisans and prisoners alike.

These stories are individually moving and disturbing, but much of their impact ends up getting lost amid the museum's farrago of multi-screen images, LED displays, and computer-synchronized dioramas. In their anxiety to rivet the short attention spans of the MTV generation, the museum's designers have skirted any in-depth treatment of their subject; they seem to believe that history can only engage us if it's repackaged with the speed and flash of a Nintendo game. Yet in the face of this constant barrage, it's difficult to take anything in, to emotionally digest it – let alone place it in context. The exhibits may hold our attention, but they do so at the cost of losing our hearts.

The most painful irony is that in seeking to document the Nazis' war against memory – which was carried out through book-burnings, censorship, and the dissemination of euphemisms such as "the final solution" – the museum has relied on the tactics and syntax with which our own society cripples our ability to remember. The strategy at work here, while it betrays a profound condescension towards the museum's audience, pervades every level of our public communication; we see it in our merging of entertainment, news, and politics. If we are at the end of history, as some social critics proclaim, it's not because time is standing still, but because historical memory has been displaced by an amnesia-prone culture mired in the eternal spectacle of the present.

Instead of trusting its public, the Museum of Tolerance puts its faith in technology. The Global Situation Room, a stark, glass-enclosed office-cum-exhibit, relays satellite feeds from around the world with the latest news on ethnic cleansing in Bosnia or neo-Nazi activity in Germany. Thanks to the global communications network, it suggests, we're on the alert against racism around the world. But viewers will find no help here in trying to decipher the intricacies of the situation in the former Yugoslavia; despite the brand-new color monitors, history is portrayed here only in black and white.

In the museum's Multimedia Learning Center, which occupies most of the second floor, thirty-one interactive computers allow visitors to browse through the electronic archive, calling up photographs, video, text, maps, and music related to anti-Semitism, World War II, and the Holocaust. The second floor also houses a small gallery where

original artifacts – camp uniforms, Nazi medical instruments, letters from Anne Frank – are displayed, but their impact is minimal; by the time you come across them, the world of things has been discredited by the world of images.

There is an almost irresistible urge to search for lessons in the Holocaust, as if every atrocity in history was guaranteed to have educational value. On exiting the Holocaust museum, visitors are confronted by a sign asking: "Who Was Responsible?" The pictures of ordinary faces that flash nearby suggest it wasn't only nefarious leaders and their devoted followers, but also ordinary people like you and me.

This same theme has already been reiterated by almost every preceding exhibit: we are all accountable for racism and must learn to be tolerant. No doubt, some visitors will find this idea deeply moving, and may even feel that the museum has altered their world view. They might even decide to pick up one of the "tolerance pencils" at the gift store, which come in different shapes and colors, because tolerance is universally a good thing.

Yet one of the Holocaust's enduring "lessons" is in fact the danger of tolerance. The great majority of Germans were not ardent Nazis, but somehow they tolerated Hitler's rise to power and the ensuing enactment of his genocidal policies. The governments of Western nations also tolerated the Nazi regime, at least at first: not one country boycotted the 1936 Olympic Games in Berlin, even though Hitler's infamous Nuremburg laws (which stripped Jews of all legal rights) had been passed a year earlier.

Today, the list of social inequities we tolerate is long and ugly. What we're lacking is not wishy-washy tolerance, but a healthy level of intolerance. This isn't just a question of semantics: as several of the museum's exhibits point out, words are a powerful weapon and like any double-edged instrument, they need to be used with care. Surely, the Museum of Tolerance intends only to simplify things so they can be easily understood by all, but simplistic messages are rarely innocuous. They excise the very complexities needed to understand our situation, and to change it.

February 1993

MARK LIPSON

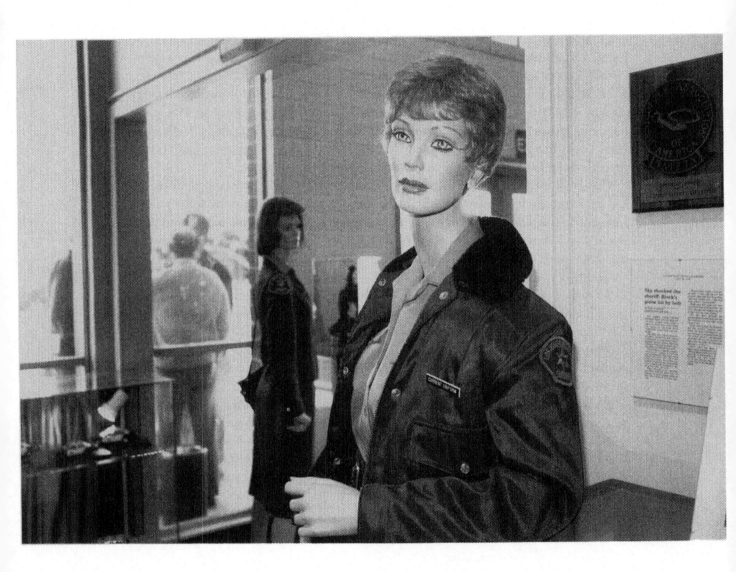

ARRESTED ARTIFACTS: THE LA COUNTY SHERIFF'S MUSEUM

While most major museums are cultural power centers, the power base of the LA County Sheriff's Museum is infinitely more tangible – how many institutions are there, after all, where the curators can actually arrest you? Visiting this peculiar showcase, which hasn't been widely publicized since it opened in 1989, is a bit like entering the official sanctum of a secret society, and though you don't really expect to uncover any significant mysteries here, the Sheriff's Museum offers some surprising insights not only about the department's world view, but also about the nature of museum power and the authority it wields in our lives.

Housed in a former high school along a commercial strip in Whittier (Richard Nixon's former home town), the museum maintains an atmosphere which lies somewhere between a holy shrine and an administrative office. Though it looks like it was put together by a couple of desk sergeants in their spare time, the basic museum rhetoric – vitrines, explanatory placards, dioramas, and video displays – appears to be in place. There's even a gift shop where official souvenirs are sold alongside SWAT-team caps and more useful items, such as handcuffs.

At the entrance, a Naugahyde-like plaque proclaims, "Preserve the Tradition, Perpetuate the Pride," but inside the museum it's never exactly clear what tradition is at stake. The half dozen galleries deal with subjects ranging from the 140-year history of local law enforcement to the occult and Hollywood glamor (among other items, there's a publicity shot of Bette Davis getting fingerprinted). And the exhibits lack a consistent tone: a chopped-down 1969 Hughes patrol helicopter would be right at

home in a science-and-technology display, while a reconstructed nineteenth-century sheriff's office looks like it was borrowed from Knott's Berry Farm. "Live" reality, meanwhile, is continuously piped in from a dispatcher's radio, allowing visitors to hear deputies mulling over detailed descriptions of the latest suspect.

Traditionally, a museum's authority is bolstered by its endless enterprise of ordering, classifying and cataloging, but the Sheriff's curators play fast and loose. Confiscated weapons are displayed without any hint of how, when or under what circumstances they were seized. A maquette of the notorious "Twilight Zone" helicopter crash is accompanied by an inexplicably ambiguous text, which fails to mention even a single person involved. Framed black-and-white portraits are sometimes identified, but just as often not, as if the unknown individual's importance should be instantly clear to the true believer. Such vagueness may be the fault of amateur curators, but it also indicates a prevailing attitude towards facts: "Who needs them?" It's as if the museum were organized by deputies who felt they were answering to a higher calling than secular reason.

In the course of a visit, nevertheless, you do run across an illuminating and eclectic array of "facts," among them the following.

Chief Sheriff Sherman Block once went undercover wearing Ray Milland's hairpiece.

The name of the heavy metal band "AC/DC" stands for "Anti-christ/Devil's child."

The mace, a spiked ball attached to a chain, is a representative weapon of twentieth-century street fighting.

With more than 8,000 employees, LASD is the largest sheriff's department in the world.

Central Jail is the largest prison in the "free world."

The California Nova, a modified four-door Chevy used by deputies, is a "mystical" vehicle.

This last decree is cited in the notecard to a restored patrol car parked by the museum's front entrance. "Mystical" is a peculiar word to describe a tweaked-up Chevy Nova. According to my dictionary, it means "having a certain spiritual character or import by virtue of a connection or union with God, transcending human comprehension." What aspect of the California Nova transcends human comprehension? The heavy-duty radiator? The grace with which the various modifications,

worked out with an editor from *Motor Trend* magazine, blend to produce sublime driver satisfaction?

Throughout the museum, subtle hints convey the impression that you are indeed on mystical, if not holy, ground, and several exhibits demand leaps of faith from the viewer. A section devoted to occultism, which we're (presumably) meant to see as a serious threat to law and order, includes displays of Tarot cards, a Motley Crue banner, a handout from Anton S. LaVey's Church of Satan, Santeria relics, and a variety of plastic dashboard saints. The whole collection is presented without benefit of explanatory notes. The sole commentary occurs beside a xeroxed copy of a tome titled *The Story of Witches*; a handwritten line protests, "This book can be checked out of most *elementary* school libraries!"

Material such as this creates the impression that deputies are waging a Christian crusade, an epic battle of Good against Evil. If the enemy is Satan, they must be modern Knights Templar. It's an attitude redolent of the far religious right, yet in Los Angeles, at least, law enforcement officers seem to be enthralled with the prospect of taking on the occult; the bookstore at the LAPD training academy, for instance, teems with titles on black magic.

As a corollary to the occult section, a number of exhibits canonize Chief Sheriff Block. A charred section of fuselage, taken from an airplane hit by lightning while the sheriff was a passenger, seems to testify to his divine election. Elsewhere, an altar of biographical minutiae includes pictures of meetings with both the Pope and Santa Claus. We learn that St Sherman was the only member of his 1955 graduating class to sport a mustache (another sign of election?), and is an earthy type who can slice bologna with the best (as he's shown doing in an historic black-and-white photo). What can you make of trivia this esoteric? Only a devoted acolyte could say.

Since criminals are the law officer's *raison d'être*, the Sheriff's Museum is inevitably a museum of crime as well. This raises a tricky tactical problem, as vitrines can subversively flatten out moral distinctions. A display of departmental insignia and uniforms, for instance, seems to parallel an equally fetishistic exhibit of gang attire, such as customized baseball hats and bandannas. Instead of delineating the differences between the two groups, these exhibits emphasize their shared passion for symbols of group identity.

The museum also boasts an astonishing arsenal of confiscated weaponry, from personalized switchblades to modified semi-automatics. There's a distinct low-tech appeal to the gangsters' weapons: compared to an assembly-line product, a sawn-off shotgun

exudes brute charisma. Its homemade looks positively radiate "personality," leading you to wonder who it belonged to, when they made it, and what happened to them. Is it the relic of a dead man? The museum offers no specifics, no case histories – evil doesn't deserve explanation.

As if the curators were anxious to avoid any hint of common ground, there's no corresponding array of guns from the Sheriff's Department. Instead, the law is represented through images of "neutralization:" a photographic essay depicts the department's annual destruction of confiscated guns, and one picture even features a bas-relief artwork made from the melted-down weapons. These corrective images distance the museum from the relics of crime which it shows off; they function much like the protective cordon sequestering an adjacent collection of gambling paraphernalia. Yet for all it omits – and this is a very selective institution – the Sheriff's Museum cannot conceal the unavoidable intimacy which exists between the law and death.

The museum contains no straightforwardly memorial exhibits, honoring neither slain officers nor suspects, but uniformed mannequins provide a ghostly presence, hovering in corners as silent effigies. And like a memento to lost youth, a jail register from the 1890s lies opened to a page of faded mug shots of sixteen-year-old boys sentenced for burglary; the shots are frontal, but mirrors angled behind the convicts' heads reveal the profiles of their hardened Boy Scout features. Perhaps it's the mirrors, traditional symbols of a mortal echo, that give you a strong feeling of death lurking in these young, gone faces. A prison log book from the 1940s, which poetically describes a prisoner's "chestnut eyes and wavy hair," also offers a kind of memorial testimony. In details like these, history leaks an incidental lyricism.

The most enigmatic display of all, though, is a severed branch, propped in a lonely corner beneath a text recounting the convoluted history of one Moreta Bay Fig Tree, a giant leafy specimen imported from Australia and now languishing on Shell Oil property in Long Beach. Not until the last line is its significance made clear: the tree was formerly used for hangings. The branch, this seemingly innocent piece from a nature exhibit, proves to be a relic of a primitive death machine, and not even the upbeat soundtrack of Randy Newman's "I Love LA," blaring from a nearby recruitment video, can drown out its macabre ambience.

It seems like an odd thing to find in a sheriff's museum, yet its presence underscores the forensic aspect of official displays, the way objects in vitrines take on the quality of evidence. Just as to the investigator, nothing is ever truly what it seems to be,

but is a clue to something else, so the Sheriff's artifacts are pieces of a missing puzzle, and require us to link their present to a prior history. They provide evidence, in other words, with which we arrive at certain conclusions, but as any good detective knows, the meaning of evidence changes depending on context and point of view, and how one defines a crime. And clearly there is a great deal of missing evidence here. No exhibits examine white-collar crime, and the exploits of women deputies are limited to a single vitrine, which also houses a decorative display of badges from departments around the state. In fact, when you leave the Sheriff's Museum, you probably won't know much more about the workings of the department than when you entered – your visit is largely a pilgrimage to a mecca where disseminating information isn't nearly as crucial as providing serviceable icons.

Which is to say the Sheriff's Museum is basically a religious institution. Its authority, in the end, isn't based on its role as an arbiter of cultural taste or as a repository of historical truth; it derives, instead, from the power of the state. There's a catch, though: in its casual, almost cavalier relationship to facts, this museum reveals how a certain kind of delirium, often assumed to be a token of instability, may be the child of authoritarian order.

January 1992

MARK LIPSON

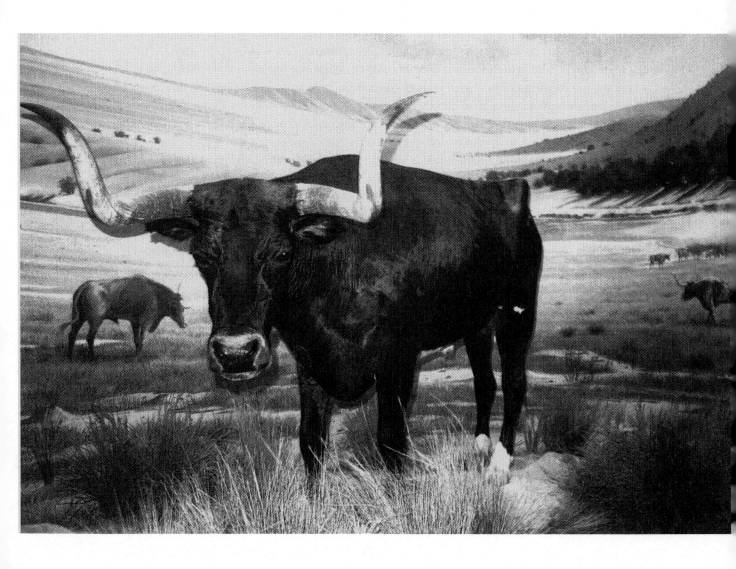

GENE AUTRY AND THE
MARLBORO MAN

"If I were to attempt a criticism of Creation, I would say 'Less matter, more form!' Ah, what relief it would be for the world to lose some of its contents."
BRUNO SCHULTZ, Treatise on Tailor's Dummies

Unlike the Richard Nixon Library and Birthplace or the Liberace Museum in Las Vegas, the Gene Autry Western Heritage Museum is not a personal memorabilia collection, though it does rely on a similarly dizzying curatorial logic in presenting what its literature calls "the legacy of the West." Spanning Frederic Remington to *Gunsmoke*, Buffalo Bill to the Marlboro Man, it's a legacy that's anything but singular. Indeed, at times the Autry seems to chart the various histories of all possible Wests – of the actual geographic area from Mississippi to California, as well as the various Wests of popular imagination. A stuffed buffalo and a rifle belonging to Doc Holliday have their place here, as do Chuck Connor's denim jacket and a pennant for the Redskins football team. Movie props, firearms, religious items, fine art, commercial imagery, folk weavings and TV costumes promiscuously mingle under a single roof – a hallucinatory deluge of matter which effectively obscures history's forms, if not its contents.

Housed in a contemporary mission-style building suggestive of a Santa Fe Hilton, the museum's exhibits are presented in the spirit that "learning can be fun." Purportedly blending scholarship and showmanship, the Autry's seven permanent galleries boast a hoard of push-button video exhibits and theatrical dioramas. In contrast to the museum's airy courtyards, these galleries are maze-like spaces with muted lilac walls and maroon carpeting; their cocoon-like, user-friendly atmosphere is a far cry from the rationalist cube of the contemporary art space.

So are the exhibits. It's no coincidence that many of them, such as a nearly full-scale

reproduction of an entire Western movie set, evoke the West of Disneyland – the permanent galleries were in fact designed by Walt Disney Imagineering. Yet despite an emphasis placed on entertainment, the aim of edifying the public is never completely subsumed; in places, the museum even hints at a revisionist history of the West. Multiculturalist posturing is in evidence in the first gallery, "The Spirit of Discovery," where the viewer is introduced to the various cultural groups "who discovered the West in their own time period."

This relativist notion of "discovery" enables the museum to exhibit a buckskin jacket from the 1850s next to a weaving by a Hmong refugee who discovered the West in the 1980s. Though there are no artifacts from other latecomers, such as the English of the 1930s or the German refugees of the '40s, you get the feeling that a beach towel belonging to Brecht or Thomas Mann would be perfectly at home. The incongruities couldn't get any sharper: a vitrine displaying coal-mining tools and a 1910 Welsh pamphlet entitled "Capital and Labour," stands near a pricey armchair by Thomas Molesworth, a "Western" designer who created outlandish cowboy-and-indian furniture for dude ranches and corporate offices, while an authentic Chimayo rug, its pattern identical to that of the Molesworth upholstery, occupies a neighboring case.

In equating these various "spirits of discovery," the exhibit suggests that the Autry Museum favors no single vision of the West. It's a philosophy that extends to the treatment of both historical fact and Hollywood fabrication. The basic premise, baldly stated, would run something like this: since much of what we know of the West derives from media imagery, Hollywood is as much a part of its legacy as real events. Complicating matters, references to the historical West are presented as irremediably tainted by myth and popular media. As the display card accompanying a Billy the Kid mannequin concludes: "Myth overwhelmed fact, and today, no one knows the real Billy."

At the Autry, no one seems to know the real West, either. The visitor is continually placed in a position of uncertainty: confronted with a full-scale covered wagon, you have no immediate way of knowing whether it's a relic from a wagon train or from *Wagon Train*. A display of ornamental chaps casually juxtaposes "genuine" pairs alongside a pair worn by Douglas Fairbanks; a video exhibit about Buffalo Bill Cody is comprised of clips from Hollywood films. Appearing in a half-dozen other exhibits as well, Cody is a key figure at the Autry, celebrated for transforming the "West" into a transcendent marketing concept. The museum often seems to follow suit, yet elsewhere this mercantile emphasis functions to demystify romantic icons. The descriptive

text accompanying a Thomas Moran painting, *Mountain of the Holy Cross* (1875), relates how the image was prominently featured in promotional campaigns for tourism and railroads around Denver. In contrast to modernist fantasies, art is here situated within the history of commerce; a nearby Bierstadt oil of a lone snow-capped peak inevitably evokes the Paramount logo rather than a West of sublime majesty and freedom.

Umberto Eco has remarked that in popular American museums there is no discussion of history without an accompanying reconstruction, noting that "for history to be received, it has to assume the aspect of a reincarnation." But whereas Eco characterized the exhibits he encountered as "a conjunction of archaeology and falsification," the Autry embodies a different strategy. The museum's fakes and reconstructions are clearly labeled as such, while movie props and costumes are presented not as simulations, but as bona fide Hollywood artifacts. It is an archaeology of the real *and* the false, where nothing is counterfeited other than the visitor's relationship to history. This is the goal of almost any diorama: the past is made present in detailed materiality, as if it were instantly accessible, something we could inspect as actual witnesses rather than recipients of someone else's interpretation.

The Autry's most theatrical exhibit recreates the scene at the OK Corral shootout, replete with costumed dummies, sound effects and a shoot-em-up narration. The particular genius of this museum, though, is manifested in a corollary display, which includes a diagram of the confrontation made by Wyatt Earp. With this yellowed document, the fantasy exhibit would seem to take on an incontestable authority; certainly, in places like the Nixon Library, legitimate artifacts are used to imbue the institution's version of history with the inarguable reality of *things*. The Autry, however, seems less interested in owning history than in discrediting it. An accompanying text reminds viewers that Earp's diagram represents the battle only from the victor's viewpoint; it isn't impartial evidence, in other words, so we are back where we started: history is ultimately unknowable, whereas the realm of legend is a sure thing.

Along with Hollywood artifacts, gun collections dominate the Autry's exhibits. Orgiastic displays of pistols, revolvers and rifles are meant to be admired not only as technological artifacts, but as instruments of myth and works of art (a recent exhibit on Smith & Wesson was titled "Artistry in Arms"). Restored to pristine condition and preserved in glass cases, the weapons appear completely divorced from any notion of function; the glass barrier of the vitrine effectively transforms them into metaphysical items, consumable only as exquisitely crafted images. Exhibits of guns used in movies

and TV shows – weapons which had already been reduced to props – further reinforce this aestheticization, as does the absence of any images of violence. A single black-and-white photo depicting four dead members of the Dalton Gang provides the only graphic evidence of the destruction dealt by the many weapons on display.

There are dozens of other important omissions, among them the absence of any major Native American dioramas or any significant exhibit on the war against Mexico (which led in 1848 to the United States' appropriation of much of the geographic West, including California, Texas and New Mexico). But suppression of information is not the Autry's true modus operandi. On the contrary, careful efforts have been made to render alternative histories largely neglected by pop culture: images of African-American cowboys, for instance, are complemented by an exhibit on racial stereotypes in Hollywood.

This is what is ultimately so disturbing about the Autry: it doesn't need censorship to buttress its Hollywood version of history. It achieves this end by delirium. Any "corrective" information bite is safely drowned out amid an overwhelming farrago of objects, images and text which, taken together, constitute an indecipherable hysteria. The operating curatorial principle seems to be *horror vacui* – smother the holes of history with more artifacts. In this respect, the Autry stands in opposition to what James Clifford has called modernism's "crucial orientation towards cultural order." The museum's tactics are not those of order, but of an apocalyptic clutter.

The Autry's incommensurable avalanche of images and things comprises a degraded sublime, inspiring stupor rather than awe as it surrounds the visitor like a cloying piece of country and western muzak. The museum's contents seem to be infinite, suggesting that the histories they represent are also exhaustive. Though this proves to be far from the case, the deluge efficiently quenches all historical curiosity. You are bludgeoned by the sheer size of the crowd of objects. You are meant to join it, to feel equally anonymous; indeed, this is how the museum has always addressed you – you, a member of the Mass Audience. (It's worth noting that the Autry's oil paintings are all cordoned off with braided rope, isolating the work so that it can be consumed at a distance, en masse. From behind the barrier, the viewer imbibes not only an image but a state of crowd containment.)

The Autry is a populist museum in another important sense: it offers a 3-D approximation of our most common mental construct of the "West." Instead of trying to change the way you think, it's out to entertain by repackaging what you already know. Every design detail reeks of the attempt to cater to an American Family whose members

are easily bored and in need of constant titillation. They are the same Americans addressed by television, and without doubt, this is a museum capable of competing with the fast edits of TV commercials and MTV. In fact, due to the plethora of video displays, an extended visit leaves you feeling as if you were trapped inside a giant television where instead of changing channels by remote, you walk from station to station. The vitrines are simply the still-life equivalent of TV sets.

The Autry, finally, doesn't provide a history of the West, but of Western imagery. It proclaims that it's not important whether an image is factually based, only whether it has staying power. Buffalo Bill Cody may have been a deluded self-promoter who ended up believing the past he invented for himself, but he is nevertheless an immortal star and so transcends the mundanities of scholarly research. Images speak to us, the museum insists, not disputable historical "facts." By comparison to this credo, history seems a parochial concept, of interest only to those in the grip of a neurotic obsession with the past.

In equating image and history, the Autry assumes a strategically elusive position, because it is difficult, if not impossible, to contest a culture that draws no distinctions between fabrication and fact. Here, your closest relationship to history is offered in an interactive exhibit of "movie magic." Sitting on a saddle mounted in front of a blue screen, you watch a video monitor where your image is keyed into a series of chase scenes compiled from various Westerns. Thanks to the miracle of technology, you are inserted into the Wild West, pursued by an ever-changing posse on horseback. In a sense, you are being chased by history, but you know it will never catch up – you escaped from that nightmare as soon as you entered the museum. Now you only need to make sure you're looking at the camera, hopefully smiling back at your own moment of ahistorical stardom.

January 1992

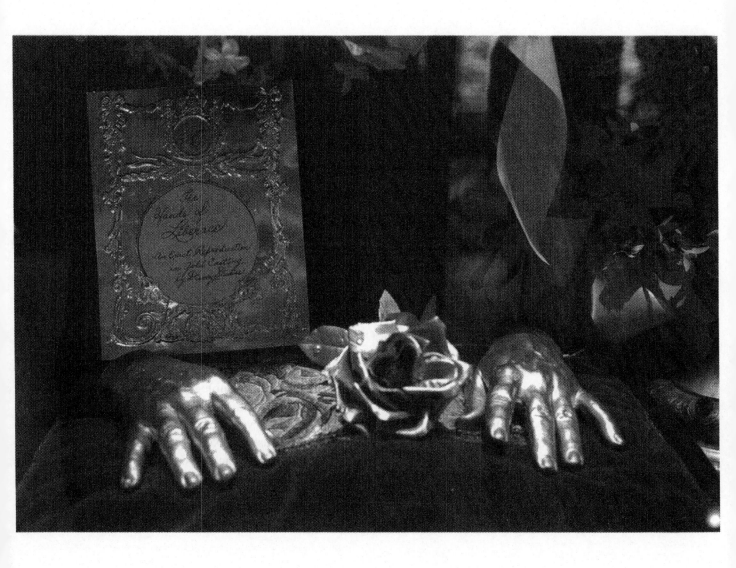

THE LIBERACE MUSEUM

As much as anyplace else in Las Vegas, the Liberace Museum and Foundation embodies the city's schizoid brand of wit, at once dizzy and knowing. For a museum, its location is nothing short of farcical: sunk in a corner mall, it occupies three stucco buildings that in a previous incarnation might have housed a Jack-in-the-Box or Radio Shack. Yet despite its pedestrian setting, the museum is an earnest shrine to Walter Valentino Liberace and the gaudiest of his possessions, among them the world's one and only fifty-pound rhinestone.

While there's a self-consciously jokey aspect to many of Liberace's artifacts, the museum presents even its most outlandish displays with the no-nonsense style of a low-budget car dealership. One gallery actually is a car showroom, featuring seven of Liberace's customized vehicles, among them a 1962 Rolls-Royce Phantom V Landau refinished in mirrored-tile mosaic. Nearby, various stuffed and porcelain animals are displayed on stark plexiglass shelves alongside a wall of celebrity portraits, including a photo-collage of Liberace posing with various Muppets. A painting of Elvis, who like "Lee" had a stillborn twin brother and a penchant for wearing capes, is given special prominence because he's the King. As evidenced by a shoddy prop crown and a purple velvet throne on display, Liberace enjoyed royal pretensions of his own.

Other collectibles on hand include nineteenth-century pianos played by Chopin, Brahms and Liszt; a Dali print; a postcard of the Pope making googly eyes; a copy of Wilde's *De Profundis*; and a script from the *Batman* episode in which Liberace appeared as guest villain. Where appropriate, the museum straightforwardly lists the prices of

these artifacts: you learn, for instance, that Chopin's piano has an estimated value of $100,000, while the Rolls lists at over $1,000,000. Instead of creating an intimidating aura of rarity around its objects, this museum simply tells you how much they cost.

In a mirror-lined gallery, visitors encounter an array of Liberace's glittering stage costumes, which are displayed on faceless silver mannequins. A sequined mink with rhinestones and jewels, a sequined bicentennial hot-pants get-up, and a pink-feathered rhinestone matador's uniform defy easy classification; to say they're "over the top" is a gross understatement. Mixing elements of superhero couture, Versailles dandyism and Hollywood cross-dressing, they appear equally ingenious and mad, like relics retrieved from some Mardi Gras zone on the other side of the looking glass.

A museum brochure cites Liberace's "tasteful opulence," but his costumes and possessions flagrantly contradict any such claim. In a number of instances, including a customized microphone that resembles a sequined dildo, Liberace's *objets d'art* seem more like pranks played at the expense of "good" taste and the pretense of aesthetic hierarchies. Certainly, they were never meant to be taken seriously. "I'm the first to admit my stage costumes have become very expensive jokes, but I have fun with them and the audience shares that with me." That sentiment, proclaimed on a plastic wall plaque, makes it plain that Mr Showmanship's excesses were as much caricature as kitsch; in contrast, his costumed heirs, such as Madonna and Prince, have embraced show-business traditions of glamor with far less humor.

Liberace's brand of cross-dressing has as much to do with class as with gender, but cross-dressing of all kinds is big in Vegas. This is one of the few cities in the USA where female impersonators are headline acts, where *La Cage aux Folles* is an institutionalized dinner show alongside *Les Folies Bergère*. (Vegas itself has engaged in a kind of masquerade since its inception: in Spanish, its name means "fertile, grass-covered plains.") It's no accident that Liberace's museum ended up here: though offically unacknowledged as an influence, the singer has turned out to be the spiritual grandfather of the new multi-billion-dollar Strip. Like its spectacular theme-oriented resorts, Liberace's camp extravagance doesn't challenge us to uncover depths of meaning or eternal truths; instead, it reassures us that everything is facade. Under the house lights, a performing rhinestone is just as dazzling as a diamond.

But celebrity cannot be simulated, there is no ersatz renown; fame is simply a factor of how many lips a given name passes over. To facilitate that process, Liberace chose to use a single moniker, in the manner of the Napoleons and Rasputins, and the various monarchs and popes of history. Today, as you drive down Las Vegas Boulevard,

hotel marquees assault you with the names of other first-name-only celebrities – not just Elvis, Jimi, Janis and the "living legends" regularly impersonated in concert, but also performers you thought were long buried, but who, surprisingly, prove to still be among us. Showbiz stars are perennially resurrected in Las Vegas, but no one famous is ever buried in this city, not even Redd Fox, who lived here, or Liberace, who epitomized the Strip's comical hybrid culture. Our final transformation – death – has no place in Vegas because this city is dedicated to a principle of mercurial and constant metamorphoses. When Liberace succumbed to AIDS in 1987 – a fact that the blue-haired ladies at the museum don't like to discuss – they took his body to Los Angeles' Forest Lawn so that it might finally rest. But the ebullient and glittering circus he left behind on Tropicana Boulevard provides a worthy monument to the aesthetic deity of the new Las Vegas.

March 1992

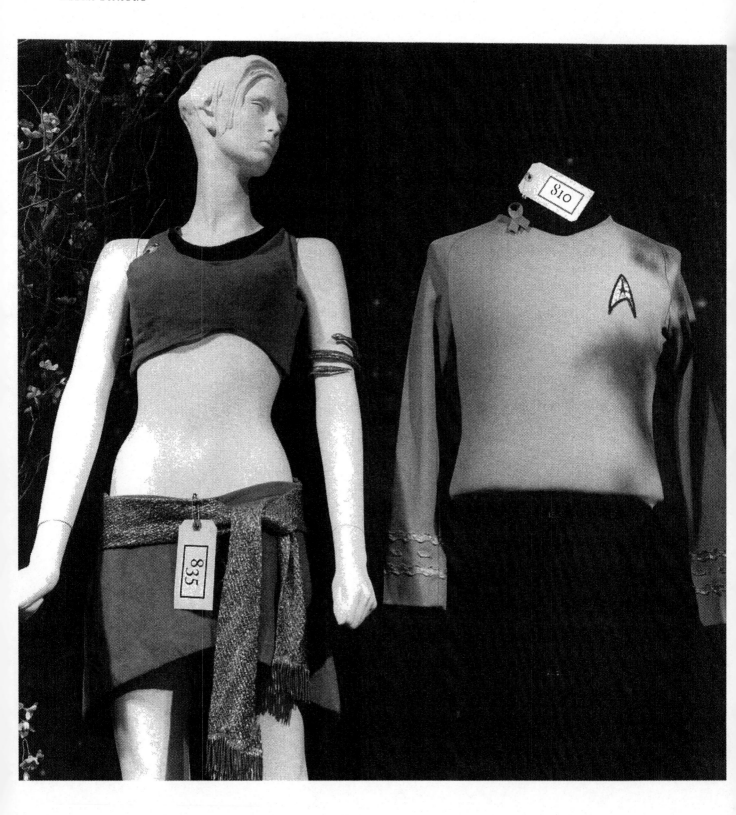

COLLECTING NAPOLEON'S PENIS

There are no limits to what people will collect. We systematically accrue representative samples of everything from matchbooks and doilies to artifacts of historical tragedy. Since at least New Kingdom Egypt, Western homo sapiens has been a collecting animal, and in the marketplace which caters to this activity, it's possible to buy just about anything. Even body parts. And not just anonymous organs and limbs, but pieces of celebrities.

This particular market harks back to the trafficking in saints' relics medieval churches inaugurated. Displays of holy fingernails and bones once drew thousands of pilgrims eager for miracles, but in our time, the body trade has evolved into a purely secular business. Various pieces of John Wilkes Booth are scattered in institutional collections across the country, and at Philadelphia's Mutter Museum – a medical hall of pathological anatomy – visitors can admire a giant tumor that once belonged to Grover Cleveland. Then there's the persistent rumor that gangster John Dillinger's penis lies squirreled away in a pocket of the Walter Reade Army Hospital Museum in Bethesda, Maryland.

Private individuals as well as public institutions barter over such human trophies. A piece of Cortez's pickled body, most of which lies in a glass casket displayed in a Peruvian church, recently surfaced on the market, and a few years back, Dr John Lattimere found Napoleon's penis in private hands, made arrangements to purchase it, and subsequently loaned it to the Columbia Medical School's Urology Department (of which he was then chairman). The emperor's member had supposedly been

passed down by the descendants of Napoleon's pathologist (there's a saying in medicine that the pathologist has the last laugh), yet short of DNA testing, there's no way of determining whether or not it's the genuine article. As with any relic, you can only say it's "alleged."

What drives us to accumulate such items? Unlike works of art, Napoleon's penis isn't a marker of social status. Nor is it something many people would want hanging over their living-room couch. Yet on one level, it epitomizes the collectible, lying as it does at the juncture of collecting and sexuality. The concept of "possession" itself reeks of displaced sexual desire, and private collections not infrequently evince a harem-like aura, as though their coveted objects were so many slumbering concubines, patiently awaiting the gaze and touch of their master. For many, the satisfaction of ownership includes a deeply private and sensual component. In Bruce Chatwin's *Utz*, a zealous porcelain collector explains that "private ownership confers on the owner the right and the need to touch. As a young child will reach out to handle the thing it names, so the passionate collector, his eye in harmony with his hand, restores to the object the life-giving touch of its maker." In museums, on the other hand, the object suffocates in an air-tight vitrine; cut off from contact, it suffers "the de-natured existence of an animal in the zoo."

If collecting has its erotic side, then auctions constitute a high-stakes pick-up scene. The iron law of supply and demand is given a human face at these events, where prices are set only by the competing passions and bankrolls of specific indviduals. By its nature, desire is contagious, and the satisfaction of securing a coveted object at auction is sweetened by the knowledge that you have removed it from the grasping hands of others. Every winning bid is a raw display of power, all the more striking because the procedure is stripped of conventional signs of force; even the most voracious bidders do litle more than flick their wrists. Yet under the surface, this decorum bristles with violent lusts.

At Butterfield and Butterfield's recent auction of *Star Trek* memorabilia, most of the artifacts were themselves unmistakably concupiscent. This isn't the place to examine the underlying thematics of a space ship "that goes where no man has gone before," but suffice it to say that on board the good ship Enterprise, sexuality hummed like radioactive cargo. The erotic life of Captain Kirk and his cohorts was given a significant boost by the show's costume designer, William Ware Theiss, whose extravagant '60s-inspired outfits formed the heart of the Butterfield collection.

Theiss's "bridge wear" for the Enterprise crew was based on classic sci-fi couture; the

uniforms were tight-fitting, buttonless, and made from lightweight synthetic fabrics. His sexier, and more imaginative, outfits were reserved for aliens. Theiss's galactic fashions conjure Liberace in orbit: psychedelic capes and sheer kaftans, often topped with gold lamé and fake fur, surround the wearer in an aura of over-ripe exoticism. Metallic bikini tops and fluorescent mini-skirts were usually either absurdly form-fitting or embarrassingly skimpy; according to the auction catalog, Theiss's "sparse creations" were meant to "barely cover the bountiful female alien form."

Judging from the bidding action, costumes are valued not only for their association with specific stars, but also for their connection to key episodes. Thus a couple of outfits sported by little-known actors sold in the $4,000 range, while a hot-pink and orange dress worn by Teri Garr, a mere celebrity mortal, went for $1,200. Not suprisingly, Captain James Tiberius Kirk's mustard "bridge tunic" pushed the price envelope by fetching $16,000.

For six thousand dollars less, a bidder at Sotheby's auction of Soviet space program artifacts purchased cosmonaut Anatoly Solovyev's space glove, worn during four spacewalks in the early 1990s. The auction took place on the same day as its Hollywood counterpart, but the items on Sotheby's block, which ranged from a Soyuz TM-10 space capsule to a chess set designed for gravity-free games, have a slightly different appeal. To possess any of these artifacts is to own a piece of world history, making you a prop master of immortality.

By contrast, Captain Kirk's tunic seems like a frivolous bit of memorabilia. More so than most other collectibles, memorabilia appeal to us emotionally, providing pleasure because of some link to childhood or adolescent memories; like nostalgia, it hints at fixation and arrested development. But as a pop icon of its era, Kirk's tunic can't be glibly excluded from our cultural inheritance. After all, our lives aren't influenced only by political and technological developments; popular shows like *Star Trek* form part of our "real" history as well. For many, Kirk's tunic is a relic of significant power; indeed, when highlights from the Theiss collection were recently exhibited at the Smithsonian, the show drew over a million visitors. (Curiously, a museum survey found that the audience tended to be slightly better educated than the average Smithsonian visitor.)

Certainly, no *Star Trek* collectible could be more capricious than Sotheby's Lot No. 68A: a remote-controlled roving lunar vehicle, which at present is collecting dust on the moon's surface. It sold for $68,500, a price which presumably doesn't include delivery charges. The lunar vehicle's new owner seemingly occupies the opposite

end of the collecting spectrum from Chatwin's lover of porcelain: possessing something on the moon offers a metaphysical thrill only; it allows you to caress an idea, and the legal fiction of ownership papers.

In some cases, though, the object itself can become almost irrelevant, replaced by the pleasure taken in exercising the urge to acquire. One falls in love not with the collectible, but with collecting itself. Maybe it's safer that way. Collectibles can pose hidden risks: we can possess things, but they can also take possession of us, besieging our every desire until, like a dark rising wave, they obliterate all other concerns. "Things are tougher than people," Bruce Chatwin observed. "Things are the changeless mirror in which we watch ourselves disintegrate."

Or as Norman O. Brown remarked, "Things are shit."

January 1994

PATHOLOGICAL BEAUTY: THE
MUTTER MUSEUM

When you enter a museum of pathological anatomy, you cross a threshold into a world where the most familiar object in your life – the human body – appears as something strange, outlandish, and at times scarcely recognizable. Its consistency, which we often take for granted, is replaced by an endlessly mutating variety of forms. Among the exhibits at Philadelphia's Mutter Museum, one finds a spinal cord shaped like a slithering eel, and preserved sections of diseased skin which resemble topographical maps of a volcanic planet. For the curious lay visitor, these displays provoke an acutely ambiguous response: as we shuttle back and forth between fascination and repulsion, our capacity to identify with the human form is tested as it is on no other occasion.

Part of the College of Physicians of Philadelphia, the Mutter was founded in 1863 as a teaching museum for medical students. Now open to the general public, it houses an extraordinary collection of anatomical and pathological specimens and models, many of which date back to the early nineteenth century. Kits of shining surgical tools used in the Civil War are exhibited near pickled body parts they may once have severed. One wall is adorned with 149 skulls, the collection of Austrian anatomist Joseph Hyrtl, who tried to identify ethnic variations of shape and size. A choice selection of celebrity remains includes a tumor taken from Grover Cleveland's jaw, bladder stones removed from Supreme Court Justice John Marshall in 1831, and a piece of John Wilkes Booth's thorax. A plaster death cast of Chang and Eng, the original Siamese twins, is accompanied by a text explaining that their connected livers were finally separated during an autopsy at the museum in 1874.

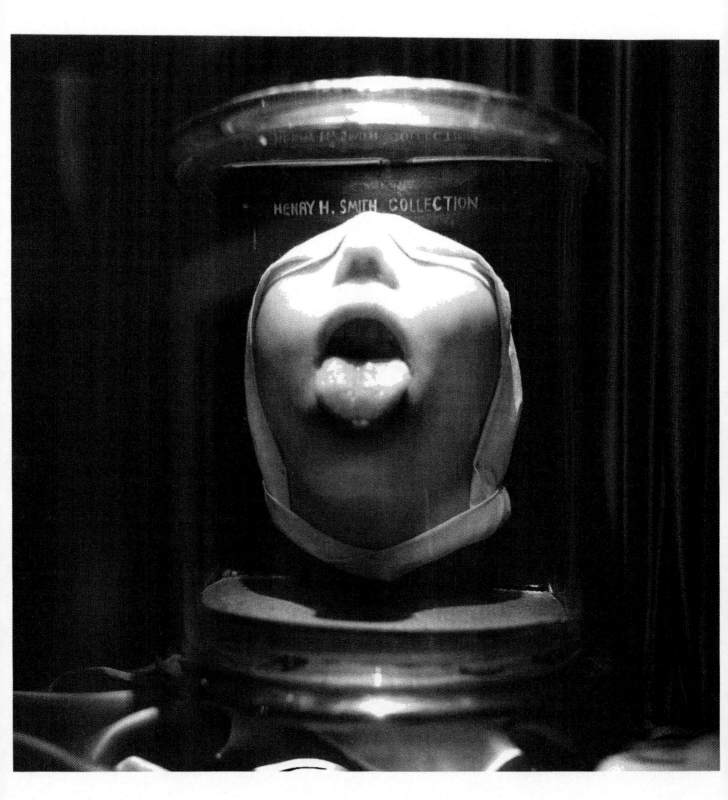

Though all the exhibits are medical artifacts, many specimens – such as a human horn, a spiraling seven-year growth taken from a seventy-year-old woman – evoke creatures from nightmarish myths. And often enough, the Mutter's presentations are so surprisingly elegant that they straddle the line between science and art, beauty and horror. A wallet-sized display of a disarticulated fetal skeleton, made by a Parisian firm in 1880, is a stylishly aesthetic object, and the museum's velvet-lined vitrines, glass bell jars, and exquisitely framed wood cases create an atmosphere that is at once voluptuous and redolent of rational order.

Among the more arresting objects on display are a series of finely detailed, nineteenth-century wax heads. The use of these anatomical models, which were less perishable and more readily available than actual body parts, grew out of an increased demand for teaching specimens. Wax models such as these were intended as visual aids, three-dimensional simulacra in which the ravages of disease could be easily studied. Unlike the more abstract artifacts produced by contemporary imaging technologies, the wax faces at the Mutter possess an eerily lifelike presence and psychological charge; consequently, it's tempting to interpret some of these exhibits as if they were works of art. One blindfolded head, with a protruding tongue dotted with pale syphilitic blotches, could easily be an allegorical portrait of the blind and mocking fool.

On some level, no matter how distorted a bodily image may be, we can't help identifying with it, and at the Mutter this empathetic experience can be one of the more humbling and unnerving aspects of a visit. At some point, many viewers find themselves wondering about the identity of those whose remains have ended up as museum exhibits. What was the story of "Harry," for instance, afflicted with a rare disease in which bone grows around the skeleton, forming a prison around the body within? The accompanying text informs us that Harry served a 39-year sentence before dying in 1973, but we're told nothing of the life he led. And try as we might, it's almost impossible to imagine.

As a teaching model, Harry also tells us a story about the limits of language. The need for visual aids of every kind reminds us that there are areas of learning where words are inadequate. To gain and transmit knowledge of the body's unseen interior, scientists often have to resort to using pictures; and in a teaching college, surgeons – like painters and sculptors – are concerned with educating the eye. Along with artists such as Philadelphia's Thomas Eakins, the occasional physician produced medical artworks, and the Mutter's collection includes some interesting examples, such as a

delicate pastel drawing by Dr Chevalier Jackson, best known as the inventor of several tools for retrieving swallowed objects. Entitled *Peanut in Bronchus Taken During Inspiration* (1928), the drawing features a brownish oblong surrounded by a sensuous vortex of pink and white swirls, and would be at home in any abstract art show. Jackson's own inspiration is elsewhere evident in a radiograph showing a toy battleship caught in the esophagus of an infant, where it appears to be bravely sailing into the body's unknown seas.

The aesthetic refinement of the Mutter's exhibits is no accident. The nineteenth-century pathologists whose work the museum documents were legatees of an Enlightenment enterprise: in the ambiguities of the material world, they sought an unseen and almost metaphysical clarity. Through observation and experiment, they hoped to colonize the body's heart of darkness with the pure and equable substance of rational knowledge. Portraits of these heroes of science, rendered in oils or carved out of stone, preside over the museum's galleries, linking each visitor's gaze to the knowing eyes of history. Displays of medical equipment, meanwhile – which range from an eighteenth-century medical chest to a life-sized model of the first successful heart-lung machine – testify to the ongoing drama of scientific progress.

Yet we are told that the medical establishment has yet to produce a cure for Harry's disease, and after a brief tour of the pathology exhibits, we may question whether our notions of order are little more than a fragile intellectual construct. Clusters of deformed fetuses, used for studying birth defects, offer evidence of nature's caprice, as does a pair of adjacent skeletons belonging to a seven-foot-six giant and a three-foot-six dwarf. To some degree, such sights inevitably confirm our own "normality" by comparison, but the Mutter's gigantic colons and two-headed skeletons can also lead us to contemplate twists of fate, accidents of birth, and the plasticity of all living matter. One's own body, after all, is potentially just as capable of metamorphosing into yet another example of expressionistic biology.

As designed by director Gretchen Warden, the museum discreetly lends itself to such musings. The collection, which was acquired in somewhat random fashion over the last 130 years, isn't presented within a rigid intellectual framework. Instead, it's organized in such a way that viewers often come across information unexpectedly. A sudden encounter with Dr Chevalier Jackson's collection of 2,000 retrieved swallowed objects, neatly organized by file drawer into groups of safety pins, buttons, coins, jacks and so on, will jolt even the most complacent visitor, perhaps prompting memories of childhood's lost relics. More so than most, this museum functions as a kind of

intellectual kaleidoscope – as you twist your point of view, its pieces fall into different patterns.

In recent years, the Mutter has become a mecca for a number of morbidly inclined photographers, such as Joel-Peter Witkin and Rosamond Purcell, who focus on the strange and disturbing beauty of its artifacts. Many of these images, which appear in the museum's annual calendar, evince a sadistic lyricism. *Profile of Sliced Face No. 2*, a platinum print by Gwen Akin and Allan Ludwig, shows a cross-section of a frozen head, cut open along the midline of the skull to expose the brain and spinal chord in relation to parts of the head and neck. The forms are vaguely floral – a stem seems to blossom into a bulbous form, and veins scatter in branch-like configurations – and yet for all their elegance and symmetry, it's almost painfully difficult to accept that this is what we look like under the skin.

It's also an oddly timeless image. We have no clues such as hairstyle, or even facial expression, that might help us date this head. For the most part, though, the museum's collection comprises a specific journey into medical history. Yet in taking us back in time, its exquisite and outdated artifacts unwittingly revive an earlier meaning of aesthetics; originally, this term referred to a discourse of the body, a science of sensuous knowledge whose object wasn't simply art, but the entire realm of physical sensation and perception. It's a definition which makes it difficult at times to draw a clear line between science and aesthetics – a point which the Mutter's myriad specimens underscore with terrifying charm.

October 1994

PART IV

SPECTACULAR BODIES

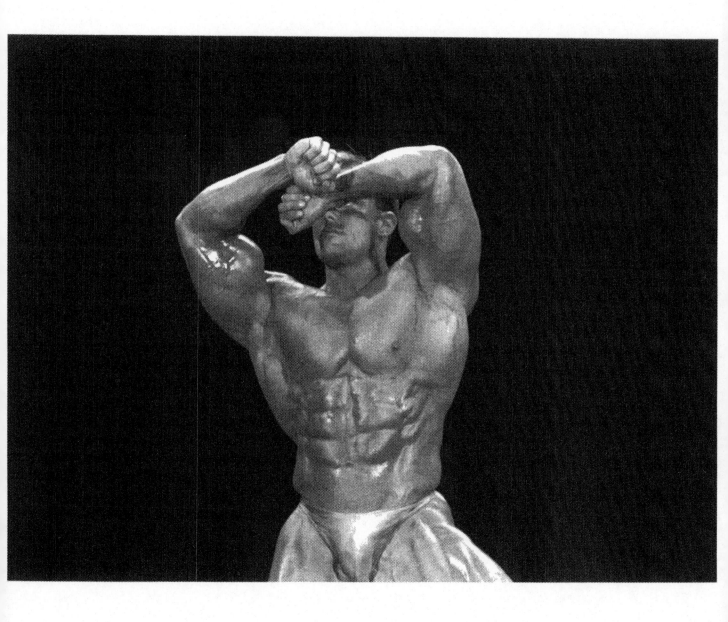

RIPPED AND SHREDDED

At the World Bodybuilding Federation championship, Mighty Mike Quinn – introduced by a promo video that showed him being arrested by the LAPD and breaking out of jail – appeared on stage with his five-foot-eight frame pumped up to 250 pounds of well-greased muscle. "Arrest him for being fat!" a heckler shouted. To the discerning audience at the Long Beach Arena, Quinn was far too "smooth," his body fat content nowhere near the two percent needed to attain a truly ripped-and-shredded physique. For the ideal built body, you want to see veins popping out. You want vascularity and mass. And you want a body that's so diamond hard it suggests an invincible fortress.

The World Bodybuilding Federation (WBF) packages this physique with MTV-style trappings; competitors are introduced in elaborate, multi-media stage shows with rap and heavy metal soundtracks. But bodybuilding itself, at least from an aesthetic stand-point, is decidedly anti-modernist. Nor is the question of aesthetics irrelevant, since the contestants are basically sculpting with flesh. They are both artist and artwork at the same time.

Definition – the degree to which each muscle and body part is articulated as an indi-vidual form – is one of the key criteria used in judging this work. The eventual winner of the WBF championship, South African Gary Strydom, has a body that could dou-ble as an anatomy chart: from his calves to his shoulders, pulsing veins and minutely grooved muscles ripple the surface of his skin, making visible what – on most bodies – lies below the surface. While he poses, a pair of ten-foot-high video screens display close-ups of isolated muscle groups. The crowd applauds for each one.

The idea of a composite body, one made up of autonomous parts, goes against the grain of modernism, which like classicism is based on an aesthetic where the part is subordinated to the whole. Modernist architecture, for instance, discards decorative ornament in favor of stripping structures down to essential forms. So the body-builder's shredded physique inevitably seems slightly distasteful to us, even freakish. It recalls the original meaning of "grotesque" as a term for an ornate decorative style mixing floral motifs with portions of human and animal forms; revived in sixteenth-century Italy, it was considered an affront to classical notions of order.

Bodybuilders, whose static poses sometimes evoke Greco-Roman statuary, are also judged for symmetry and body "flow." Individual muscles are supposed to be developed in proportion, and for exhibition, skin is oiled and all body hair removed to create a slick, unified surface. But in the absence of perfect symmetry, isolated parts pump without regard to the whole, creating an anarchic vision of the body's astonishing complexity.

Making no pretense of natural harmony, the built body is obviously a constructed artifact, the product of a social technology. (Playing off this idea, Jim Quinn, the massive runner-up at the WBF contest, appeared on stage in the role of a computer-assisted futurist.) On one level, it clearly represents a dream of total control over biological functions. Mighty Mike Quinn was booed for being "fat," because, among other defects, he didn't have muscle striations across his butt – an area which, for a crowd of control freaks, is a symbolic minefield. No less a philosopher than Sartre has related the rear end's troubling obscenity to the fact that it sways and moves by itself, out of its owner's purview, but that was long before the 1980s ushered in the aerobic body, which, like the bodybuilder's, is prized not for its sensitivity but for its hardness. It's probably no coincidence that this impregnable aesthetic became popular at the same time the AIDS epidemic was reminding us how vulnerable we really are.

Pumping iron supposedly produces orgasmic sensations in one's muscles, but the built body is really about mastering pain. Between dietary deprivation and stressful workouts that induce vomiting and blackouts, bodybuilders suffer like few other athletes. The V-shape of their torsos is a geometry of pain. It's less a celebration of sensual beauty than the badge of a masterful, triumphant ego.

"In intense suffering the world disappears and each of us is alone with his self," writes Milan Kundera in *Immortality*. "Suffering is the university of egocentrism." In the case of the bodybuilder, whose physical pain can never be shared, suffering reinforces an

underlying narcissism. Near the end of the documentary *Pumping Iron* (1979), there's an unforgettable scene where Arnold Schwarzenegger admits that when his father died he refused to go home and help his mother with the funeral because he was in training for a contest two months away. Being obsessed with your body, he explains with a chilling smile, means suffocating all feeling.

At the WBF championship, recurring military motifs – one contestant strode out on stage firing a machine-gun – underscored the activity's implicit aggressiveness. But in the end, bodybuilding seems like a strange and curiously neutered kind of mastery. Power is reduced to accumulating bulk, as if occupying more space in the world translated into having a firmer grip on life. Most bodybuilders simply wind up looking like prisoners trapped in a monstrous armature of flesh.

Of course, bodybuilding also reflects the desire to exhibit oneself as a work of art. Why else would we have gyms with street-level picture windows? Becoming a piece of art is one way to pursue immortality, yet the bodybuilder's self-display ultimately seems closer to an open-casket viewing: the shredded physique reveals our mortal insides, but as something bone-hard, as if already congealed with embalming fluid. The paradox of bodybuilding is that the taxidermist has stuffed himself.

June 1992

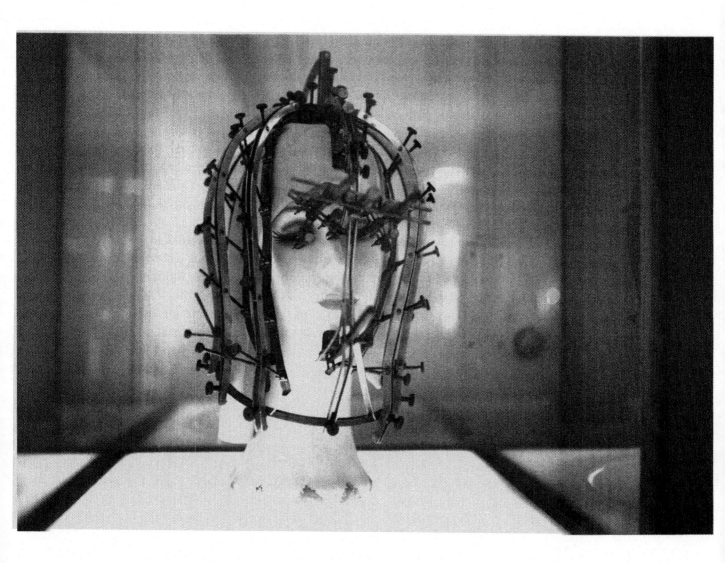

O SUPERMODEL

Dear Claudia,

 Congratulations. As we arrive at mid-decade, you and your fellow Supermodels seem secure in your place as '90s glamor icons. You've become stars in your own right, more noteworthy than the clothes you wear and the products you sell. Fashion layouts now revolve around *your* celebrity: in last month's *Harper's Bazaar*, a lavish photo-narrative recounted Kate's path to fame, and in January, to mark her twenty-first birthday, a retrospective survey of her work will be published. You and Christy, meanwhile, have already been the subject of TV documentaries, while Cindy hosts her own MTV program. Most endearingly, perhaps, your image showed up on a bootleg skateboard edition a couple of years back. Even the dirty dudes of the thrasher world are enthralled.

 With all due respect, I sometimes wonder if all this attention is for the best. I mean, I know I feel good when I behold an image of your extraordinary über-self, but how do I know the collective triumph of Supermodels isn't the final nail in the humanist coffin, the end of our desire for images with meaning and depth?

 "People today have a sense that things haven't worked out in the world, that all the old narratives are tattered and frayed," confides a close friend who follows fashion. "The appeal of Supermodels is that they cut straight to the chase. To the pure essence of being. Remember, it's not what they do that counts, but who they are."

 In other words, while actors act and singers sing, models occupy a special niche because you don't have to *do* anything. You just have to project beauty, which comes

naturally. This is what grace, in its religious sense, is all about: an exemption from the labors of the world, through unmerited divine assistance or favor. Naomi Campbell is the author of a novel, *Swan*, widely believed to be ghostwritten and on which another person holds joint copyright. But Naomi, embracing a postmodern notion of authorship, at least endorsed the novel, like she would any other product, and it's her name that appears in the large type.

We all want to be loved just for being ourselves, and in this respect we all want to be like models. But when I see your image, wherever it may be, I get a personal thrill because it seems you exist only for me. It has to do with the way you Supermodels appear to reveal yourselves for the camera, to let it probe your psyche as well as your skin. Yet at the same time, lest we get too queasily intimate, you remain perfectly self-contained; even when you gaze directly into the lens, you're always somewhere else. *Playboy* pin-ups, by contrast, meet the viewer's eye with a direct proposition – *I'm here, come and get me.* But when I come across your colleague Kate in *Harper's Bazaar*, naked except for thigh-length white patent leather boots and laid out on a bearskin rug, she looks right through me like I'm not even there.

That inaccessible aura is the secret of glamor. Actors, and even the English monarchy, have become too human, and too exposed, to remain truly glamorous. But you models exist beyond scandal's orbit, as remote as silent film stars. That's why the TV series *Models Inc.* is such a dismal failure – besides the fact that its stars could never be confused with Supermodels, the show's back-stabbing melodramas bypass the very heart of your appeal. Models, like heaven, are basically an eventless medium. And like the divine, you defy rational explanation.

Perhaps the word itself tells us something about your appeal. A model can mean a simulation, a prototype, a surrogate for the real thing. A Supermodel is also a kind of simulation, the result of hours of work by teams of stylists, hairdressers, makeup artists, and at a later stage, photographic retouchers. You're a figment of fantasy, Claudia, and we're a culture of fantasy addicts.

When individual models became celebrities in the early '60s, they were part of a distinct cultural moment. Jean Shrimpton, Twiggy, Baby Jane Holzer and Veruschka belonged to a scene encompassing rock 'n' roll, avant-garde movies, pop art, and youth-sprung fashions. But today, Claudia, neither you nor your peers reflect anything so well defined. When Miami designated a Claudia Schiffer Day back in 1990, the proclamation cited that you were the epitome of prettiness, grace, and charm. Beauty is your only content.

No doubt you remember what Nietzsche said on the subject: "To experience a thing as beautiful means: to experience it necessarily wrongly." Because in the face of the beautiful, we inevitably project our own feelings onto the object of admiration. If your beauty masters our emotions, we assume you must be masterful. Because we deceive ourselves in this manner, beauty has developed a shadowy reputation over the years as something not to be trusted, but suffice it to say that no femme fatale ever achieved her ends without the help of a willing dupe.

And who are your dupes, Claudia? The liberal cliché holds that women are oppressed by the attractive images spewed out by the media. All this emphasis on beautiful bodies, instead of vital minds and compassionate hearts – is this how a woman's personal worth should be measured? Yet given the chance, I'm sure you would point out that Supermodels and role models aren't the same thing, and that nobody's perfect, not even you.

At least that was the premise behind *Vogue*'s September cover story, which asked five of your colleagues to list their physical flaws. Naomi, of course, couldn't find any, but Cindy cited a bump on her hand and complained that she looks better with her clothes off. Christy claimed, preposterously enough, to have a beer belly. Since you neither drink nor smoke, Claudia, I feel sure you're spared that particular curse, but I wish you'd been part of that survey. Do you even have a flaw? Your breasts, I've been assured by *Esquire*, are real. What about that guileless overbite?

Maybe you're the girl Max Factor was looking for. His Beauty Calibrator still sits in his Hollywood museum, waiting to measure a perfectly proportioned face. Max never found his ideal, and his strange, baroque contraption, which resembles a device from the Inquisition, remains as a testimony to our cultural obsession with the unattainable. In a society where image is everything, where we live in constant contradiction between what we are and what we dream of becoming, Supermodels help reinforce that conflict – even as you allow us the illusion that we can transcend feelings of envy and powerlessness by losing ourselves in a model world.

We're counting on you, Claudia. Cut straight to the chase.

Yours sincerely,
RR
December 1994

CHILDREN AND OTHER
MINIATURE COLLECTIBLES

During a recent visit with a friend, I heard a startling confession. "I'm worried," he said, speaking about his son. "He's already got a fake smile." The toddler in question is only two years old, but when I studied him, I found myself agreeing with my friend's assessment – his smile just didn't look genuine. It seemed more like a facial tic picked up while auditioning for a kindergarten role in *Melrose Place.*

For all I know, this little boy will probably grow up to be perfectly "normal;" what strikes me about the episode is the nature of our adult response. We felt surprise, and even horror, that a child might have learned to dissimulate at such an early age – which says less about the realities of childhood than our idealized picture of it.

It's not an image of our own making: since the 1850s, modernists have portrayed children as figures of unfettered creativity, innocent of cultural conditioning and true to their unspoiled inner selves. A feigned smile, on the other hand, evokes this happy character's evil twin: the child actor, an icon of pampered corruption exemplified by the Hollywood brat sporting sunglasses and an ingratiating smirk. This underaged idol disturbs our once neat division between adult and child, and if we delight in tabloid stories about former child stars who've turned into heroin addicts or Hare Krishna cultists, it's because, in a roundabout way, they reaffirm our other picture of childhood, the innocent version, by reassuring us that the juvenile actor is indeed an anomaly and a monster.

In the emerging postmodern model, though, kids may find that a fake smile comes in handy. Today's toddler is frequently cast in the role of a miniature adult. Boomer

parents, whether shopping for tiny chinos at Gap Kips or pint-size Harley-Davidson boots at Lorenzo's Kids, are feverishly remaking children in their own image. On the surface, it all seems almost fatally cute: little Mikey in his size two bomber jacket, wearing his own cologne, Ray-Bans, and a '50s ducktail, just like Dad. Stores like American Rag Youth cater to this growing obsession, allowing retro-style parents to outfit their children in vintage clothes such as poodle skirts, mohair sweaters, western shirts, and, yes, leather jackets, which begin at sizes for two and three year olds. Baby Guess, meanwhile, produces denim jackets and pants for mini James Deans, minute conformists in the guise of hip outsiders.

Like other miniature collectibles such as antique furniture and doll houses, the miniature adult offers us a peculiar thrill: it reflects our world in a more finely detailed, and so more perfect, mirror. Dressed in their parents' nostalgia, the child in vintage clothes is the human version of a pseudo-'50s diner like Johnny Rockets. It's a cleaned-up memory designed to restage an illusion of lost innocence. As the first TV generation and the heirs to instant history, boomer parents are afflicted with fetishistic longings for anything which calls to mind their own disappeared past. So much the better if that reminder comes from a piece of their future.

Yet the rise of the miniature adult goes beyond nostalgia. The marketing of kiddie toiletries and perfumes, a new trend in the US and already popular in Europe, speaks to more contemporary concerns. The scented tyke, wearing Guerlain's recently introduced Petit fragrance, is armed for a socially competitive arena, where a seductive image is a tool of power.

To succeed against its fellow contestants, the miniaturized adult also needs a well-engineered physique capable of symbolizing its high-performance orientation. In other words, like Mom and Dad, kids had better head to the gym and get their butts in shape. Conveniently, there are now a range of fitness centers designed especially for youngsters, places like My Gym in Santa Monica, or the Hacienda Heights chapter of Discovery Zone Inc., the nation's first franchised indoor gym targeted at the twelve-and-under crowd. As a press release claims, it's "designed to challenge children to have fun while they develop their bodies." Polymorphous perversity is superseded by a concern with infantile muscle tone.

On the evening news and on talk shows, we encounter the postmodern miniature who sues his or her parents for divorce. What more grown-up image could we ask for? Only, perhaps, that other media favorite – the child as computer wizard, beneficiary of a hi-tech pedagogy and our coming lord and master in the digital universe.

The flipside to this particular vision is the uneasiness we feel about leaving our children with high-resolution babysitters. When company arrives and the kids need to be efficiently dispatched, we sit them down in front of a video, a computer game, or a good old-fashioned TV show. This is tantamount to leaving one's children in the hands of strangers, and in these therapeutic times, when childhood is associated with blame, our reliance on mass media daycare only heightens our disquietude. By remodeling kids into miniature adults, we vainly disguise a vexing reminder, and find reassurance in an image seemingly immune to child abuse in all its forms.

In a culture of narcissism, though, the bottom line is that boundaries between adults and children dissolve. To put it another way, in a culture which infantilizes everyone, there can be no generation gap. We all wear the same style clothing, listen to the same pop music, and wield the same remote to channel surf the same wavelengths. Even our use of language, as in the mainstreaming of Valley-speak, serves to reduce all ages to a common denominator.

Oddly enough, the underlying fantasy that we should all be ceaselessly enjoying ourselves in some hyperactive simulation of childhood adds up to a new kind of puritanism. Pleasure is no longer prohibited, but is now relentlessly imposed as an imperative. Not to be having fun amounts to an admission of social ineptitude, and the price we pay for this is a consuming and corrosive unease.

The single site in Los Angeles that best captures this grim psychic economy is the Disney corporate headquarters in Burbank, designed by architect Michael Graves. Built in 1990, this sandstone-and-stucco monolith features a facade starring the Seven Dwarves as large columns, holding up a classical pediment. But Graves's cartoony architecture isn't remotely playful; instead Sleepy, Dopey, Doc and company evince a monumental solemnity. Like grotesque totems of arrested development, they stand as a forbidding testament to our demand for perpetual enjoyment.

The grimness they convey is apt: our culture of miniature adults and adult children is founded on a harsh repression – and what is repressed is our capacity to take on the full spectrum of emotional life which exists beyond the confines of "fun." Ultimately, compulsive infantilization encompasses a sly and pernicious form of violence. When serial killer Richard "The Night Stalker" Ramirez issued his famous courthouse goodbye, "See you in Disneyland," he spoke with haunting eloquence.

In the end, though – or so we tell ourselves – kids will always be kids. And if worse comes to worse, we can teach our miniature adults how to act the part.

March 1995

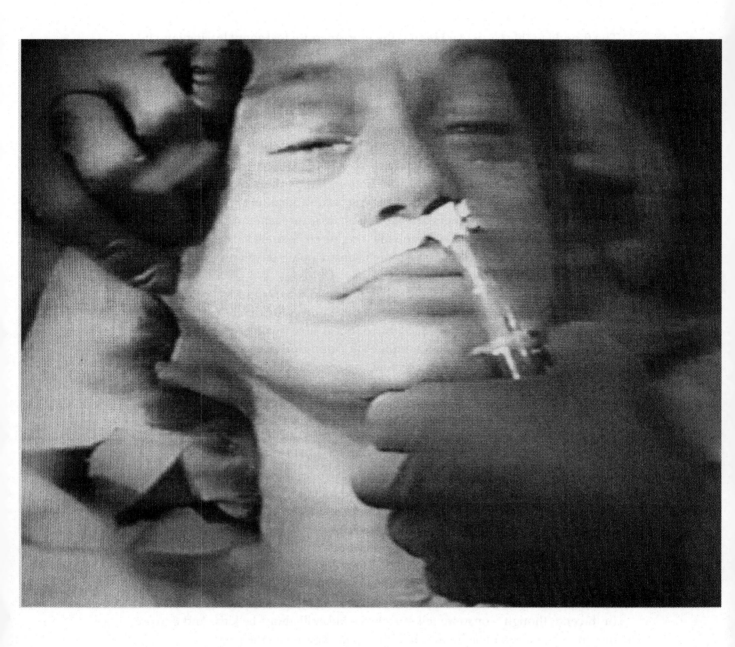

THE SURGICAL REVOLUTION

Is Michael Jackson the Frankenstein of pop? A British jury may soon answer that question. To settle a suit he filed against the London tabloid *Daily Mirror*, Jackson will have to bare his multi-million-dollar face to the scrutiny of the court. After closely inspecting the handiwork of his plastic surgeon, the jury will have to determine whether he's been "disfigured" (as claimed by the *Daily Mirror*) or if he looks no odder than anyone else in the courtroom, excluding, of course, the bewigged lawyers.

Defining "disfigurement" could prove to be a tricky question. Jackson may not have a third nostril and his cheekbones may not take off in different directions when he smiles, but what if the jury decides that plastic surgery has left him looking frighteningly plastic? Not monstrous, perhaps, but inhuman. Yet perhaps that's precisely the look Jackson wanted, the one that best expresses how he feels inside. To this perennial client of the knife, an artificial countenance may be a mask for which he's eternally grateful.

At the Foundation for Facial Plastic Surgery, one of several such associations headquartered in Southern California, the world capital of cosmetic surgery, the concept of face-as-fashion-accessory is a commonplace. At their annual symposium in Newport Beach last month, lectures on the program covered dermapigmentation, the latest in subcutaneous fillers and laser forehead lifts, as well as more esoteric items such as "Management of the Dusky Flap." But the most talked about new trend was "facial sculpting." Whereas traditional plastic surgery was essentially a two-dimensional practice concerned with cutting and tightening, the art of the '90s begins by altering the

skeletal contour of the face. As one panelist declared, as if setting the agenda for the next decade: "I now think in terms of augmentation as much as reduction." Plastic surgery, in other words, has entered the arena of classical sculpture.

Complementing the surgical menu of earlobe trims and liposculpting, a number of relatively new operations utilize solid body props that allow the skin to be draped in a three-dimensional vector, avoiding the appearance of "linear pull." Not long ago, this kind of facial contouring was limited to chin implants, but techniques now exist for building up cheeks, foreheads, and jawlines as well. Even the poor face-lift candidate – someone with insufficient skeletal development – can be remodeled with submalar augmentation, which fills out the face by simulating the appearance of soft-tissue bulk. This surgical revolution has been made possible by innovative implants, many of which are made from synthetic materials like Gortex (a waterproof material popularly used in down jackets and sleeping bags), but the cutting edge in the field, so to speak, may prove to be the use of demineralized bone implants; under ideal conditions, these sculpted parts will graft with the bones in your face. Art and life have never been so close.

In Fay Weldon's *The Life and Loves of a She-Devil*, the heroine's plastic surgeon compares his calling to the miracle of creating life: "To transform the human body, the shell of the soul, was, Dr Ghengis felt, the nearest a man could get to motherhood: modelling, shaping, bringing forth in pain and anguish." But at the Newport Beach symposium, most of the surgeons seemed to see themselves competing not with mothers, but with sculptors. "We now have the ability of sculpting the living," one lecturer declared; another enjoined his colleagues to think of the face as artists do, in terms of "volume/mass entities." Promotional posters for implants, meanwhile, offer ad copy like "Carved by the Master," presumably appealing to self-styled Rodins of the operating table.

Admittedly, this cosmetic discourse is also peppered with choice phrases like "tip projection," and "barrier integrity" (as in "a disheveled epidermis with no *barrier integrity*.") Yet like artists, plastic surgeons – and their patients, who are at once patron, collaborator, and raw material – inevitably make aesthetic judgements. "We all know the ideal configuration for the face is oval," one lecturer blithely asserted, apparently unaware of non-European ideals where a rounder, fuller face is considered more attractive. According to another, the faces worth studying are "the ones that make money" – those of models and stars.

In the particular precinct of vanity occupied by plastic surgery, our cultural worship

of youth takes the form of a veneration of straight lines and smooth surfaces. The vital convexity of a youthful cheek is valued as an assertive geometric form. A "perfect" nose makes a right angle with the face; a "strong" chin is squarish. A body constructed according to these principles – essentially those of modernist architecture – is a sign not only of perfection, but also of power. Why should a man bother getting a chin implant? Not just because most women, according to a study cited during the symposium, will find you more attractive, but because a prominent chin is a symbol of authority, whereas a receding chin signifies weakness, indecisiveness, passivity.

As celebrities increasingly go public about their "aesthetic procedures," the moral taint of plastic surgery, once associated with criminals on the lam and ex-Nazis in Argentina, has diminished. Physically altering one's appearance is now often seen as an economic proposition, a business necessity in a society enthralled with idealized images. Yet plastic surgery still threatens our basic assumptions about identity. "There is no such thing as the essential self, it is all inessential and liable to change and flux," states Weldon's Dr Ghengis, linking plastic surgeons to a major strain in postmodern thought.

Disappointingly, most surgeons in the field, and the clients they service, remain mired in a classical aesthetic. Offered the chance to reinvent themselves, patients mundanely reproduce conventional images of beauty. How long must we wait for the Antonio Gaudi of plastic surgery, or for an avant garde clientele sporting ears that resemble Spock's? In their essentially postmodern enterprise, surgeons could take a lesson from their artist colleagues: instead of simply aiming to duplicate the features of a *Vogue* model, why not borrow elements of beauty from different eras of history? This is precisely what the French performance artist Orlan has been doing for the last decade, reconstructing parts of her body to conform with assorted images from art history.

In *Dr. Adder*, K.W. Jeter's underground science fiction classic, the eponymous hero helps to create a more diverse world by altering his clients' bodies, including their genitals, to correspond with the baroque self-images they unconsciously maintain. Such unconscious images, as any psychotherapist will tell you, are difficult to change, but when biology is treated as fashion, as it is in the world of plastic surgery, ideal images can be treacherously shortlived. During one presentation at Newport Beach, a surgeon showed a slide of a 1960s cover model, and observed that her high angular cheekbones are now out of date, having been superseded by a rounder version. The fad for bee-stung lips – a trend which began in the early '80s, when AIDS created a

desire for genital surrogates – will presumably one day lose favor among white women; African-American women, meanwhile, are seeking lip reductions in increasing numbers.

Cultural ideals aren't the only things that change. The fact is, manmade body parts suffer the same fate as natural ones. "We thought hip implants and breast implants were going to last thirty years. Very few do," one panelist noted. "But what's wrong with having to replace them?" It's not so much a matter of planned obsolescence, but technically, for all its recent advances, plastic surgery is still in a highly experimental phase. In the program's most telling presentation, a surgeon showed slide after slide of his worst mistakes while discussing routine complications from nerve damage to sensory dysfunction. At times, his performance veered on becoming a macabre stand-up comedy routine. "Boy, did I make a mess of this one. Two days later that chin implant had drifted right down to the patient's Adam's apple!"

As a way of altering one's image, rather than one's bodily experience, plastic surgery addresses our desire to provide others with a visual testament of our worth. The body in this case is regarded only as an object of display, a point made comically plain in the trade show galleries where salesmen eagerly demonstrated a new radio-surgery instrument on a piece of rib steak. Andy Warhol, that connoisseur of mass production, hinted at this assembly-line quality of surgical "improvements" in *Before and After*, a 1960 painting based on an ad for the perfect rhinoplasty. On the left side, a woman is shown with an irregular beak; on the right, she appears with an all-American ski-jump model. It's a wry commentary, yet artists are no more immune to cultural ideals than anyone else: about three years before making this work, Warhol had had a nose job himself.

In a world where image is everything, the temptation is to try to become an image yourself; after all, if you can't beat 'em, join 'em. The final picture you leave behind, however, won't be a pretty one. When cremated, synthetic implants melt down into gobs of burnt residue, which can't be poetically scattered to the winds.

September 1992

LUCHA LIBRE: WORLD WITHOUT BORDERS

Compton, Friday, 11:30 pm.

They're like angels with beer bellies, vaguely sinister types who might've been kicked out of heaven for not making the cut-off weight. When these masked creatures fly across the ring and crash, the mat booms like a giant bass drum, rumbling this dingy auditorium with blasts of reverb. The little girl in the next row, pinked out in her best church gear, bends over with her hands clasped in prayer every time somebody makes a particularly noisy splash. As if in answer, her angels keep bouncing back from the dead.

The ritual we're watching is a modern-day mystery pageant, a bellicose masquerade which, on Atlantic Boulevard, plays every Friday night in a converted dance hall where the only decorations are a few stenciled banners and a strobe light. Of the one hundred spectators on hand, about half appear to be under the age of thirteen, and many of them, like the wrestling angels in the ring, wear headgear which could pass muster with the Justice League – dazzling, graphic masks emblazoned with bright trim and flared sequins. You feel like you've walked into a family brawl on Halloween, or a rowdy, all-hours daycare facility.

Lucha libre, as Mexican pro wrestling is called, is less a sport than a journey into a fictional universe where 2,000 characters collide in strange mythological conundrums: Heavy Metal meets Ulises, El Angel Azteca tackles Vampiro Casanova, Hannibal marches against Kung Fu. Though it takes the form of an athletic contest, you can't

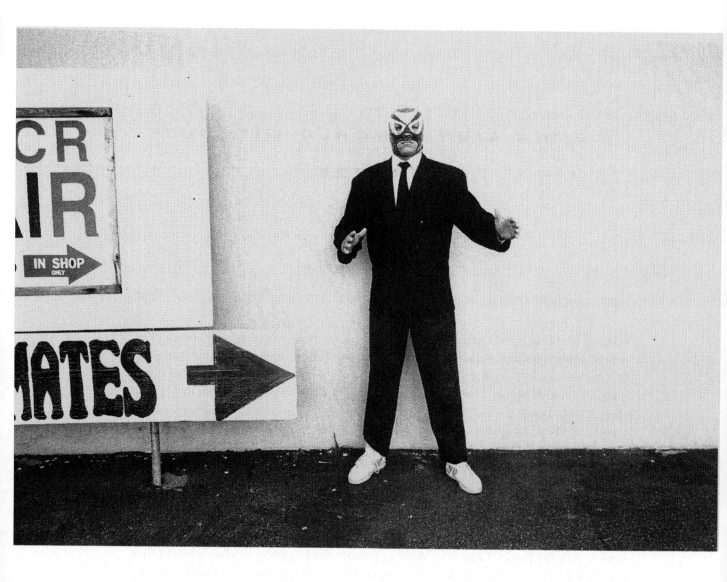

bet on *lucha libre* because, as the audience knows, the outcome is decided in advance. Yet to criticize its lack of "real" wrestling is a bit like faulting Kabuki theater for not being more naturalistic. Mixing elements of pantomime, acrobatics, myth, rock 'n' roll, the history of torture, comic books, and religion (the most popular *luchador* of all time was named El Santo – "The Saint"), *lucha* is a captivating hybrid. It echoes strains of pre-Columbian cultures even as it evokes the aura of carny scenes, freak shows and circus strongmen.

At the heart of *lucha* lies the charisma of the mask. Charisma itself is a promise of transformation – we are drawn to figures who seem to possess the requisite energy and grace to change our world – and in almost every context, masked men are engineers of change. We confront them at times of emergency, or they appear to create such times: executioners, bankrobbers, soldiers in gas masks, Klansmen, Hazmat disposal teams. Their veiled presence spells menace and danger; it reeks of secret powers, and a non-human agency unchecked by laws. You can get away with murder in a mask, and this ethos underlies *lucha*'s outlaw appeal. Watching a match, spectators sense that anything is possible.

Technically, it almost is. In contrast to US pro wrestling, with its power moves, bodybuilder physiques and cartoon theatrics, *lucha libre* emphasizes speed, agility, and an acrobatic style. It celebrates nimble feet and a delirious tempo. Leaping from the ring posts, catapulting off the ropes, three-man teams soar over and into each other like an aerial circus retrained by the Three Stooges. Intricate and brutal maneuvers are executed with the elegance of synchronized swimmers. And at its very best, *lucha* supplies a riveting fable of metamorphosis: the wrestlers' identities seem to be in constant flux, as one moment they're airborne like birds, and the next they're wriggling on their backs like four-legged crabs.

In Los Angeles, *lucha libre* exists in an almost underground scene, kept alive by a handful of smalltime promoters and journeymen wrestlers. To witness the full-blown efflorescence of *lucha*, and to trace its roots, you must go to Mexico, where in his heyday El Santo regularly outpolled the president in popularity contests. Because *lucha* thrives south of the border, and withers in the north, its native life may also tell us something about the different masks worn by our neighboring cultures.

A swarming megalopolis of squalor and elegance, Mexico City is slowly collapsing – and not only in a metaphoric sense. The very landfill on which it was built is gradually caving in, compounding such existing woes as unbreathable air and undrinkable

water. This beautiful sinking city is also the one place in the world where you can find *lucha libre* performances every night of the week, filling venues that range from seedy neighborhood halls to indoor stadiums holding 20,000.

In Mexico, *lucha* is practically a national pastime: approximately 76 million tickets are sold each year in 187 different arenas across the country, and in the capital city it's been a vibrant cultural institution since its beginnings in the early 1930s. At any neighborhood newsstand, you're sure to find at least half a dozen local *lucha* magazines, and in cinemas, wrestling films with titles such as *Vampiro vs the Bats from Mars* are still selling tickets. *Lucha libre* is even the subject of a permanent museum exhibition, where it's saluted as the nation's "most authentic popular urban culture." Yet wrestling today is still a long way from being a respectable bourgeois diversion. "*Lucha* is like the dream of the poor," I was told by an old-time promoter. "It doesn't attract the big money of boxing, but it's spectacular and calming."

On any given night outside Arena Mexico, the city's premier showcase, young men and unescorted children swarm around vendors hawking plastic *luchadores* and homemade masks, and every child who can afford it ends up wearing his favorite wrestler's face. Inside, the ambience is a curious mix of old and new: the stout, cigar-wielding, tuxedoed emcee is vintage '50s, but the fog machines and "Welcome to the Jungle" soundtrack reek of Télevisa's recent influence. (Télevisa, Mexico's giant television monopoly, has recently begun promoting a cleaned-up, MTV brand of *lucha* to middle-class viewers.) I buy a ten-peso ticket and climb up to the upper balconies, which, with a nod to the new regime, have been sealed off with chain-link fencing, putting a stop to the venerable tradition of throwing beer cups filled with piss at the ring below.

There are advantages to sitting up close for matches, such as listening to fans cry out requests for specific holds, which wrestlers sometimes dedicate in the fashion of disc jockeys ("This leg crunch goes out to the lady in row 4"). But *lucha libre* is a theatre of hyperbole, and its exaggerated gestures reach every vantage point in the arena. Even from the ten-peso seats, and probably even from a satellite in space, it's easy to distinguish the *rudos* from the *técnicos* – the two great moral categories dividing Mexican wrestling. Every match pits *rudos*, who brazenly disrespect the rules of the game, against *técnicos*, who seek victory by stoically working within the system.

As a political metaphor, their relationship is instantly comprehensible, and on the surface, most matches seem to allegorize a struggle between good and evil. But the *rudo*'s allure, his ability to inflame the crowd's passions by acting the role of arrogant dandy or cowardly bully, often surpasses that of his clean-playing opponent. If there's

one point *lucha libre* makes clear, it's that charisma knows nothing of morality. The crowd loves to hate a good *rudo*, and a truly talented performer like Negro Casas, one of the *luchadores* heading the bill tonight, can make an audience love or hate them at will. After rousing choruses of boos with an early sequence of dirty moves, he wins us back with a series of straightforwardly spectacular flips and virtuoso pins. It's a remarkable performance in audience manipulation.

Though *rudos* inevitably lose, few matches are unambiguously decided. Often, *rudos* will pulverize their opponents only to be disqualified for foul play, leaving the battered *técnicos* with a hollow victory. The official status quo, in other words, is never simply what it appears to be, and this message may account in part for *lucha libre*'s appeal to the disenfranchised. In its staging of relentless corruption and startling metamorphoses, it holds out a reminder that nothing in this world lasts forever.

Over the last decade, *lucha*'s popularity with the poor has been exploited by a growing number of "social wrestlers." Super Barrio, one of Mexico City's best known masked figures, wrestles not in the big arenas but in the city itself, sparring with evil slum lords and corrupt politicians. Though his true identity remains a mystery, he's one of the city's most popular public figures, and since his first appearance at a 1987 demonstration – two years after the earthquake which left 150,000 people homeless – he's been a potent and whimsical symbol of the struggle for tenants' rights in the *barrios*.

In leading the fight for fair housing, Super Barrio shows up at demonstrations dressed like a Mexican Liberace, sporting gold boots, a shimmering cape, a lace-up mask, and a bright yellow and red bodysuit with the initials SB emblazoned on his shirtfront – an homage to Superman, or perhaps to *luchadores* like Super Astro, Super Muñeco, and Super Porky. As the cartoon ambassador of an unofficial government, supported by those whose reality the actual government continually ignores, Super Barrio mediates between municipal authorities and indigent tenants, and when necessary, rallies crowds to prevent landlords from evicting poor families. Because of his popularity, the police are reluctant to arrest him, and over the years, a number of publicized meetings with cabinet-level officials have endowed him with a certain legitimacy. President Salinas even requested an interview with him during the 1988 presidential campaign.

Hooking up with Super Barrio is a lot easier than tracking down most superheroes; by dialing the Barriomobile cellular hotline, I learn of a rally scheduled later in the day near the Arena Mexico. When I arrive, several hundred demonstrators of various

ages, some carrying handpainted signs with the SB insignia, are already parading behind their portly hero. They are protesting Télevisa's policy of de facto censorship: though Super Barrio has appeared on TV shows in the US, Europe, and Japan, he's been unofficially banned from Mexican television.

Attired in his gold undies and red tights, Super Barrio doesn't exactly *lead* the demonstration; instead, he functions more like the human equivalent of a car ornament, or more precisely, a crowd crystal, exerting a centrifugal force on bystanders simply by virtue of his appearance. Yet when the march later moves to the Superior Court building, Super Barrio reads a speech in a low-key monotone that instantly conveys his status as an average guy. His jelly-roll physique reinforces this impression. Why is the people's wrestler so out of shape? Precisely because he's one of the people. Only the mask transforms the ordinary into the "super." In creating a secret identity to mirror the social invisibility of his constituents, Super Barrio recuperates the potential strength of anonymity in a powerful public form.

You couldn't get away with this act in East LA or South-Central – it would look too much like a low-budget Hollywood stunt. But in Mexico, where the mask has a long history which stretches from national heroes like El Santo and Zorro to Aztec and Olmec priests, the presence of a masked superhero lends the proceedings a charged atmosphere. Aroused by its intimacy with a living effigy, the crowd repeatedly interrupted the other speakers with spontaneous chants of "Su-per Bar-ri-o! Su-per Bar-ri-o!"

Working a line between politics and street theater, Super Barrio engages his opposition on a symbol level, yet his effect in the world is unarguably concrete. "He saved me from being evicted," one of the demonstrators told me as we waited for Super Barrio to emerge from a behind-closed-doors session with housing officials. "Everyone is his friend. Anyone can go to his house for help."

When I approach Super Barrio for an interview, he refers me to Marco Rascón Cardova, a journalist and activist in Asamblea de Barrios, the tenants' rights organization with which Super B is closely associated. Marco is the ideological mouthpiece of Super Barrio, and as I later learn, his Dr Frankenstein. Fortyish, with bright bulging eyes and an infectious laugh, Marco Rascón resembles a hip activist professor; back in the late '70s, however, he spent three years in jail for a bank robbery intended to fund Latin American guerrilla movements, and his involvement in community organizing goes back over a decade.

The next day, we meet for lunch at a VIPS restaurant (the Mexican equivalent of Denny's) where we're joined by an unnamed associate of Marco's: a short, stocky man

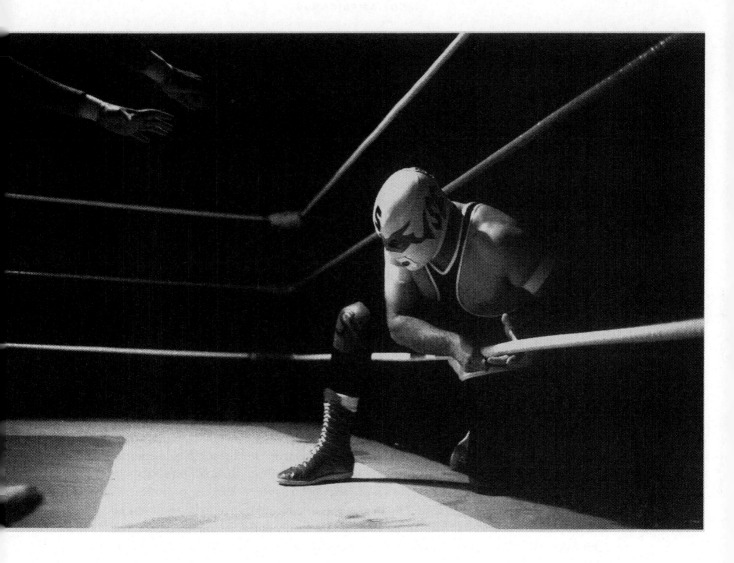

with a squarish brown face and a tranquil demeanor belied only by his relentless chain-smoking. Marco never introduces him, and when I later ask if this is Super Barrio, they both ignore my question.

"The earthquake in '85 led to some very important changes in Mexico City," Marco declares. "Before that, the society here was characterized by its coldness, but in its wake, a great civic movement developed. There were unprecedented demonstrations of solidarity as the government failed to adequately deal with the severe housing crisis caused by the earthquake.

"With this great mobilization, I had a vision of something to do with wrestling, which is popular in the poor neighborhoods. El Santo was always very charismatic in his mask and could draw big crowds wherever he went, so some friends and I eventually came up with the idea for Super Barrio. It was meant to be a kind of prank, something to be used once or twice at most.

"But we were surprised by several developments," he adds with a laugh. "The first time Super Barrio showed up at a demonstration, people weren't sure what to make of him, but once they saw the reaction of the authorities, who were shocked to be negotiating with a masked man, they realized his importance. With Super Barrio, we were able to put the bureaucrats on the defensive, even in their own territory."

From a political viewpoint, the mask also facilitates collective identification; erasing individual identity, it's the property not of a single citizen but of a movement. "Super Barrio is a collective symbol, and his power exists only in a communal form," Marco Rascón acknowledges. "In a way, he is a response to the fascist idea of the superhero. Super Barrio's the contrary of all that. He's not Superman, he doesn't have superhuman powers, he's just an ordinary guy. He hasn't been built up through publicity, but through grassroots campaigning. He's a product of struggle, not of consumption.

"Before Super Barrio, everything to do with social movements had to be represented in a very serious way, with proper respect for the solemnity of the people's struggle," he continues. "All the social movements we see in the US still have this solemnity. The political opposition there is expressed in very humorless, rational terms, but in Mexico, people don't distinguish so precisely between the real and the fantastic. Perhaps we all need to take what Walt Disney has done, and apply it to our own agenda."

The burden of living life as a superhero – even a humorous, leftist one – seems enormous. Was it difficult, I ask, to find someone willing to play the role of Super Barrio?

"Choosing the right person presented a dilemma," Marco replies. "Super Barrio

had to be able to speak well, to know the language of the ring and also the language of politics, and he needed to be somewhat playful as well, to appeal to a popular audience. And on top of it all, he had to have a good physique. Somehow we ended up with this young provincial guy who was very shy and a little overweight, but once he put on the mask, he was transformed. It was like he became a different person."

At this point, Marco's anonymous associate pipes up for the first time. "There are indeed two separate personalities, which sometimes are not at all alike. When Super Barrio puts on his mask, he can't abandon his defined character, it's part of his job. He has to try to be understanding at all times, to deal with everyone very respectfully, whether it's a drunk in the street or a high dignitary. He is very calm, and he doesn't call for rash actions. Instead, he encourages people to think things through.

"But when he takes off his mask, he's a very different person. Super Barrio without his mask is often bitter and angry, he's impulsive, and what he can't do with the mask on, he does when he takes it off."

For Super Barrio, clearly, a mask isn't something to hide behind, to wear while carrying out scandalous actions; on the contrary, he's allowed to indulge his whims only when "wearing" his own features. Tellingly, this curious reversal of the mask's power is echoed in Superman's predicament: as a public hero, he maintains a hands-off policy towards Lois Lane, and can pursue her only as Clark Kent. Marco smiles when I bring this up. "People ask us all the time, what's the difference between Superman and Super Barrio? The answer: Super Barrio exists!"

The Museo de Culturas Popular is a municipal museum at the edge of Mexico City's elegant Coyoquan suburb, not far from Frida Kahlo's house. In 1992, the museum installed a permanent wing devoted to the world of *lucha libre*, spanning everything from its historical roots ("*La Lucha en Mesopotamia*") to modern-day novelties like midget wrestling (a popular gimmick in most *lucha* promotions) and a gallery of wrestling-inspired artworks. A Wrestling Hall of Fame features fully costumed waxworks of *lucha* immortals, and an homage to the seventy-eight registered women *luchadoras*, who until a few years ago were not allowed to wrestle in the city limits.

One of the museum's most informative exhibits lays out a typology of *lucha* masks and personas, encompassing figures from history (El Trojan), literature (Dracula), astronomy (Alfa Centauris), religion (El Santo), medicine (Dr Wagner), mythology (Zeus), drama (Pierroth), nature (Hurricaine Ramirez), as well as animal characters (Felino) and representations of the sublime (El Misterioso).

In wrestling, as elsewhere, there are no limits to the identities made possible by masks. One of the ring's greatest gimmicks played precisely to this endless semantic horizon: Mils Máscaras ("A Thousand Masks") used to wear a different costume every time he wrestled. While each mask worn by Mils generated the certainty of a static icon, it also implicitly hinted that identity is unstable and elusive, not only for the *luchador* but for his die-hard fans as well, whose allegiance to a shape-shifting wrestler demanded a flexible psychology of its own.

In Mexico, *luchadores* never take off their masks in public. For television interviews, they will show up in three-piece suits, but with faces still covered; in movies, the wrestling hero will keep his mask on whether he's taking a shower or seducing his leading lady. And there's no greater dishonor in *lucha libre* than to be stripped of one's mask in the ring; once publicly exposed in a mask match, the loser can never cover his face again.

What is lost is not only a second skin, but the *luchador*'s purchase on immortality. "My mask has formed every aspect of my life – as a man, an adolescent, as the head of a family, as a professional. It has become part of my body, part of thoughts and dreams, even part of my soul," writes Blue Demon in one of the exhibition texts. To forfeit the mystery of the mask, then, is to lose one's very soul.

On a public level, it also entails the sacrifice of a legend. In *lucha libre*, popular personas are often passed on from generation to generation: El Santo, for instance, begat El Hijo del Santo, who went on to assume the family mask and all its glory. Like the protagonist of a ritual, the man wearing the mask is merely the latest incarnation of a larger tradition. Dynasties are created in this way, founded on anonymity, and their destruction is a traumatic event. When El Hijo del Santo's wife, in the midst of messy divorce proceedings, released photos showing the man behind the mask, tabloids across Mexico ran screaming headlines declaring "The End of the Legend!"

A curious thing happened, though. The story was of course denied by El Hijo's promoters, and in the face of that denial, no one could prove whether or not the photographs were indeed the genuine article. To show them to be fakes, after all, El Hijo would have to be willing to de-mask in public. But like his father of legend, he exists only as a masked man, in a symbolic realm beyond proof.

Because it reduces the play of human features to a static tableau, a mask inevitably evokes the eerie authority of our earliest figurative sculpture – the face frozen in rigor mortis. In *lucha libre*, however, every wrestler seeks to turn his opponent's features

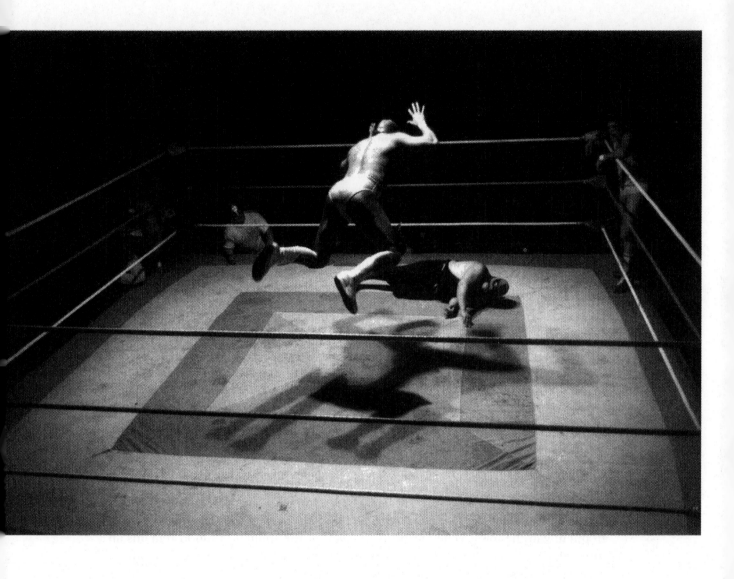

into a writhing mass of pain. And this exhibition of suffering is not merely a by-product of the fighting, but its very aim. In each match, every wrestler is reduced at some point to a state of absolute abjection, to a posture of ruin from which no resurrection seems possible. "In wrestling, as on the stage in antiquity, one is not ashamed of one's suffering, one knows how to cry, one has a liking for tears," notes Roland Barthes in his unsurpassed essay on pro wrestling.

In this caricature of distress, the wrestler moves through *lucha*'s own Stations of the Cross, often seeming to cooperate with his torturers, assisting them as they drape his body over the corner ropes to keep him vertical for another pummeling, or lock his arms in one of the many holds which evoke images of crucifixion. "Wrestling is the only sport which gives such an externalized image of torture," Barthes observes, and indeed, if *lucha libre* remains the poor man's spectacle, it's because the suffering in the ring isn't sufficiently sublimated for middle-class tastes. Here, pain isn't the necessary by-product of a goal, as in boxing or pro football, but an end in itself.

This isn't to say that *lucha* fans are sadists. Instead of yearning to see "real" suffering, they expect to witness its transformation into something theatrical and ultimately absurd. The wrestler acts out his anguish in farcical pantomime, recalling the exaggerated gestures of silent film actors and vaudeville entertainers. Underneath its violence, *lucha libre* is largely a school for comedy. Nowhere is this more evident than in the role of the referees, who typically appear to be morally lax dandies; as they have little to do in terms of actually enforcing rules, their hardest task is trying not to look bored. Since the moral climate of wrestling is universally suspect, the very pretense of maintaining order in the ring seems nothing short of laughable.

But *lucha*'s comedy is laced with real pain. When a *luchador* hurtles out of the ring like a human missile or is roughly dropped onto an opponent's knee, he takes authentic risks. And when he cuts himself with a hidden razor and bleeds in the ring, the line between theater and reality blurs. Blading, as this illegal practice is called, occurs more frequently in the lower echelons of *lucha libre*, but the spilling of blood remains an integral, and deeply satisfying, aspect of the spectacle at all levels. A contest without blood feels empty – not because it falls short of any sadism quota, but because the presence of real blood streaming down a wrestler's face moderates the prevailing aura of fantasy; it assures us that the *luchador*'s suffering is not completely illegitimate. "Don't get AIDS!" someone will yell from the crowd at the sight of bloody wrestlers butting heads, yet the spectator is eager to witness some kind of sacrifice, to see mythical characters brought down to earth in a ritual of mortality.

Outside the ring, the wrestler's existence is dominated by more prosaic rites. To fight professionally in Mexico, *luchadores* must first pass a rigorous examination administered by La Comisión de Boxing y Lucha. Besides possessing athletic talent and a certain amount of charisma, candidates must be willing to take punishment and to perform even when injured – and injuries hound most regular performers. In Mexico City, at least, there's financial compensation: by fighting every night of the week, a popular wrestler can make a decent living. But in a provincial *lucha* outpost like Los Angeles, the labor is largely one of love. The *luchadores* who work here usually make no more than $10 to $20 dollars per fight, and count themselves lucky to get paid at all. Local bouts are not infrequently canceled at the last minute when small promoters can't make insurance pay-offs, and "no shows" by top names are a common occurrence. (When Negro Casas once failed to appear for a local match, the promoters explained his absence by announcing that his father had passed away – which was in fact true, though he had died two years earlier, and knowledgable fans screamed in protest.)

Still, Los Angeles *luchadores* can find moments of quiet renown. It may be seeing one's mask included in the museum-calibre display at George Vasquez's TV & Repair Shop in West Covina, where the masks of local heroes like Pilota Suicida and Lover Boy are showcased alongside those of Mexico City's premier *luchadores*. Vasquez, who says he's one of only two serious collectors in the US, has filled the entrance to his shop with close to 175 masks, ranging from El Sicodelico's op-art spiral to architectural statements such as a mask topped by a gold pyramid. "Sometimes when I arrive in the morning, the store window will be all smudged and dirty, because at night people have been pressing their faces against the glass, trying to get a better look at the masks inside," Vasquez tells me. "They're fascinating even to people who don't know what they are."

Lucha's magic, evident even in a West Covina mini-mall, can spring into action wherever there's a willing audience. The crowd itself is an important character, and without its collaboration no performance can really succeed. On Sunday afternoons at the All Nations Center in East LA, it takes a few matches for the audience to warm up properly. A *rudo* might have to pick a fight with a favorite target in the crowd, taunting them with obscene gestures and verbal abuse, before the rest of the spectators begin taking it personally and toss their crumpled up programs and empty cups at the ring.

If the night goes well, by the last match the scene has been set for the kind of

unrestrained anarchy with which every great performance culminates. In these climactic moments, the script fades from view and in its place emerges an illusion that things are truly out of control, that the fighters won't stop until they've obliterated each other. And this venture in licensed mayhem inevitably spills from the ring into the spectactors' seats, as *luchadores* bash each other with fold-up chairs, ring posts, bottles, anything they get their hands on. Once the ring is so thoroughly violated as an ordering frame, the spectators themselves may even join in the melee, setting upon each other in an orgy of lawlessness.

For that instant, the whole world is a carnival. This is why *lucha libre*, unlike many sports, is not something you can really understand by watching televised matches. You can have that experience only if you're part of the action. *Lucha* may be one of the last forums where this special relationship between performer and audience continues to exist, one where the line separating them is clear yet elastic. It's a relationship capable of whirling from worship to intimacy in a split second, and in this subdivided culture of ours, it reveals a fleeting picture of a world without borders.

January 1994

LIVING LARGE

During the last half dozen years, oversized clothing has become something of a uniform for various youth tribes. Double-extra-large t-shirts and absurdly baggy pants with dropped crotches have been embraced not just as a fashion statement, but as a social posture. For a style to take hold at a given moment, after all, it must say things that people are willing not only to support, but to embody; it has to sum up a prevailing spirit or attitude.

On first look, bagginess is a style that gives its slimmer wearers the appearance of anorexic cartoon characters, or of small children smothered in adult clothing. But to get a better handle on the conceptual contours of bagginess, consider some of the things that oversized clothing *doesn't* do. It *doesn't* reveal the contours of the body, for instance, and in this respect it's the antithesis of spandex or a surfer's wetsuit. It also reverses the values of a musclebound aesthetic: whereas weightlifters tend to wear skintight clothes to emphasize their bulk, power and strength, baggy clothes speak to mobility and loose-limbed agility.

Essentially an anti-fashion fashion, it involves taking clothing that is historically meant to be sized and worn a certain way, and defiantly restating those intentions. The advantage of starting with ready-mades is that your raw material is already socially coded; consequently, your innovation conveys a double message. It upsets the implicit expectations of how the clothing's supposed to look, and then it allows you to make your own statement by the way you wear it.

The renegade appeal of preposterously oversized clothing dates back at least to the

1940s when *pachuchos* and African-Americans appropriated the drape shape of zoot suits. Because it was World War II and materials were scarce, the zoot suit's billowing folds were seen, at least by mainstream society, as a wasteful and unpatriotic excess. The current oversized fashions have yet to be labeled unpatriotic, but they still manage to hit nerves vexing to many authority figures.

Just last month, in fact, the Downey Unified School District considered an amendment to its dress code that would ban oversize pants and shirts. A school administrator explained that safety concerns lay at the heart of this move. "These styles can make it difficult for a student to write or to keep papers neatly on a desk," I was told. "They could also present a physical danger, just in terms of tripping and falling. In short, they might prevent students from functioning appropriately within a school campus."

But in the absence of any documented health hazards, one suspects school authorities have outlawed the gear precisely because it already possesses an outlaw appeal. It's bad enough that it caricatures adult clothing; what's worse, however, is its fugitive air. Baggy garments call attention to the wearer's outrageous form, but they also suggest a dematerialized body; in extreme cases, outfits hang so loosely as to recall images from *The Invisible Man* – uninhabited suits strolling down the street of their own volition. Ultimately, it's a form of stealth clothing, a radar-defying style which makes actual proportions and scale difficult to determine. Adding to the confusion, jumbo garments tend to de-emphasize visible signs of gender: once shrouded in tent-sized t-shirts, bodies look pretty much alike.

Curiously, the baggy aesthetic made one of its earliest appearances in professional basketball, showing up sometime around 1986 when Michael Jordan, among others, traded in the traditional crotch-pinching gym pants for oversized shorts that dangled almost to the knee. Jordan's fans might argue that his ballooning shorts served a functional purpose, allowing greater freedom of movement, but they were clearly a size beyond anything even vaguely practical. It was purely a fashion statement, and Jordan's only recourse to individualizing his dress; though players are required to wear the team uniform, there's no restriction dictating how small or large that uniform need be.

Bagginess also connotes an extremely casual, untailored approach to sport. It's the opposite of a militaristic view of a uniform, which has to do with precision fit; it suggests instead that the wearer is off-duty, enjoying a bit of civilian leisure. Dressing this way for a competitive battle comprises an implicit challenge – not to the "dignity of the

game," but to one's opponent. It's a declaration that you don't have to take them very seriously, as if you were saying, "Hell, even with my shorts flopping down around my knees, I can still kick your ass."

As a performer, Jordan is celebrated for his high-flying moves and individualistic flair, rather than for being a "team player." The origin of the extra-large style, though disputed, is usually traced to two groups also known for their audacious and unconventional athleticism: breakdancers, who needed roomy gear for performing their inner-city yoga, and California skateboarders, who popularized the look after borrowing it from the gangsters in Venice's Dogtown neighborhood, an early home of the skater scene.

The jumbo fetish may well have developed independently in these two subcultures, but it's worth noting that they share several characteristics. Both breakdancing and skateboarding are individual, rather than team, activities, and emphasize spontaneous stunts and a kind of kinetic surrealism that has no recognizable place in the known movements and gestures of everyday life. Both disciplines involve more than a little showing off. And they have something else in common as well: an illicit pedigree. Breakdancing developed in urban environments where police harassment is the norm, while skateboarding actually *is* illegal in most city areas.

Yet on another level, these clothes are about symbolically increasing personal space at a time when public space and safety have been severely diminished. As the future shrinks before our eyes, they offer the solace of individual aggrandizement. Of course, you could just as easily argue that baggy fashions are for those who feel they're going nowhere fast, because one of the most striking impressions they leave is of something deflated, like a punctured inner tube. In the end, this elusive and overdetermined fashion leaves us clinging to shapeless conclusions, and the eternal verité that every radical new style is invented so a younger generation won't have to dress like its parents.

March 1994

PART V

SEEING DOUBLE

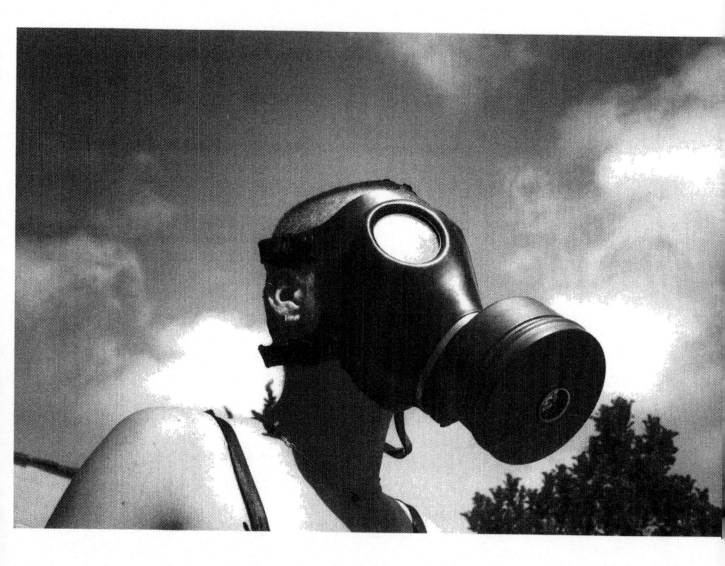

PICTURES FROM A FUTURIST WAR

Whether it covers the face of a US soldier, a Moslem praying at dawn, an Israeli child or a TV reporter, the image of the gas mask is one of the key visual motifs that have emerged from the media's coverage of the Gulf War. Like any mask, it replaces the mobile play of human features with an immutable rigidity. It removes the familiar and makes room for menace. Most of all, it weds the individual to the anonymity of mass production, and shows us how this war has transformed the human face into a robotic countenance. This fits in nicely with a major theme of the media coverage – that this is a war fought by machines, not people. Indeed, the stars of this media show are a cast of cruise missiles, laser-guided bombs and hi-tech aircraft. In this war, the charisma has been monopolized by technology.

The promise that "this will not be another Vietnam" has already proved true in the field of photojournalism. In contrast to the coverage of the Gulf War, many of the images sent home from Southeast Asia were shockingly graphic. You could turn on a TV and find a picture of a bone-thin, half-naked woman running down a country road clutching a napalmed baby to her chest. As though trying to prod a society grown numb to its own violence, the media resorted to ever more gruesome imagery, depicting the horrors of battle with a sensationalism that breached earlier standards of journalism.

The photos from the Gulf conflict, on the other hand, don't aim to shock as much as to instill awe. How else can you react to the videotaped pictures of Baghdad during a night-time air strike? In these grainy images, the sky appears convulsed with streaking

explosives; flaring up in white balls of light, anti-aircraft missiles seem to interpenetrate and multiply as they soar into the darkness. The nightscoped video's X-ray-like quality adds to the otherworldly atmosphere, making for astonishing pictures which seem closer to science fiction than to any previous image of war.

Tellingly, descriptions of the scene, from correspondents and pilots alike, have relied on festive metaphors. "It was like the fireworks at Disneyland, multiplied by a hundred," one pilot remarked at a televised press conference. Others mentioned lit-up Christmas trees and swarms of fireflies. But it was CNN's John Holliman, reporting live from Baghdad, who came out and said what almost every viewer had to be thinking. "This is beautiful," Holliman gasped more than once. "This is really beautiful."

Beautiful? Perhaps not since Filippo Tomaso Marinetti's 1909 Futurist manifesto had anyone so unabashedly described war as "beautiful." For Marinetti and his colleagues, who glorified technology and speed, war was the ultimate form of modern art. Because of his later enthusiastic alliance with Italy's fascists, Marinetti is an awkward figure for art historians, and his influence on twentieth-century art is downplayed. The other night, however, Holliman and a world of watchers seemed in wholehearted agreement with the principles of Futurist aesthetics.

Certainly, Marinetti would have approved of the *New York Times* television critic who characterized the first day of war as "perhaps the most exciting evening on television ever." He would also have admired the *LA Times*'s front-page color photo of a Tomahawk missile being launched from a battleship, a picture in which the missile appears as a completely abstract image, a clean white shaft of light burning against a black sky. Pictured like this, the weapon has a striking, almost magnetic appeal – an idea reinforced by the crowd of sailors watching spellbound from the ship's deck. Like so many photographs sent back from the Gulf, this image wants to convince us that we are witnessing a completely different type of war – a hi-tech campaign conducted with surgical precision, evoking not death and destruction, but professionalism and computer-assisted competency. By glorifying the splendor of destructive weapons, photographs like this try to reassure us that the Gulf War will not be a messy, morally confusing conflict like Vietnam. This time, war will be artful.

For no other war has our image-recording network been so thoroughly in place. The coverage from the Gulf is practically omniscient, with news clips mimicking the total closure of Hollywood's shot/reverse-shot format; first we get the ground-zero POV, and then we're shown the reverse angle from cameras mounted on attacking

bombers and missiles. As a viewer, you have the impression of having been presented with the full sweep of visual reality. The moral issues of the war are squeezed out of the frame, as the ballet of aerial assault becomes absorbing in and of itself.

Yet the ultimate spectacle of the war is revealed in two pictures taken not in the Gulf, but in the United States. Both depict people watching TV. In an *LA Times* photo, we see a woman who appears terrorized by the image of President Bush on her giant screen. She tensely clutches a pillow in her lap, and sits at a right angle to the set, as if she were afraid to face it directly. Her dread and isolation are striking, and so is the fact that, aside from the chair, there appears to be no other furniture in the room. This is the American interior stripped down to its bare essentials: shutters on the window, and a coldly gleaming tube that balances bright anxiety against the consolation of a human image (no matter how unappealing). As it is her sole visible connection to the world, we sense that the woman in the picture has no choice but to remain loyal to her electronic window.

The second photograph, which appeared in the *New York Times*, shows a man in a business suit standing before a display window filled with television sets, all broadcasting the same picture: Saddam Hussein kneeling in prayer. As with Andy Warhol's multiple-image silk-screens, this proliferation of Husseins has a contradictory effect; it gives the image an incantatory power, and simultaneously neutralizes it. But what makes this photograph stand out is the way it suggests that for the spectator (who watches with hands clasped behind his back in a military pose), the news of war is redundant: like the TVs on display, it's merely another object for sale, enticing us, in this case, with the fantasy of being privy to the private moments of a world leader.

During Vietnam, the images of atrocities were ostensibly intended to arouse public concern. Often as not, they tended to have the opposite effect. As the critic John Berger noted in his 1972 collection of essays, *About Looking*, the moment of agony in the war photograph is a moment discontinuous from the rest of existence, and so it ultimately instills in the viewer a sense of remove. This remove is likely to be perceived as a symptom of a personal moral inadequacy. "And as soon as this happens," Berger observed, "[the viewer's] sense of shock is dispersed: his own moral inadequacy may now shock him as much as the crimes being committed in the war."

Two decades later, our neo-Futurist society may be beyond shock or experiencing moral inadequacy. The pictures of war we are seeing suggest that instead we've reached a level of disengagement equal to Marinetti's blustering madness. No wonder,

then, that our few campus-bound peace marchers look so pathetic on the evening news. Predictable and devoid of glamor, they're no competition for the Disneyland fireworks of multi-million-dollar weapons systems. Marinetti, who always hoped that Futurist aesthetics would play a substantial role on the stage of world history, must be laughing in his grave.

February 1991

BRAVE NUDE WORLD

Among the many shots of naked world travelers in the recent issue of *Nude and Natural*, a glossy quarterly published to promote "clothes-optional lifestyles," one photo stands out. Posed against the background of a tropical waterfall, two palefaced nudists stand beside a pair of local, and fully dressed, police officers. It's a wry reversal of the stereotypical image showing dressed (civilized) Westerner and unclothed (natural) native, except for one thing: with their matching wire-rim glasses and distended beer bellies, the nudists are hardly an advertisement for aboriginal grace. Their birthday suits are strictly off-the-rack.

When we look at pictures of nudists, we don't just see naked bodies, we behold an ideology. Whether they're shown driving a tractor or frolicking around a volleyball net, there's clearly nothing casual about their lack of clothing; instead, their nudity functions as the overt emblem of a comprehensive world view. It carries with it the history of an international movement which in America dates back to the 1920s, and in Germany to the turn of the century. It's also the badge of a segregated social identity: in France, nudists divide the world between themselves and those they call "textiles."

While there are factional camps within the naked kingdom (the more ecologically oriented British *naturists*, for instance, frown upon the term "nudism"), the movement's one universal tenet holds that nudity is natural – not just in bed or in the shower, but everywhere from the work-station to the golf course. Only in nakedness can we find the unadorned truth of experience; only by stripping away civilization's false veneers can we move closer to Nature and her eternal verities.

MARK LIPSON

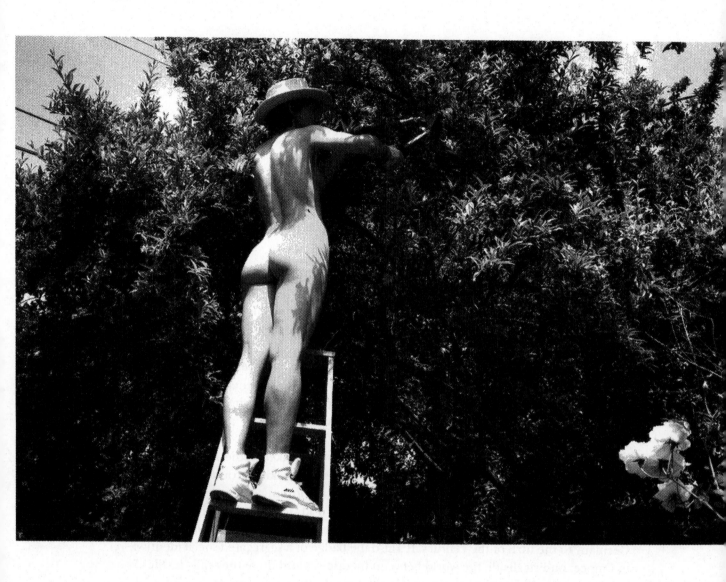

Yet nudist pictorials inevitably, if unwittingly, seem to undermine this creed, since few civilized bodies look remotely "natural." Skipping through photographic histories and periodicals such as *Nude and Natural* or Australia's *Sun and Health*, the reader encounters physiques molded by desk jobs, fatty diets, and couch potato regimes. Unlike the tribal peoples frequently pictured in these publications as a reminder of our glorious garmentless heritage, the Western nudists – their bodies unbalanced by sloping necks, sunken chests, and pinched shoulders – look like they could be posing for the "Before" pictures in a chiropractor's office. Removing their clothes doesn't make them seem remotely natural, but reveals just how shaped by civilization they actually are.

Diane Arbus, who was fascinated with people's social masks, especially the kind that can't be discarded, took some celebrated photographs of nudists that underscore this paradox. Shot at a couple of East Coast nudist camps in the early '60s, her portraits dwell on the peculiarly contrived quality of her subjects' nakedness. In one photo, an overweight nudist family lounges on a neatly manicured lawn like a bloated latter-day counterpart to the Parisian picnickers in Manet's *Déjeuner sur l'herbe*. Everything around them speaks of a suburbanized Nature, and their own nudity is plainly domesticated as well, accessorized with the trappings and hairdos of '60s middle-class society. It's the emperor's new clothes in reverse: here everyone's convinced themselves they're actually naked when in fact they appear to be fully adorned, wearing the attitudes, postures and facial expressions of the dressed.

A crucial philosophical difference separates Arbus's pictures from the kind found in nudist magazines: Arbus arranged her subjects in static poses, echoing (perhaps unintentionally) the classical approach to the nude as passive object. The pictures in nudist publications, on the other hand, present a boisterous vision of nudists on the march; we see them mowing lawns, playing tennis, fishing, painting, farming, barbecuing, even computing (a recent *Nude and Natural* article offered hints on "How to be undressed on line.")

Virtually all nudist photos are set in the great outdoors, even shots of people doing typically indoor things like playing chess or typing. Behind this convention lies an insistence not only on the health benefits of fresh air bathing, but also its public character. Where the Western tradition of the nude concentrated on isolated individuals in scenarios conducive to fantasy, nudist pictures emphasize couples and families interacting in group recreation, usually in a setting identifiable as a communal space.

That the nudist forever appears not as a lone figure but as a member of a community imbues these pictures with a vaguely cultish aura, and perhaps even a political dimension. Throughout its history, in fact, nudism has been identified with a rebellion against urban bourgeois life. Beginning with the Wandervogel, a German back-to-nature youth movement at the turn of the century (and, incidentally, the people who brought us the raised-arm "Heil!" salute), freedom from clothes has been equated with freedom of expression. A number of artists took this idea quite literally: in 1914, the American painter Charles Burchfield noted in his journal, "I find my mind is more impressionable when I am divested of all my clothing." Ten years later, a gymnastics teacher named Adolf Koch spearheaded a movement of Socialist nudists in cities across Germany, while elsewhere in that country Aryan nudist societies were advancing a cult of idealized, wholesome bodies. This history, fraught with starkly utopian impulses, lives on even in today's most purely hedonistic nudist images, because these, too, inherently reject society as we know it.

Outside of hardcore porn, the documentation of performance art is the only other photographic genre that routinely features naked people actively engaged in sundry pursuits. As with pictures of nudists, the nakedness portrayed in these images is usually linked to a liberated stance, a proto-hippie shedding of accepted values. *Why I Got Into Art* by Anonymous, a book published privately last year (and rumored to be the work of one of Los Angeles' better-known artists), chronicles the impact of these photos – specifically pictures of nude female performance artists – on a generation of males coming of age in the late '60s and early '70s.

As the book's title implies, these pictures exercise a seductive allure, though what they promise is a long way from the soap-scented sexuality of *Playboy*. In an accompanying essay, pop critic Diedrich Diederichsen writes of the "leftist pinups" which appeared in Germany's underground press in the late '60s: pictures of naked rebels "smeared with mud or armed," and exuding a "revolutionary femininity." They seemed to hold out a challenge to young male viewers: "Only when you are ready to kill your parents, set fire to your school, ride on the underground without paying and stab your teacher to death, only then may you touch us."

Nothing in nudist iconography issues a similiar challenge. Though bodies are shown going about their daily business, they're consistently, and depressingly, neutered – stripped not only of clothes but of the last trace of concupiscence, revolutionary or otherwise. The point, no doubt, is to convince us that nudists are solid family types who just happen to appreciate life in the buff. Indeed, most nudist publications strain to

project an impression of therapeutic "normality," and a brave nude world where the possibility of incest is nil because sex doesn't exist. Nudists don't fuck, they breed. So we get photos featuring every combination of naked mothers and sons, brothers and sisters, granddads and grandkids, all shown enjoying the same activities as the rest of us, only a little more so since it's infused with the life-enhancing sensuality of unburdened humanity.

Obviously, that experience can't be achieved simply by casting off one's clothes. While it's easy enough to step out of your Calvins, the underpants of history aren't so tractable, and these days, in an environment wallpapered with air-brushed images of the flesh, nudists aren't the only ones who might have trouble getting truly naked. As the tattoo and piercing crowds seem to have intuited, our bodies are already thoroughly marked, so we might as well adorn them with designs of our own choosing.

August 1993

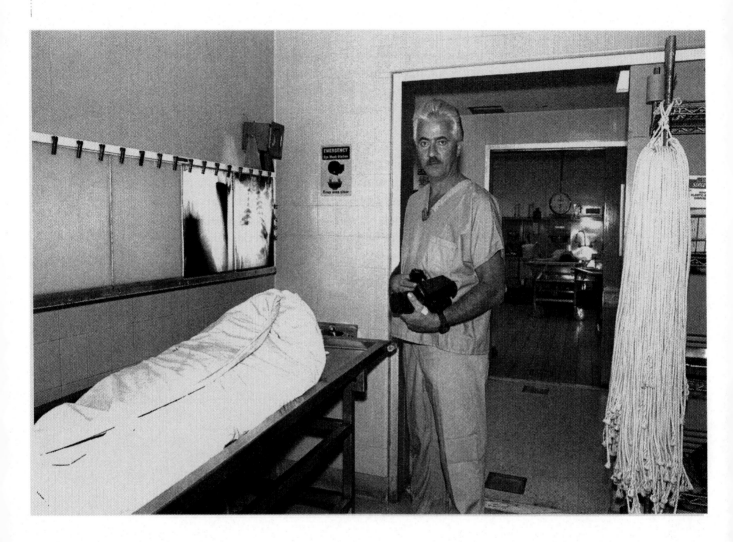

ON FORENSIC PHOTOGRAPHY

Photography makes living subjects appear lifeless – frozen, struck dumb, yanked out of time – yet in photographs the dead come alive. It's a paradox I first encountered in Michael Lesy's *Wisconsin Death Trip*, a documentary venture into the "historical actuality" of 1890s Wisconsin. Pairing period newspaper stories and archival images, Lesy's book (recently reissued by Doubleday) includes several photos of babies in coffins: bedecked with white lace and floral wreaths, they appear uncannily re-animated, as if bodies struck down by epidemics could be resurrected on strips of celluloid.

Since every subject of a photograph shares a certain cadaverous stiffness, the line can blur between the lifeless and the living. How then do you shoot a corpse so it appears truly dead? With this question in mind, I paid a visit to James Njavro, the sanguine chief of forensic photography at the LA County coroner's office.

Njavro's department is responsible for preserving a visual record of every cadaver handled by county coroners. Because there's no statute of limitations on murder cases, his office has negatives on file dating back to 1937. Eight full-time staff members, most of whom come from mortuary backgrounds and all of whom have been trained as autopsy technicians, photograph an average of 45 "cases" a day. Last year, they photographed close to 2,500 murder victims as well as 6,000 autopsies, producing approximately 150,000 color prints. Strangely enough, the bureaucratic conditions under which these pictures are taken don't mitigate their power; in fact, they enhance it.

Njavro isn't allowed to show me the department's archive, so I have to wait until he's

called out of his office to examine a group of photos on his desk. Hidden among various images of bullet wounds (known as "locator" shots) is a full-figure photograph of a young black man laid out on a specimen table like a languorous male odalisque. Thick Frankenstein stitches bisect his torso, evidence of a futile effort in an emergency room. Miraculously, despite having been stripped, cut open, sewn up and laid out like a piece of beef, the corpse maintains a resilient human dignity.

Though the average TV viewer takes in 13,000 dramatized killings by age eighteen, few if any of those images bear the least resemblance to this photograph. Nothing in the picture moralizes over why this man was killed. There is no hint of judgement, though the cadaver's naked vulnerability invokes the innocence of a defenseless victim. The property of a public agency, it's essentially a private image, meant for exhibition only in court, and my looking at it is an intrusion, a rupture of its limited intentions. Since I'm not seeing it through bureaucratic filters, it hits me with a power it was never meant to have.

It probably doesn't make sense to speak of honesty in a photograph, but the impersonal archival image – "objective" in that it excludes any individual stylistic trace – seems to give the dead subject its due. The distanced format accidentally produces results far more intimate and respectful than most photographs of the naked body found in the art history file. Rather than perusing color prints, I feel like I'm handling a dead man's belongings.

While the photos boast a technical hygiene, aspects of forensic photography are a dirty job. At the coroner's office, a room with an unsterilized cadaver is sometimes referred to as a "contaminated room," and each corpse is approached as if HIV-infected. Both photographer and supervising physician wear surgical masks while in the photography studio, which, except for the mounted strobe lights, looks more like a low-budget operating room. When Njavro gives me a brief tour, the corpse of a tiny black boy is being washed down by a member of his department. The corpse will eventually be photographed head to toe on a specimen table, lying propped on its side and supported from behind by a triangular metal stand (this allows photographers to capture a full frontal portrait without having to shoot down from a ladder).

From across the room, the cadaver almost looks like a sleeping infant, and my pulse is suddenly flying. I've never shared space with a naked corpse of any age and looking at photographs hasn't prepared me for the shock. Evidence of death is pretty much banished from our daily life, its management entrusted to specialists, and the physical presence of this tiny body seems like a violent intrusion from a foreign reality. I keep

staring, eyes locked like magnets, in the foolish hope that if I look long and hard enough, it will begin to seem familiar, and no more threatening than a snapshot.

In *On Photography*, Susan Sontag complains that "the camera makes reality atomic, manageable, and opaque. It is a view of the world which denies interconnected- ness . . ." Yet the invention of photography didn't recreate this way of seeing so much as it reflected an ethos already in place – particularly the idea that subject and object are distinct entities, rather than part of a continuum. It's a notion first canonized by Descartes, but as cultural historian Morris Berman points out, its roots reach back to Plato and the Judaic concept of a transcendent God who creates the world yet stands apart from it as a separate consciousness.

But as an agent of this world view, the camera ends up structuring many of our cultural rituals, from family reunions to photo opportunities and striptease shows. In *Sexual Personae*, Camille Paglia insists that striptease is a sacred dance of pagan origins, whose "profound meaning" lies in the fact that "a nude woman carries off the stage a final concealment, that chthonian darkness from which we come." But the routines at Live Nude Dancing, a generic strip club near LAX, seem to be influenced less by biology than by a fairly recent photographic convention: hardcore pornography.

In contrast to classical striptease, where the dancer's accessories – fishnet stockings, gloves, feathers – set up her eventual nakedness as nothing more than a final theatri- cal prop, the dancing here is strictly clinical. There is no hint of narrative, no series of progressive revelations; instead, after removing her bikini, the performer runs through a series of gynecological poses, holding each one as if modeling for a medical photographer. A mini-spotlight illuminates her (usually shaved) vagina, reproducing the closeup frame of porno magazines. Only the blaring music, the last vestige of the burlesque tradition, provides a non-photographic reference.

The thing we most cherish about photographic reality may be precisely its aura of detachment; at Live Nude, that disassociation, mirrored in the dancers' air of profes- sional indifference, is part of the turn-on. Basically, the performers are presented as moving magazine pictures. Their photo-op smiles, indicating that they've emotionally vacated the premises, are emblems of our separation of image, mind and body. Yet in a sex show where the dancers neither sing nor speak but remain silent as centerfolds, the distance between subject and object is presumably part of the appeal.

These thoughts bring to mind a story related by a friend who once posed for Helmut Newton, our photographic voyeur par excellence. Helmut had asked to shoot her, and

during their first session together, she felt confident that she was giving him her charismatic best as a model. But Helmut had photographed her with little enthusiasm. The session dragged on in dispirited fashion, until finally, tired and frustrated, she found herself thinking how contemptible he really was, how troll-like and utterly pathetic. When she looked up, Helmut was suddenly snapping away with great excitement. He'd found something – disdain – which his camera could relate to.

Taking photographs, as every holiday season reminds us, can also be a social performance where the end product is largely superfluous. (It's hard to imagine anything more monotonous than party pictures.) We bring out our cameras mainly to confirm that an event is special, deserving of a lasting record. It's part of a bonding rite as well: to accommodate the camera, we huddle closely together, and for a moment become an intimate group.

Implicit in the picture-taking ritual is an assumption that our cameras will somehow capture an aspect of our personal point of view. A lot of Angelenos I know took snapshots during the riots this past April, usually of nearby fires or burned-out buildings; their intent wasn't simply to document these scenes (since the mass media were providing saturation coverage), but to capture their own experience of the events. Their pictures, however, generally share the same distanced quality: the subjects look too far away, and the image's neat frame undercuts the drama of a moment when boundaries were broken.

At the time, though, the act of shooting pictures might have been a means of penetrating, or at least drawing closer, to something frightening and unpredictable. In a certain respect, it may have been a ritual not unlike the superstitious actions of obsessive compulsives, a gesture repeated over and over again in the unconscious hope of warding off future calamity. Whether we're looking through the lens of a digital camera, a videocam or an old-fashioned 35mm, there's comfort in seeing the world shrunk to viewfinder size, and feeling for a moment that we can hold its tumult in our hands.

June 1992

HEAD SHOTS

According to a slim and provocative manual titled *How to Sell Yourself as an Actor*, Hollywood agents are searching for self-knowledge – not in their own lives, necessarily, but in prospective clients. The self-knowledge they're looking for isn't exactly what Socrates and Buddha had in mind, though. It translates into a simple, brutal formula: if you look like John Candy, don't go after Johnny Depp roles.

Actor's head shots, at least the successful ones, are meant to convey this kind of self-awareness. Descendant of the mug shot and the identity photo, the head shot is supposed to sum up a marketable individuality. It plays to the assumption, as does classical portraiture, that our faces betray our inner character. Yet encountered as part of the ambience of LA's drycleaners, delis, bars, and liquor stores, the conventional head shot does something else: it transforms any and every visage into an eternally anonymous icon, a virtual personality with the not-quite-human look of police composites and wanted poster portraits.

The head shot deals not in revelation, but in exposure, and in this respect it recalls the clinical quality of hardcore pornography – even the term itself sounds vaguely pornographic, like a variation on cum and beaver shots. And like those genres, it's at once utterly explicit and completely impenetrable, which may partly explain the secret of its unsavory quality. But there's more to it than that, because the head shot is also an almost surgical display of desperation; regardless of an individual actor's expression, what is most striking in the end is his or her consuming desire to be noticed.

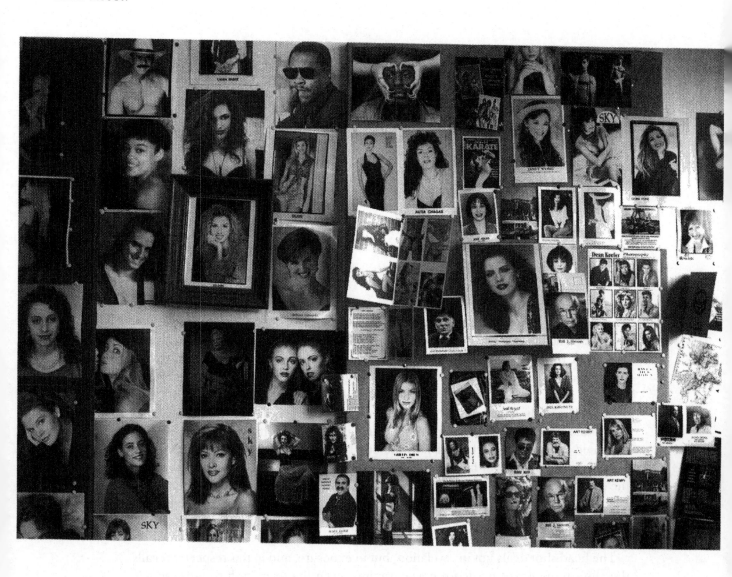

Meant to single out their subjects from the crowd, head shots do the opposite, reducing them to a visual common denominator. Beyond the standard studio lighting and inevitable retouching, this effect springs from the fact that the head shot is what's known in the trade as "a working picture:" it aims to sell a product, not to enlarge our experience of the world. Technically, its purpose is to furnish casting directors with information as to how a person actually looks, yet in fact it depreciates every face into an article of consumption, subliminally engraved with the words "Buy Me."

Like the traditional nude, the head shot is also rigidly conventionalized so that every visage is staged within the same narrow parameters. There are only so many ways, after all, that you can light the human face and still produce an image capable of serving the head shot's specific commercial agenda. Artsy angles, contrast and shadows, intriguing backdrops – these are unwanted distractions. And given the usual treatment, even celebrities look like generic contestants from a never-ending Ur-audition.

The Hollywood cult of "self-knowledge" adds another layer of constriction, as actors often attempt to package themselves as easily recognizable types. Readymade expressions adorn the faces of countless sultry babes and studs, effervescent ingenues and sensitive romantic leads; even the midway-through-rehab heavies, with their half-alive eyes and deadset mouths, seem to order from the same catalog of facial expressions. Racial clichés narrow the bandwidth even further: the Asian child actor turns up in a karate outfit, the African-American in a football uniform, because these images correspond with the stereotyped roles most available in Hollywood.

Yet one kind of head shot constitutes a radical innovation as portraiture: in addition to a central image, it features four insets placed in the corners. In each of these smaller pictures, the actor appears with a different costume and expression, presumably to demonstrate a versatility suited to "character" roles. Often enough, however, these pictures convey the impression of a freaky shape-shifter or multiple personality, bouncing off the walls in a terminally private universe.

The most popular recent trend has been to replace head shots with "three-quarter" or "half-body" portraits. Besides showing off the actor's physical attributes at a moment when our culture is relentlessly body-conscious, these images require less retouching because they show the actor's face – and its lines, pores, and wrinkles – from further away. As a result, these shots are valued for providing a more accurate likeness.

In practice, though, few studio portraits come close to even suggesting verisimilitude.

It's not simply that the subjects seem to be acting, which would be only natural under the circumstances, but that the reality count in these images is conspicuously low, hovering somewhere between that of wax figures and the facades on a movie studio street. They give you the uncanny feeling that if you could turn the actor's portrait around, you'd find only an evacuated shell behind the mask-like smile.

This has nothing to do with the specific psychology of actors as a group, because in front of the camera we all become performers. And looking through it, as Susan Sontag remarks in *On Photography*, we become customers or tourists of reality, including our own, as the camera "creates another habit of seeing: both intense and cool, solicitous and detached." This is what head shots make so unnervingly apparent, and it's most obvious, and disturbing, in photographs of child actors. Eager to catch your eye, their beaming faces stare right through you, as though nothing could ever occupy a focal point for their gaze beyond the adoring lens, as if they were both tourist and attraction in one.

In Sam Fuller's *The Naked Kiss*, an ex-hooker describes the unbridled, boundary-assaulting tongue missive that warns a pro she has a violent psycho on her hands. The head shot is the visual equivalent of that kiss. It reminds us that the most explicit image is rarely the most revealing, and it also speaks to the extent to which genre and medium create the parameters of individual "character." With the head shot, everyone is shown to be a celebrity, and celebrity itself – as at Madame Tussaud's – is revealed as a form of cultural embalming.

September 1994

CRIME STORYBOARD: WELCOME TO
THE POST-RATIONAL WORLD

Forget about Quentin Tarantino and all the other postmodern Peckinpahs – the future of chillingly violent images lies in the hands of forensic animator Alexander Jason. A leading expert witness in ballistic events, Jason was the first to introduce "3-D" computer-generated animation into a criminal proceeding. His debut cartoon, produced in 1992 for the murder trial of pornographer Jim Mitchell, has no soundtrack, contains no gory special effects, and lacks any dramatic structure. But it's a deadpan tour-de-force, far more haunting and memorable than most Hollywood neo-*noir*. And for better or worse, it's part of a revolution that's changing our language of justice.

The Mitchell video, which reconstructs the movements of a homicide victim during a sequence of eight gunshots, looks like a grisly, and quasi-scientific, video game. Bullets are depicted as bright red spikes, the better to identify entry and exit wounds, while terse statistics on each ballistic event flash on the screen. Oddly realistic details – like the way a beer bottle bounces and rolls when it's dropped by the victim – add unexpected pathos. The result is an unnerving viewing experience where cartoon violence, a relatively innocent cultural form, is made to stand for the real thing.

In another Jason animation produced for a case in Colorado Springs, we see a blue police officer shooting a naked green woman, who is shown kneeling in bed pointing a silver pistol. The woman has no genitals, but does have breasts, presumably so we can see where the officer's bullet enters near her right nipple. In other videos, figures are occasionally depicted with clothing, and in a few cases race is also indicated, yet this

MARK LIPSON

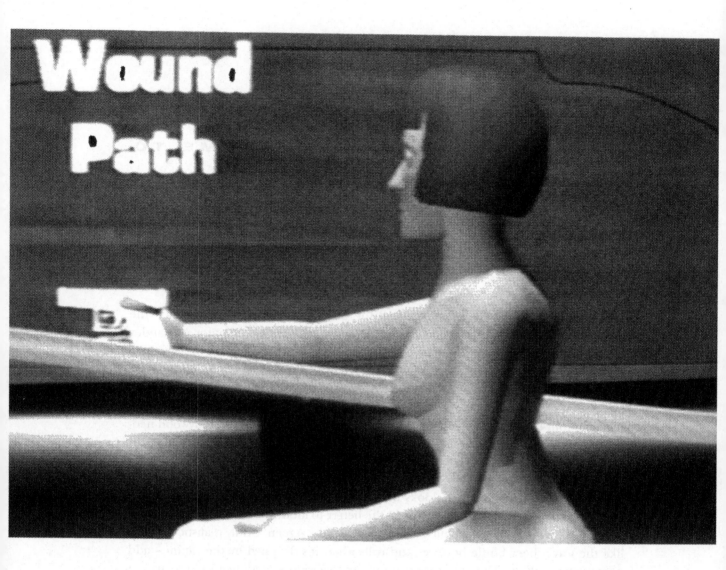

realism is tempered by the use of uncanny effects: a torso may abruptly dissolve to reveal the underlying skeletal structure, allowing us to trace a bullet's path through the body. In one stunning cinematic flourish, Jason creates a shot from the bullet's point of view, taking us from a policeman's gun, through the victim's chest, and into the wall beyond.

For all their hi-tech verve, these cartoons are carefully based on physical evidence, autopsy and crime photos, ballistics analyses, police reports, and witness statements. They are admitted in court not as evidence, however, but as *exhibits* – material used to demonstrate or illustrate a witness's testimony. And they are being admitted with growing frequency in civil and criminal proceedings alike, along with a host of other computer-generated images. As an article in *American Lawyer* declared last year, lawyers and visual consulting firms are "turning trials into multi-media events that combine the drama of *Divorce Court* with the authority of a CNN soundbite."

Behind this development is a growing consensus that jurors will pay more attention to CRT displays than to their fellow citizens. "When it's on TV, people find it easier to believe," asserts a brochure from Litigation Sciences Inc., a Culver City-based company which provides multi-media trial support services. As if in explanation, the same pamphlet notes that the average high school graduate has spent 15,000 hours watching television, and only 11,000 in the classroom.

We're not yet at the point where cross-cutting has replaced cross-examination, but in more and more high-stakes cases plaintiffs and defendants enter the courtroom as competing productions. The offices of a company like Litigation Sciences Inc. are basically those of a hi-tech production facility, with hallways of rooms for writers, directors, and producers, as well as computer-graphic work-stations for mouse jockeys. They produce everything from color-coded charts to trial exhibits organized on CD-ROM, and the underlying approach echoes that of the film and advertising business. The visual strategist sells us a product using pictures.

It doesn't require legal genius to realize that corporations which can afford six-figure productions may have an edge over the private client or state attorney who can only finance a low-budget presentation. Trial consultants, not suprisingly, like to downplay this situation by insisting that their work involves little more than translating oral testimony into visual form. Their only object, ostensibly, is making complex issues easier to grasp, to help jurors comprehend what an exit wound tells us about a bullet's trajectory, or to make sense of an expert witness's deposition on the growth pattern of a toxic plume in underground water.

Yet hi-tech productions introduce an expert's opinion in an authorative and impersonal form, as something seemingly unattached to human agency and bias. An animated video, however schematic, is also generally more compelling than a verbal description, and ultimately more memorable. At the end of a lengthy trial, the most lucid image in a juror's mind might well be that bright, colorful, two-minute cartoon which was replayed again and again, and in memory the line between real event and reconstruction easily blurs.

Lawyers, of course, have utilized visual and theatrical devices for centuries. Over the past hundred years, attorneys have jazzed up legal proceedings with sensational snapshots, charts and diagrams, as well as the occasional witness rolled in on a wheelchair, and there still exist companies, such as the Evidence Store in New Jersey, which cater to the trade by supplying lurid stage props and forensic models.

But the presence of TV monitors in the courtroom is the symptom of an epochal change. It seems that even in our legal system, supposedly our foremost institution of rational judgement, we are moving from book- and language-based communication to an iconic culture. In support of this drift, visual strategists fondly cite studies which demonstrate that jurors retain far more of what they hear and see than of what they hear alone; indeed, without helpful illustrations, many jurors fail to understand common courtroom instructions, let alone complex technical arguments.

The strategists insist there's nothing wrong with this turn of events; as former hunters and gathers, we are visual creatures by nature, they tell us. It's certainly true that even as infants, we delight in observing movement. People still lean out their windows in summer to witness the bustle in urban streets below, and millions of us look forward each night to watching the flux of pixels on our TV screens. We enjoy kinetic spectacles of all kinds, perhaps because their activity corresponds to the movement of thought and emotion in our hearts and minds.

But an addiction to visual stimulation, which shouldn't be confused with a survival reflex, corrodes our capacity for abstract thought, and if courtroom protocol bows to the short attention span of jurors, something crucial to our truth-telling ritual may be sacrificed in the name of expediency. Clearly, a certain stillness – or at least a minimum of movement – plays a key role in the courtroom's ceremonial aura. There is a decorum and formality to the trial process, an aura of high seriousness, which it is necessary to maintain, because it intimidates most people into telling the truth. When we treat that process as entertainment, honesty becomes a secondary consideration.

One thing is certain: as computers and software drop in price and desktop animation becomes increasingly sophisticated, jurors will no doubt see more and more cartoons of the truth. And in a culture where almost everything is translated into the language of entertainment – from politics to athletics to law – a jury of one's peers may simply be a jury of couch potatoes.

December 1994

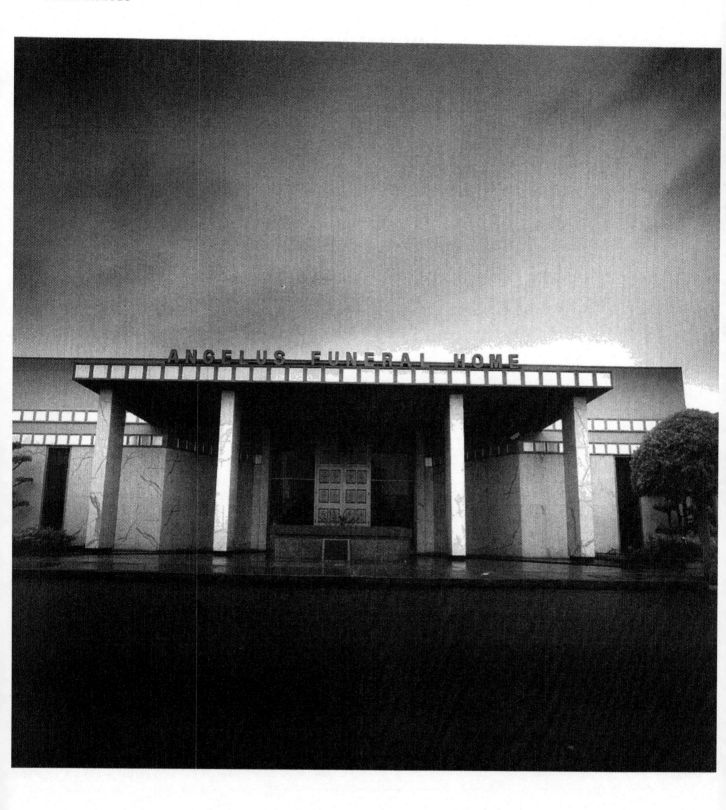

SENTIMENTAL SURVEILLANCE

Is a new kind of memory creating a new kind of person? Observing my three-year-old nephew watching himself in yet another home video, I wonder about his image health. The pictures are unnaturally sharp and intense, and on the TV screen a closeup of his head is a powerful icon more than half the size of his real body. Some day these and other taped images could be the raw material of his most vivid recollections of childhood; since they've been replayed over and over, cutting a groove in his memory, they should at least be the easiest to access. Remembrance provides ballast, it gives us weight in the world, but what will it be like to recall the brightest segments of one's life from someone else's point of view?

As the TV generation is replaced by the camcorder generation, a significant, almost Copernican shift occurs: the act of making an alienated spectacle of our lives becomes a personal responsibility. We no longer have to count on someone else, a Big Brother, to do it for us. Our blossoming culture of auto-surveillance already extends from the backyard to the bedroom, and with the recent introduction of two new commercial services, you can now star in video productions from beyond the grave, and before you've even been born.

First Moments Video Productions is a company that pushes a single product: prenatal video. The brainchild of a Canadian medical entrepreneur, First Moments provides its clients with a ten-minute ultrasound recording. The complete package (priced at $49.95) includes a soundtrack of the fetal heartbeat, voiceover narration that guides the viewer through the ultrasound images, piano mood music, and the

opportunity to record the fetus's response when you talk to it or play a favorite song. They can also print out still pictures – precious first entries in the future baby's scrapbook.

At First Moments, everyone refers to the fetal image as if it were already a performing infant. When the company started doing business in Canada, a Vancouver newspaper ran a story criticizing the operation from a pro-choice viewpoint, claiming the videos encouraged women to regard the fetus as an independent human entity. "What we do is just for entertainment," a company spokesman insists, but this is precisely the problem. Every media spectacle demands a star. Once it's entered the realm of the visible, the fetus inevitably becomes a site for our emotional projection, a three-inch celebrity asserting its right to be seen. The portrait produces the persona, not the other way around.

At no extra cost, the intrauterine spectacle comes replete with therapeutic catharsis. The company's brochure claims that an ultrasound video "has the benefit of bonding the parents to the child before the mother is actually 'showing.' " It's also credited with easing sibling jealousy by allowing the fetus's future brothers and sisters to get used to the idea of a new family member. Presumably, what's therapeutic isn't the grainy video image, but merely the fact that an image exists. It's something you can symbolically possess, and so it doesn't matter if the body portrayed is a technological artifact, because at least it's *your* artifact.

Image therapy is given a different twist by the Tribute Program, a Washington-based enterpise that packages video memorials. Marketed through funeral homes, their product incorporates family photographs of the deceased into slickly edited presentations featuring gushing orchestral soundtracks and a selection of Hallmark-style nature scenes. At the Angelus Funeral Home, a regular user of the Program, I attend a screening of the deluxe model. As the chapel lighting dims, violin music swells through a surround-sound speaker system, star-shaped lights twinkle above on the stucco ceiling, and a draped velvet curtain rises to reveal a giant rear-projection TV. Computer-animated credits flash across the screen with glitzy authority, soaring over the standard deep space background, and I settle into my upholstered pew, wondering if popcorn is included in the price.

Like almost any memorial tribute, the tape presents a sentimental and one-sided picture of a human life. In contrast to the average eulogy, though, the Tribute Program is filled with inadvertent allegory. After a sequence of still photos depicting the dead person's wedding, we see a generic nature image showing a path through the

woods. Is this the path not taken? And what lies at the end of the road? Elsewhere, shots of mortality-evoking sunsets, righteous lighthouses, and wind-blown birches ("the wind bloweth where it listeth"?) are sandwiched between snapshots of the deceased. By association, even the family album pictures take on symbolic weight: in an especially haunting shot, the tribute subject sits on a boat deck, waving at the camera; given the context, it seems as if he's bidding us goodbye from a ferry to the afterlife.

When we speak about the dead at a funeral, the words are motivated by an absence, and they struggle to gauge, if not fill, the void left behind. The large-screen video image, on the other hand, is a presence unto itself. Bolstered with sentimental tunes that borrow heavily from *The Way We Were*, the parade of nature scenes and frozen, perpetually smiling faces is highly manipulative. Without even knowing the subject, I'm moved.

Predictably enough, video memorials are also supposed to have a therapeutic impact. "Instead of leaving the service with a sense of loss, family members and friends leave remembering scenes they may have participated in," a funeral home staff member tells me. "We usually request that the video tribute is shown after the viewing of the casket. That way people don't leave here with the remains as their last image." Yet like the preserved and made-up corpse, the Tribute Program is a means for embalming our memory of the dead person's image; as a technological fetish, video memorials nourish the same dream of putting an end to the corruption of the flesh.

Through our relentless self-surveillance, the mass audience of yesterday achieves a limited type of mass stardom. Death promises not oblivion, but the release of your own personal premiere, something you can now plan out in advance in much the same way that you would compose a will. It could be that out of our collective rapture of the pixels a new kind of video therapy is emerging, but what remains to be seen is whether it can transcend nostalgia and take on some of the traits of those more active forms of remembering that can help elucidate and redefine the present.

February 1992

MARK LIPSON

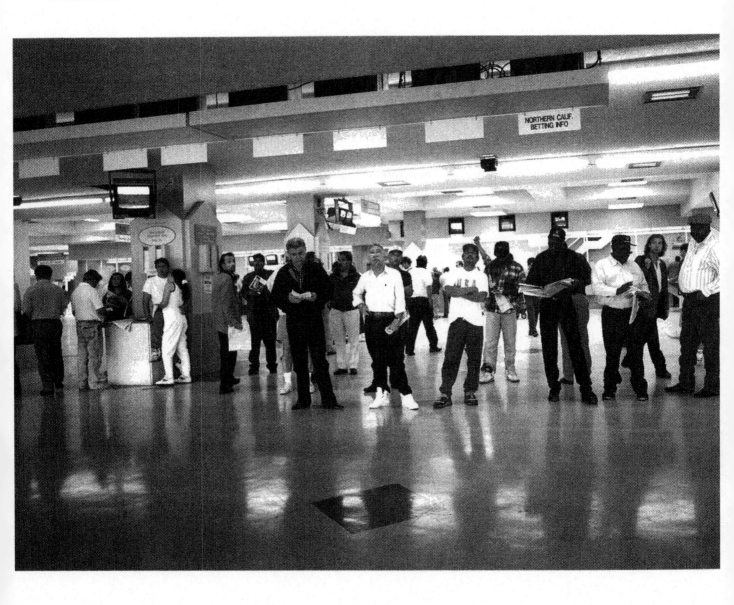

THE NEW HOLLYWOOD PARK

For a good part of his career, the artist Robert Irwin earned an income by playing the horses, translating his aesthetic philosophy into a theory of handicapping. (Site-specific art didn't pay very well in the '70s). In Lawrence Weschler's biography of Irwin, *Seeing is Forgetting the Name of the Thing One Sees*, the artist explains how he juggled logic and intuition at the track, and – as with his art – made a point of taking into account marginal data and context. What intrigued me most, though, was the convincing way he laid out a method to win money betting on horses. My future seemed assured.

A few months at the old Hollywood Park set me straight. In retrospect, what I remember most of that time, besides the pain of losing many carefully planned bets, is the crowd, which was a kind rarely encountered in a freeway megalopolis like Los Angeles. Comprised of members of every ethnic group in Southern California, trespassing class lines and representing all ages, it was a true big-city crowd, and its seedier elements found a graceful echo in the mild shabbiness of the park's facilities. In a land of palm trees and suburbanized desert winds, the track was a microclimate of urban spunk.

By contrast, the "*new* Hollywood Park" (as the race announcer persists in calling it) strives to evoke the pastoral in the heart of downtown Inglewood. A recent $18 million renovation has recreated the track's pre-War "lakes and flowers" motif, transforming the infield into a fantasy of flowing streams, sculpted rocks, spurting fountains, and canals. The dirt walking ring, formerly located in front of the grandstand, has metamorphosed into the "Garden Paddock," a lush spread of greenery and flowers which

fronts the main entrance. And the track's fall meet, formerly called the "Meeting of Champions," has been rechristened "The Autumn Festival."

In Los Angeles, where seasons are hard to distinguish, it's the kind of play you can almost get away with. Much like the "new" Hollywood Boulevard, the revised Hollywood Park attempts to resurrect a bygone glory, though in this case the remodeled history dates back not only to the 1930s (the track opened in 1938), but to the Middle Ages. One revived tradition, the Goose Girl, seems to evoke both periods: attired in fairytale Dutch dress, she can be seen strolling the infield gardens and rowing her Swan Boat across the manmade ponds. For this reason, she's also referred to around the track as the "Lady of the Lakes," a moniker right out of Arthurian legend, if not Raymond Chandler.

With a nod to the Knights of the Round Table, the park's outer wall is decorated with the contemporary equivalent of heraldry: the "silks" of prominent owners. With their abstract geometric designs, many silks also call to mind generic corporate emblems, but at Hollywood Park the point seems to be reminding the plebeian visitor that racing and royalty go together. Forget about those drunken scuffles in the bleachers, this is the Sport of Kings.

Race horses were in fact first bred by a monarch – England's Henry VIII – and in appearance, they remain royally seductive, the animal equivalent of *Vogue* cover models. At the track, their beauty provides a distraction from the business of gambling. Sentimental associations may be another reason why California, like many states, permits betting on races but not casino gambling; especially in a city of cars, horses are nostalgic items, a holdover from a time when animals had utilitarian value as transportation, and the pace of life wasn't completely regulated by machines.

Thoroughbred racing, however, goes beyond nostalgia to tap deeper longings. The sight of a tiny rider perched on a giant galloping beast, utterly immobile in contrast to his mount's churning legs, replays an ancient spectacle of transformation: for the duration of the race, that jockey is part of the animal. It's something that's supposed to happen only in myth. Testifying to the sacredness of this union, a monument to Native Dancer (1939–1967), who successfully merged with his riders to win three Hollywood Gold Cups, occupies a place of honor in the Garden Paddock, where it beckons as a holy shrine for Thoroughbred pilgrims.

But despite its pastoral motifs, the new Hollywood Park is basically a closed-circuit TV network. Thanks to a state law passed in September, the track is now open year round as a "simulcast facility" licensed to broadcast races from other tracks when

there isn't a local meet. Color monitors are suspended from the ceiling in every conceivable place, including the grandstand, where most patrons choose to follow the action on the tube rather than with binoculars. Even as the horses plunge down the backstretch directly in front of them, most fans prefer to watch the giant screen next to the infield tote board. Many people don't even bother stepping outside at all, since plenty of crisp Toshiba monitors hang near the betting windows, but for most – television *en plein air* is a satisfying way of mixing nature and culture, which is what Thoroughbreds themselves are all about.

When Robert Irwin first started handicapping, detecting key details of a race was largely a matter of perceptual acuity and intense concentration. You bet on horses you knew were better than their statistics, and as long as not too many others noticed the same things you did, you could find odds worth wagering on. But in an instant replay world, a philosophy of immanence inevitably loses its edge. These days, each race is immediately rebroadcast on the track's countless monitors and – as Irwin bemoaned – any "idiot" can see whether a horse lost simply because it was boxed in at the gate or bumped in the stretch. As an added service, the track now features a "request line," allowing visitors to review any race run during the current season.

Yet the idea that "information is power," a truism whose currency peaked during the Cold War, seems suspect at Hollywood Park. When everyone has access, information alone isn't power – what counts is your ability to process it, to "catch the feel of a situation two jumps before it becomes a fact," as Irwin put it. In the new Pavilion Study Hall, race-track scholars conduct their research at minimalist formica desks, sifting through vast flows of numerical data, from the speed fractions listed in the *Racing Form* to the ever-changing odds on the tote board. Perhaps for some, this graduate student atmosphere cushions the inevitable shock of losing, but at Hollywood Park no amount of research can guarantee a winner.

There are many ways to victimize oneself in this world, but the track offers some special consolations. For the sincere handicapper (as opposed to the impulse bettor), there is a unique thrill in literally turning the lead of statistics and observation into gold. And in addition to winning money, there's a spiritual lift which comes from a sense of transcending time: in predicting the outcome of a race, you achieve a feat of prophecy. After a good day at the track, making sense of your own life doesn't seem like such an absurd proposition.

Of course the track is a hothouse for all kinds of fetid metaphors, especially that old standby "Life is unpredictable." An attraction like Hollywood Park also comprises a

layered discourse on social hierarchies. From the posh accent of the track's South Africa-born announcer, to the emphasis on the horses' pedigree (their "class"), and the economic segregation enforced by differently priced seats, cultural ideas about "quality" are routinely played out. For all its Disneyland elements, in other words, Hollywood Park mirrors the world outside, even boasting a drug epidemic that involves not just jockeys (suspensions for cocaine use are not uncommon), but also the horses, who are regularly run on painkillers as well as anti-bleeding and anti-inflammatory drugs which are legal in this country but banned at European tracks. As for violence, you don't have to wait for a tragic spill – just watch closely down the backstretch where most jockeys whip the hell out of their mounts.

But it's always summer in Southern California, and on television, nothing hurts.

March 1992

9 781859 840030

Printed by Printforce, United Kingdom